D0513708

Donald Moffett

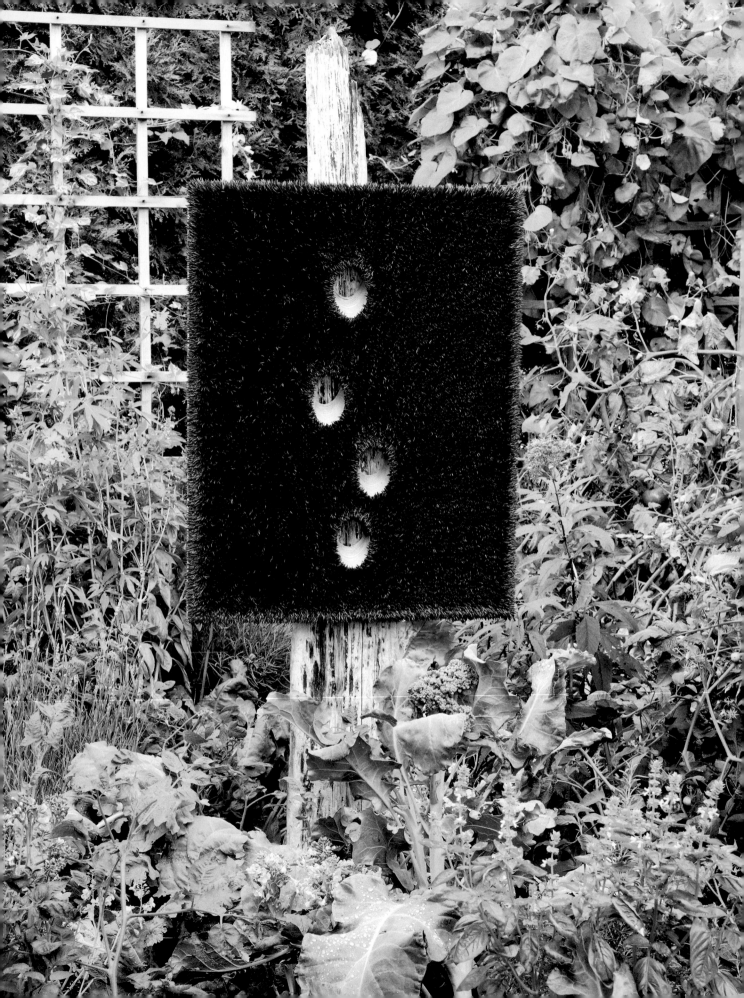

Donald Moffett
The Extravagant Vein

Valerie Cassel Oliver

with contributions by

Bill Arning

Douglas Crimp

Russell Ferguson

Donald Moffett

Contemporary Arts Museum Houston

Skira *Rizzoli* NEW YORK

Published on the occasion of the exhibition *Donald Moffett: The Extravagant Vein*, organized by Valerie Cassel Oliver, Senior Curator, for the Contemporary Arts Museum Houston.

Exhibition itinerary:

Contemporary Arts Museum Houston
October 1, 2011–January 8, 2012

The Frances Young Tang Teaching Museum and Art Gallery, Skidmore College, Saratoga Springs, N.Y.
February 18–June 3, 2012

The Andy Warhol Museum, Pittsburgh
June 23–September 9, 2012

Donald Moffett: The Extravagant Vein is supported by generous grants from The Andy Warhol Foundation for the Visual Arts, Carol C. Ballard, Agnes Gund, Linda Pace Foundation, and the National Endowment for the Arts. Additional support is provided by contributions from a donor who wishes to remain anonymous, William F. Stern, and Emily Leland Todd.

ART WORKS.
arts.gov

LINDAPACEFOUNDATION

This exhibition has been made possible by the patrons, benefactors, and donors to the Museum's Major Exhibition Fund:

Major Patron
Chinhui Juhn and Eddie Allen
Fayez Sarofim
Michael Zilkha

Patrons
Louise D. Jamail
Mr. and Mrs. I. H. Kempner III
Ms. Louisa Stude Sarofim
Leigh and Reggie Smith

Benefactors
Baker Botts L.L.P. / Anne and David Kirkland
George and Mary Josephine Hamman Foundation
Jackson Hicks / Jackson and Company
Marley Lott
Poppi Massey
Beverly and Howard Robinson
Andrew Schirrmeister
Susan Vaughan Foundation, Inc.
Mr. and Mrs. Wallace Wilson

Donors
A Fare Extraordinaire
Anonymous
Anonymous
Bergner and Johnson Design
The Brown Foundation, Inc.
Jereann Chaney
Susie and Sanford Criner
Elizabeth Howard Crowell
Sara Dodd-Spickelmier and Keith Spickelmier
Ruth Dreessen and Thomas Van Laan
Marita and J. B. Fairbanks
Jo and Jim Furr
Barbara and Michael Gamson
Brenda and William Goldberg / Bernstein Global Wealth Management
King & Spalding L.L.P.
KPMG, LLP
Judy and Scott Nyquist
David I. Saperstein
Scurlock Foundation
Karen and Harry Susman

The catalogue accompanying the exhibition is made possible by a grant from The Brown Foundation, Inc.

Funding for the Museum's operations through the Fund for the Future is made possible by generous grants from Chinhui Juhn and Eddie Allen, a donor who wishes to remain anonymous, Elizabeth Howard Crowell, Barbara and Michael Gamron, Brenda and William Goldberg, Mr. and Mrs. I. H. Kemper III, Leticia Loya, and Fayez Sarofim.

The Museum's operations and programs are made possible through the generosity of the Museum's trustees, patrons, members, and donors. The Contemporary Arts Museum Houston receives partial operating support from the Houston Endowment, the City of Houston through the Houston Museum District Association, the National Endowment for the Arts, the Texas Commission on the Arts, and The Wortham Foundation, Inc.

Texas
Commission
on the Arts

UNITED

Official airline of the Contemporary Arts Museum Houston.

2011 2012 2013 2014 / 10 9 8 7 6 5 4 3 2 1

First published in the United States of America in 2011 by

Skira Rizzoli Publications, Inc.
300 Park Avenue South
New York, NY 10010
www.rizzoliusa.com

in association with

Contemporary Arts Museum Houston
5216 Montrose Boulevard
Houston, TX 77006
www.camh.org

Distributed to the U.S. trade by Random House, Inc.

Library of Congress Catalog Control Number: 2011931512
ISBN: 978-0-8478-3727-4

Cover: *Lot 051408 (X)*, 2008; acrylic, polyvinyl acetate with rayon, and steel zipper on linen, wood stretcher; 54 x 44 inches. Private collection, New York; courtesy Marianne Boesky Gallery.
Front endpaper: *Lot 112704*, 2004 (detail); oil and aluminum paint on linen with wood panel support; 16¼ x 22¼ inches. Courtesy the artist.
Back endpaper: *Lot 101002.04 (r)*, 2002/2004 (detail); oil and aluminum paint on linen with wood panel support; 11 x 8½ inches. Private collection.
Page 2: Outdoor installation of *Lot 072310 (4/O)*, 2010; oil on linen with wood panel support; 31 x 25 inches. Private collection, New York; courtesy the artist and Marianne Boesky Gallery.

For the Contemporary Arts Museum Houston:
Valerie Cassel Oliver and Justine Waitkus, Publication Coordinators
Karen Jacobson, Editor

For Skira Rizzoli Publications, Inc.:
Margaret Rennolds Chace, Associate Publisher
Julie Di Filippo, Editor

Design: Miko McGinty, Inc.
Printed and separated by Trifolio, SRL
Printed and bound in Italy

Contents

Foreword

It is a great cliché to say that an artist's "time has come," but sometimes to speak the truth you need to trade in clichés. In the case of *The Extravagant Vein*, the first museum survey of two decades of work by the artist, Donald Moffett's time has indeed come.

Moffett has been a consistent presence in the art world for the last two decades, yet he seemed always to remain in the category of "artist's artist," the netherworld of talented cult figures whose names art mavens trade like rare baseball cards. While critically well regarded, his work is resistant to being reduced to a simple sound bite. Given its breadth and ambition, his oeuvre always needed to be seen in a survey of this scale to be fully appreciated. Bodies of work that seemed slyly evanescent on first encounter now seem epic in retrospect. As the director of the Contemporary Arts Museum Houston, I am happy to report that the time for that appreciation is at hand. Since Moffett is an artist born and raised in Texas, with family in Houston, this is the ideal locale for such an exhibition to occur.

Moffett is an artist whom curators tend to adore, and we are happy to report that the show will be on view at the Andy Warhol Museum in Pittsburgh and the Frances Young Tang Teaching Museum and Art Gallery at Skidmore College, Saratoga Springs, New York. I would very much like to thank Tom Sokolowski, former director, and Eric Shiner, acting director and Milton Fine Curator of Art, at the Warhol, as well as John Weber, director, and Ian Berry, Malloy Curator, at the Tang, for their early enthusiasm for the project. I truly look forward to seeing this show installed in these two great museums, as I am sure to gain new insights from their curatorial interpretations of Moffett's work.

Moffett has worked with a number of stellar galleries over the course of his career, and we are indebted to many of them for information, support, and the loving care that they have taken with his works. Marianne Boesky Gallery has mounted some of the artist's most extravagant exhibitions, bodies of work and installations that have made Moffett's critical reputation and form the basis of this exhibition. As someone who remembers well when Marianne Boesky opened her gallery in 1996, and as a regular viewer and fan of her program ever since, I was thrilled to work with her on making this exhibition a reality. Stephen Friedman Gallery in London and Anthony Meier Fine Arts in

San Francisco have also given consistent support to Moffett's unique vision over many years and have lent their expertise to bringing this exhibition to fruition. I also am happy to add the legendary Houston dealer Fredericka Hunter at Texas Gallery to this august list. She shared her wisdom and insights freely and deserves much of the credit for making this exhibition a success.

This publication is our first collaboration with Skira Rizzoli, and I want to thank Charles Miers, Margaret Chace, and Julie Di Filippo. We look forward to our next project together. The contributing authors who shared their insights into Moffett's art are all giants in the field as well as old friends. Douglas Crimp conducted a profoundly moving interview with the artist, and Russell Ferguson provides an astute analysis of his career. Together their contributions make for an illuminating excavation of the artist and his time. Reading them will add to the viewing experience both for those of us who have been watching Moffett's work for decades and for those who are coming to it for the first time. When I arrived at the Contemporary Arts Museum Houston in 2009 and learned of the project, I offered my own services as a contributor to this publication, and I am proud to be part of this team. The synergistic relationship between book designer Miko McGinty and Moffett was a joy to behold, and the result is this book, which is in many respects a work of art in itself.

We could not have made this exhibition a reality without the generous support of the Andy Warhol Foundation for the Visual Arts and the National Endowment for the Arts. A number of private individuals have also stepped forward to make this artist's exhibition all it can be. It is my pleasure to publicly acknowledge the generous support of Carol C. Ballard, Agnes Gund, William F. Stern, and Emily Leland Todd, as well as other friends who wish to remain anonymous. Special thanks go to Steven Evans, the new director of the Linda Pace Foundation in San Antonio, Texas, who was enthusiastic in his support for this project, as a funder and as the lender of a gorgeous work by Moffett. We look forward to finding many ways to collaborate with our colleagues in San Antonio in the future.

All the many supporters of CAMH have helped to make this exhibition a reality, but it is the work of our Major Exhibition Fund donors that allows the museum to pursue curatorial excellence unencumbered. Their vision and generosity year after year allow our great curators to do their important scholarly work, and being able to count on them is the lifeblood of our museum.

Our staff as always has done a bang-up job, and Amber Winsor and her team in CAMH's development department—Olivia Junell, Amanda Brenbrenner, and Victoria Ridgway—led the charge to marshal adequate resources for the massive endeavor. They are to be congratulated for their many successes. Curatorial manager Justine Waitkus has negotiated many complex aspects of the exhibition and its tour, and we are grateful for her relentless attention to detail. And while the work of Tim Barkley, registrar, and Jeff Shore, head preparator, is still months away, I thank them in advance for approaching this exhibition with their typical enthusiasm.

Our greatest debt of gratitude goes to the artist-curator team of Donald Moffett and Valerie Cassel Oliver. Valerie has been working on this exhibition for several years: as always with her, the timing is impeccable, ahead of the curve enough so that the exhibition happens at exactly the right time. She has developed a very close relationship with the artist and his work, and the two have a strong shared vision for this exhibition— so much so that the first time we had lunch together I noticed that they were finishing each other's sentences. The relationship in which an artist's works gain in impact from the curatorial discussion is the holy grail in museum work, and to witness it is a powerful experience. The most powerful experience of all, however, is when we see how an exhibition effects change in the way the art of our time is taught and understood. I am grateful to everyone who has allowed me and the Contemporary Arts Museum Houston to participate in that change.

Bill Arning
Director

Acknowledgments

As a curator I have had the good fortune to work at an institution that has for more than sixty years valued curiosity, critical rigor, and the challenging task of writing history as it happens. I am grateful to the Contemporary Arts Museum Houston, its board of trustees, and its director, Bill Arning, for allowing me to be fearless as a thinker and curator.

I first met Donald Moffett in 2002 at an exhibition featuring his work at Texas Gallery in Houston. Over dinner, Donald and I immediately connected. I never forgot his thoughtfulness, not just about art and art making but about life, politics, and family as well. Every year subsequent to our first meeting, Donald would travel to Houston to visit family. Our acquaintance quickly grew into a friendship built upon mutual respect, a love for the great state of Texas (we are both natives), and of course food! Suffice it to say, when Donald's survey exhibition was in danger of falling through the cracks because its original curator, John Smith, had left the Andy Warhol Museum for the National Archives in Washington, D.C., I immediately volunteered to undertake this project under the auspices of the Contemporary Arts Museum Houston. It was an extraordinary opportunity to champion and celebrate the work of Donald Moffett, whom I believe to be an exceptionally talented artist.

This exhibition and its accompanying publication have been a collaborative effort. I have been tremendously fortunate to work with Donald, who has shown himself to be a truly generous and compellingly reflective human being. I hope that my profound respect for him and passion for his work resonate with what viewers will see and read in this catalogue. This is the first major survey of the artist's work, and we worked closely with the members of his studio team, including Gwendolyn Skaggs, Julia Rommel, and Larry Levine. I thank them for their crucial assistance. Donald's gallery representatives, led by Marianne Boesky, were also integral to the organization and success of this undertaking. This project could not have come to fruition without their efforts. I am grateful for the support of Marianne Boesky, Serra Pradhan, and Adrian Turner at Marianne Boesky Gallery, New York; Stephen Friedman and David Hubbard at Stephen Friedman Gallery, London; and Tony Meier, Rebecca Camacho, Sarah Granatir Bryan, and Megan Spencer at

Anthony Meier Fine Arts, San Francisco. I also owe a debt of gratitude to my colleagues Ian Berry, Malloy Curator at the Frances Young Tang Teaching Museum and Art Gallery, Skidmore College, and Eric Shiner, acting director and Milton Fine Curator of Art at the Andy Warhol Museum, who saw the merit of bringing this exhibition to a broader audience and advocated for its presentation at their institutions.

The publication marks our first collaboration with Skira Rizzoli. I am greatly appreciative of this opportunity and wish to express my thanks to Charles Miers, Margaret Rennolds Chace, and Julie Di Filippo. I had the good fortune to work with a brilliant group of coauthors—Bill Arning, Douglas Crimp, and Russell Ferguson—and I thank them for their contributions to this volume. Sarah G. Cassidy ably compiled the detailed chronology and bibliography. Both Donald and I have long wanted to work with the publication's designer, Miko McGinty, and this book is a testament to her keen eye and sensibility. I am grateful for her insistence that details matter. I am also indebted to our remarkable editor, Karen Jacobson, for her thoughtful attention to the texts.

At the Contemporary Arts Museum Houston, I am fortunate to work with a family of tremendously dedicated and talented individuals. Without their help and support, an endeavor of this magnitude could never be realized. Curatorial manager Justine Waitkus was instrumental in keeping all aspects of the project on track and coordinating the exhibition tour. Registrar Tim Barkley managed loan requests and oversaw complex shipping arrangements. Jeff Shore, head preparator, deserves a special thank-you for his amazing exhibition design and for supervising the installation. I am also grateful to the museum's communications and marketing manager, Connie McAllister, for her diligence in ensuring visibility for this exhibition in Houston and coordinating publicity efforts with the other venues. And I am tremendously grateful to Amber Winsor, director of development, and her team for their enormous efforts in securing much-needed funding for this project. Trustees Sissy Kempner and Lynn Herbert undertook a campaign to secure individual donors, achieving a success rate that exceeded expectations and raising enthusiasm and anticipation for the exhibition along the way. And I would be remiss not to acknowledge the invaluable contributions of Cheryl Blissitte, assistant to the director, who not only was instrumental in key communications regarding loan requests but also served as our in-house proofreader, carefully reviewing various drafts of this catalogue.

Finally, I wish to thank the lenders, whose names are listed on the following page. Their generosity in sharing works from their collections is a true testament to their belief that Donald Moffett deserves a comprehensive survey that not only traces his development as an artist but also reflects the depth of his contribution to contemporary art.

Valerie Cassel Oliver
Senior Curator

Lenders to the Exhibition

Shelley Fox Aarons and Phillip Aarons
Marianne Boesky Gallery
J. Ben Bourgeois
Mickey Cartin/The Cartin Collection
Adam Clammer
Tony and Deb Clancy
Clo and Charles Cohen
Charles and Nathalie de Gunzburg
Milton Dresner
Jennifer and John Eagle
Dr. Alan Fard and Ed Simpson
Stephen Friedman Gallery
Agnes Gund
Alan Hergott and Curt Shepard
Chris Hill
Mickey and Jeanne Klein
Siobhan Liddell
Peter Marino/Peter Marino Architect
 + Associates
Jennifer McSweeney

Anthony Meier Fine Arts
Donald Moffett
Meryl Lyn Moss
Museum of Contemporary Art, Chicago
Museum of Fine Arts, Houston
The Linda Pace Foundation
The Rachofsky Collection
Lora Reynolds and Quincy Lee
The David Roberts Art Foundation, Ltd.
Lisa and John Runyon
Charles and Helen Schwab
Jeff Stokols and Daryl Gerber Stokols
Howard and Donna Stone
Dr. Marc and Livia Straus
Teri and Barry Volpert
Scott Watson
Whitney Museum of American Art,
 New York
Sharon and Michael Young

Several private collectors

Donald Moffett: The Extravagant Vein
Valerie Cassel Oliver

Any thoughtful investigation of the work of Donald Moffett must consider the larger context in which it was created. Moffett came to New York as a young artist in 1978, just a few years before the AIDS crisis would change everything for him and his contemporaries. He became a founding member of Gran Fury, the propaganda arm of ACT UP (AIDS Coalition to Unleash Power), which created powerful slogans and graphics that exploded misperceptions about AIDS and condemned the government's torpid response to the rapidly spreading epidemic. Even before his involvement with ACT UP, however, Moffett was conducting his own propaganda campaign with his *He Kills Me* posters (1987). This and other seminal works born out of the moment—such as the Silence=Death logo, developed by the Silence=Death Project in 1987; *Kissing Doesn't Kill*, a public service video and print campaign created by Gran Fury in 1989; and *Call the White House* (p. 37), Moffett's light box and postcard project of 1990—have shaped our very understanding of the AIDS crisis and remain persistent afterimages of the times. From 1989 to 2001 he was also working with fellow Gran Fury member Marlene McCarty as a partner in the graphic design studio Bureau, which produced notable activist works as well as more commercial projects.

One consequence of the public nature and undeniable power of Moffett's activist work is that it has often overshadowed the personal work that he produced concurrent with his involvement with Gran Fury and Bureau and has continued to produce in the years since. Any survey exhibition offers a valuable opportunity to contextualize the artist's practice within a larger art historical trajectory. In Moffett's case, a considered investigation of the entire scope of his career may also enable viewers to understand how his early engagement provided a nucleus for his later practice. Rather than perceiving his career as having developed along parallel tracks—the personal work and the activist collaborations—we might instead see it as one that grew out of a historical moment in which the personal became inextricably bound up with the political.

The works Moffett made prior to 1996 show a more direct connection to his activist work, using appropriated imagery from newspapers, magazines, gay porn, and television or found objects such as bowling balls (p. 33), which he combined with text. Two of the

series featured in the exhibition, Gays in the Military (1990) and Nom de Guerre (1991), emerged during this period. While his work received considerable recognition, by 1994 Moffett was experiencing burnout following his years of intense work with Gran Fury and Bureau and the loss of a lover and innumerable friends and colleagues to AIDS.

In 1996, after a period of regrouping during which he did not show his work, Moffett had an exhibition of small, apparently abstract paintings at Jay Gorney Modern Art in New York that he retrospectively called *A Report on Painting*, a title that he describes in his interview with Douglas Crimp in this volume as "modest and grandiose at the same time." As the artist explains, the show was a report on an investigation that he had undertaken in his studio: "I had been making paint stand up rather than lay down, asking (or rather forcing) it to do something unnatural. But also I was tossing my lot in with a nonfigurative minority—or so it felt. I had not softened on meaning or content, but I wanted to try another language for getting there." Moffett now regards this exhibition as a turning point, and much of his work of the past fifteen years can be seen as reframing and expanding the medium of painting without abandoning the meaning and content that were so central to his earlier work.

A Report on Painting was the first presentation of a new body of work consisting of highly textured monochrome canvases that Moffett referred to as "lot" paintings. (As a rule, the lot titles include a series of numbers that indicate the month, day, and year on which he began the painting.) These works would mark a seismic shift in his practice, placing him within the trajectory of painters such as Lucio Fontana, Jasper Johns, Robert Ryman, and Robert Rauschenberg. While Moffett initially focused on working with paint on canvas, he had long had an interest in technology, experimenting with light boxes and video earlier in his career, and he would later find a way to combine other media with painting.

This exhibition features selections from the major bodies of work created by the artist over the past twenty years. It is a comprehensive but by no means exhaustive survey of Moffett's oeuvre, which assembles for the first time all four bodies of his so-called light loops, in which video images are projected onto a monochrome canvas: What Barbara Jordan Wore (2001–2), The Extravagant Vein (2003), D.C. (2004), and Paintings from a Hole (2004). The selection of works is intended to reveal the breadth of the artist's practice, showing his ability to move fluidly between such mediums as painting (the primary focus of the exhibition), works on paper, photography, sound, and installation.

Works on Paper: Gays in the Military, Nom de Guerre, Mr. Gay in the U.S.A., Blue (NY)

In the series Gays in the Military (1990) and Nom de Guerre (1991), Moffett combined found historical portraits of celebrated military figures with abject and broadly humorous texts that trumpet their prowess, though not necessarily on the battlefield. The series

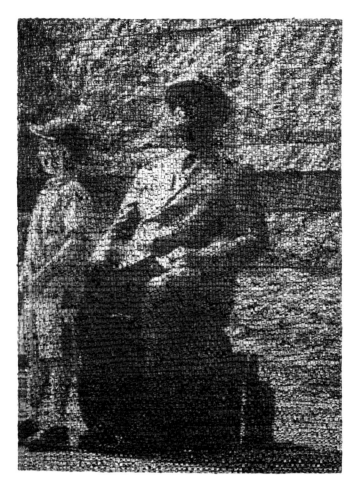

Donald Moffett, *Aluminum/FDR and Friends*, 2004; video projection, oil and alkyd on linen, 80 x 60 inches. Collection Teri and Barry Volpert, New York.

responded to contemporaneous debates on the appropriateness of gays serving in the armed forces, which would eventually lead to the establishment of the "don't ask, don't tell" policy. As Hilton Als and Laura Cottingham wrote in regard to the Gays in the Military series, the works "suggest what the U.S. Pentagon refuses to admit in their insistence on a 'gay ban': that homosexual men already serve in the armed forces, and have throughout history."[1]

In 1993 Moffett would take a more somber approach to the topic of gays in the military in the diptych poster *In Honor of Allen R. Schindler* (p. 166), produced in collaboration with Marlene McCarty under the aegis of Bureau. Schindler was a radioman

in the U.S. Navy who was brutally murdered by a shipmate for being gay. Moffett would later address the dangers faced by gay men in civilian life, as well as the sometimes absurd tragedies that seem to be endemic to American culture, in a group of eighteen drawings collectively titled *Mr. Gay in the U.S.A.* In 2001 the artist sat in the courtroom during the sentencing of Ronald Edward Gay. Angered that his surname had become synonymous with homosexuality, Gay had randomly opened fire in the Backstreet Bar, a known gay hangout in Roanoke, Virginia, on September 22, 2000, killing Danny Lee Overstreet and wounding six others. In his simple line drawings, Moffett recorded the interior of the courtroom, the appearance of the accused killer, the faces of his victims, the jury box, and other elements of the scene, creating what Holland Cotter described as "another oblique document in this artist's continuing study of the shifting positions of normality and strangeness, in which he lets the facts speak for themselves."[2]

Blue (NY), Moffett's series of exquisite monochrome photographs from 1997, was prompted by his move to an apartment whose casement windows afforded extraordinary views of the sky over Manhattan. This body of work is discussed in depth in Bill Arning's essay in this publication. It is worth noting here, however, that in the exhibition this series is coupled with Moffett's *He Kills Me* poster, in which then president Ronald Reagan served as the face of the government's deadly indifference to AIDS. The juxtaposition captures two distinct moments in the artist's experience of the pandemic: the despair and anger that marked the early years of the crisis and the tentative sense of optimism that became possible with the advent of improved drug therapies and official recognition of AIDS as something more than a "gay man's disease." Windows onto seemingly limitless expanses of blue are set against the spiraling depths of ignorance and fear that characterized the 1980s, providing a visual metaphor for a turning point in Moffett's life and work.

Light Loops: What Barbara Jordan Wore, The Extravagant Vein, D.C., and Paintings from a Hole

Moffett introduced his "light-loop" paintings with the series What Barbara Jordan Wore (2001–2). The project was created and presented in two parts—first as a group of paintings and photographs at Texas Gallery in Houston in 2001, and second at the Museum of Contemporary Art, Chicago, in 2002. The exhibition in Chicago marked the debut of the light loops. The series celebrated the extraordinary Texas congresswoman Barbara Jordan, whom Jim Lewis eloquently describes in the catalogue of the Chicago exhibition:

> Barbara Jordan was a black woman from Houston, the third daughter in a working-class, churchgoing family, a graduate of Texas Southern University who went on to law school at Boston University and then returned to Houston, where after a few failed attempts, she became a member of the

Texas State Senate from 1966 to 1972, then of the U.S. House of Representatives from 1972 to 1978. . . . Her legislative skills were considerable, and her achievements were real and impressive, but for better or worse she is remembered now, as she was admired then, as an emblem of righteousness, equity, inclusion, and progressiveness.[3]

These are the values that Moffett highlights in the work, which, as Russell Ferguson explains in his essay in this volume, incorporates footage and audio of an influential speech that Jordan delivered to the House Judiciary Committee in 1974 supporting the impeachment of President Richard Nixon in the wake of the Watergate scandal. Moffett projects images of the congresswoman onto the canvas, and the effect is mesmerizing in part because of the way she is illuminated against the textured gold plane. She is neither tangible nor immaterial, yet her presence has a powerful resonance.

Moffett continued to explore the use of video projections in three subsequent bodies of work. For D.C., Moffett created his own video footage, using a handheld camera to document such Washington, D.C., landmarks as the White House, the J. Edgar Hoover Building (headquarters of the FBI), the statue of Franklin D. Roosevelt, the Watergate Hotel, and the Dupont Circle metro station. The video is edited into loops of varying lengths, and in some works, such as the FDR piece, the frames appear almost static. One is clued in to the fact that they are moving images only through subtle alterations: the American flag softly waving above the dome of White House or the sudden intrusion of a tourist into the frame. In the footage of the Dupont Circle metro station, which serves a neighborhood that has historically been home to the city's gay community, Moffett trains the camera on a figure dressed in a hooded sweatshirt ascending the escalators toward the R Street exit. We are privy to the movement upward from the darkened tunnel and experience an expanse of sky that echoes the artist's Blue (NY) series.

The Extravagant Vein, the light-loop series from which the title of this exhibition is taken, engages the tradition of landscape painting. The title alludes to both gold in its raw and natural state (the canvases are painted gold) and the throbbing vein of the swollen phallus. The gold canvases provide a screen onto which Moffett has projected his own footage of the Ramble, an area of New York's Central Park that was conceived as a "wild garden." Lushly planted and crisscrossed by winding trails and a manmade stream, it has been known as a gay cruising site since the early twentieth century but has also been the scene of violent homophobic attacks. A writer for *New York* magazine described the situation in 1978: "Gangs of toughs—teenagers and the macho middle-aged, usually drunk, occasionally including a couple of off-duty cops—roam the Ramble at night, engaging in an old American pastime: fag bashing. You don't have to be gay. . . . You don't have to be doing anything except walking through the tangled darkness to be abused, shoved, threatened at knifepoint, kicked, and beaten. But these shadowy dangers are in sharp contrast to the serenity of the sun-flecked arboreal mecca the Ramble

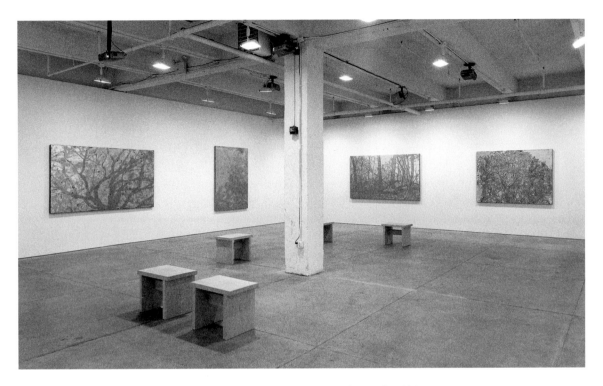

The Extravagant Vein, 2003, installation view, Marianne Boesky Gallery, New York.

becomes for thousands of gay men throughout each day."[4] In choosing this particular landscape, Moffett evokes the opposition of nature and culture, as well as the site's dual associations with pleasure and danger.

In Paintings from a Hole, Moffett moved away from imagery of recognizable figures and landmarks, instead providing a playful riff on painting as a performative act. Videos projected onto a series of canvases show a disembodied arm emerging from a hole at the center of the canvas and then extending itself, with paintbrush or roller in hand, to visibly paint the painting. The painting is never finished. It is in a constant state of being painted, unpainted, and repainted. The static nature of a painting is undermined, its constancy destabilized. The painted lines are real, the space is real, the surface is real, and yet Moffett suspends reality with the surreal performance of an arm and hand moving sometimes awkwardly and at other times fluidly across the canvas. This interaction between the painting and the painter, however abstracted, paves the way for new experiences and perceptions.

Sequence of stills from *Untitled/Black (Lot 070504)*, 2004; video projection; oil and alkyd on linen. Collection J. Ben Bourgeois, Los Angeles.

Lot Paintings

The earliest of Moffett's lot paintings featured in this exhibition are presented as a component of the What Barbara Jordan Wore series. These three paintings demonstrate the range of this body of work—from highly textured and dense applications of extruded paint to understated, delicate surfaces that mimic cloth.

In the installation work *Hippie Shit* (2005), a series of large-scale paintings are hung tightly in a row under the glare of fluorescent lights. The paintings are accompanied by a sound track of the songs "What's Going On" (originally recorded by Marvin Gaye); "(What's So Funny 'Bout) Peace, Love and Understanding" (written by Nick Lowe); and "For What It's Worth" (originally recorded by Buffalo Springfield). The songs, all penned and recorded in the late 1960s and early 1970s, were regarded as protest songs at the time. For this installation, they are recorded as instrumental versions on harmonica performed by Marcus Milius, Bob Conte, and Gayle Brown. The three harmonicas, which are distinct in tone and character, evoke a sense of melancholy and lament. The starkness of the light against the paintings feels like a wake-up call, and Moffett himself has characterized the work as growing out of his own realization that particular forms of activism, protest, and civil disobedience now feel like remnants of a long-gone era.[5]

In 2007 Moffett began two bodies of work, Gutted and Fleisch, which explored the legacy of Minimalism and abstraction in contemporary painting. His paintings are conceived as experiments in space and the expansion of the canvas beyond the two-dimensional frame, but he infuses them with references to the transgressive and, at its farthest extreme, self-destructive nature of sexual desire. Even the titles (*Fleisch* is German for "flesh" or "meat") suggest sexual violence and sadomasochism.

In Gutted, zippers have been sewn into the canvases, which are unzipped or flayed, exposing the underside. The act of peeling and pulling back the four quadrants of the painting reveals the rich color that Moffett has painted directly onto the wall, creating depth and three-dimensionality. In Fleisch, he continued his interrogation of Minimalism and the limitations of the traditional two-dimensional frame. Referencing Italian painter Lucio Fontana, he slashed, pierced, and otherwise tore into the painted surface. Unlike Fontana, however, Moffett reassembled the pierced and slashed parts using zippers and embroidery stitches. There is a reference—perhaps violent, perhaps clinical, perhaps ritual—to slicing into flesh, carving the surface of the body as an act of scarification.

The use of the hole was carried over into subsequent series, particularly Comfort Hole (2010), in which Moffett transposed the use of slashes and piercing from canvas onto wood panels. On the surface of the wood, he employed his signature technique of extruded paint, extending the language of his lot series while simultaneously pushing monochrome painting into stark sculptural relief. By referring to the openings in the paintings as "fuck holes" or "glory holes," he subverts the seemingly dry formalism of Minimalist painting.

Moffett pursued this line of investigation in his installation at the Marianne Boesky Gallery space at the 2010 Frieze Art Fair in London. The work consisted of a series of cobalt textured paintings emanating in two directions from a pristine white painting shaped like an empty frame. Below the paintings and radiating from the corner of two adjoining walls was an excerpt from Walt Whitman's poem "The Wound-Dresser":

> Many a soldier's loving arms about this neck have cross'd and rested,
> Many a soldier's kiss dwells on these bearded lips

Whitman, an iconic American poet, is celebrated not only for his pioneering use of verse but also for his frank (at least for the time) treatment of sexuality and his political directness in the turbulent period of the Civil War and its aftermath. "The Wound Dresser" served as a cry against the inhumanity of war and a tribute to the bravery and sacrifice of the wounded men he tended as a volunteer nurse in hospitals in Washington, D.C. A few years after Moffett made the video of the Dupont Circle metro station for his D.C. series, these lines from the poem were inscribed on the station's concrete entrance as a memorial to the men and women who died during the AIDS pandemic of the 1980s and 1990s:

> Thus in silence in dreams' projections,
> Returning, resuming, I thread my way through the hospitals,
> The hurt and wounded I pacify with soothing hand,
> I sit by the restless all the dark night, some are so young,
> Some suffer so much, I recall the experience sweet and sad . . .

The lone sound work in the exhibition is the installation *Impeach* (2002). In this work we hear the voice of John Lewis, the Democratic congressman from Georgia, defending then president Clinton during his impeachment hearings in 1998. Lewis, a leader and hero of the civil rights movement who was severely beaten during the early protests, sought to diligently and forthrightly restore the dignity of the office of president and also of Congress itself as it detoured wildly from "its work on behalf of its citizens." In the installation, Moffett renders the distinctive cadence of Lewis's voice, which is the result of the injuries he sustained during the protests and was neither altered nor manipulated for the work, into tangible material. Sound becomes both material and content as the congressman's voice builds to a crescendo that literally engulfs the listener.

Although Moffett has explored a variety of media since 1996—including photography, video, installation, and sound—he has made painting the core of his work. His use of extruded paint to produce three-dimensional relief on canvas has reinvigorated the medium: no one else has applied paint quite like Moffett, and it has become a signature

technique. Moreover, his use of projected video images in the light-loop paintings has brought a kinetic element to a normally static medium, energizing the highly textured surfaces of his canvases with the play of light, shadow, and color. The addition of sound and moving images creates an immersive experience not ordinarily associated with painting, suggesting that the medium has a limitless potential that artists like Moffett are only beginning to explore.

Moffett's art is about the act of painting, about light and landscape, as well as who inhabits that landscape and the ways in which it shifts according to time and place and context. His passion for painting is perhaps surpassed only by his dedication to social justice, not just for gay people but for all those who have been denied equal rights. He has built on the medium's long history as a forum for political expression and for chronicling atrocities and abuses of power, confronting political and social issues head-on with eloquence and an intense sense of advocacy. He is equally effective in challenging preconceptions about painting, demonstrating that a monochrome canvas need not be a flat, smooth surface devoid of corporeal traces or references, that—in defiance of traditional modernist theories[6]—it can instead be sculptural, cinematic, socially engaged, and content driven. By showing his hand—both literally and figuratively—Moffett has propelled the discourse into the new millennium.

Notes

1. Laura Cottingham and Hilton Als, "The Pleasure Principled," *Frieze Magazine*, no. 10 (May 1993), http://www.frieze.com/issue/article/the_pleasure_principled/.

2. Holland Cotter, "Donald Moffett—'The Extravagant Vein,'" *New York Times*, February 21, 2003.

3. Jim Lewis, "Ms. Jordan and Mr. Moffett," in *Donald Moffett: What Barbara Jordan Wore*, exh. cat. (Chicago: Museum of Contemporary Art, 2002), 7.

4. Doug Ireland, "Rendezvous in the Ramble," *New York*, July 24, 1978, http://nymag.com/news/features/47179/.

5. Donald Moffett, conversation with the author, April 19, 2011.

6. See, for example, Clement Greenberg's "Modernist Painting," from his Forum Lectures, originally broadcast on the Voice of America in 1960, in which he states: "It was the stressing, however, of the ineluctable flatness of the support that remained most fundamental in the processes by which pictorial art criticized and defined itself under Modernism. Flatness alone was unique and exclusive to that art. The enclosing shape of the support was a limiting condition, or norm, that was shared with the art of the theater; color was a norm or means shared with sculpture as well as with the theater. Flatness, two-dimensionality, was the only condition painting shared with no other art, and so Modernist painting oriented itself to flatness as it did to nothing else." Reprinted in *Art in Theory, 1900–2000: An Anthology of Changing Ideas*, ed. Charles Harrison and Paul Wood (Oxford, U.K.: Blackwell, 2009), 775.

Air Can Hurt You Too:
Blue (NY), Full and Empty
Bill Arning

Described literally, the photographs in Donald Moffett's Blue (NY) series (1997) are small blue rectangles in white frames, barely inflected with variations of tone. A few have wispy clouds, but most are just blue. It would seem that there is little to discuss then. How does one feel about the color? Is what is visible enough to engage the heart beyond the retinal pleasure of the color? In order to expand the discussion, it is required that we put the work in its art historical context and locate it within the narrative of the artist's career.

There has been a discursive shift between the generations in their understanding of monochromatic artworks. Let's employ the white paintings of Robert Ryman as the prime example of a monochrome painting. In the earlier interpretive discussion on monochrome, the limited palettes of Ryman's work were envisioned as ascetic restrictions, as a forsaking of the orgiastic joys of full color, for some sort of self-depriving, masochistic pleasure. Now I can imagine no sighted being walking into a room of Ryman's paintings like the sequence semipermanently installed at the Art Institute of Chicago—*The Elliott Room (Charter Series)* (1985–87)—and not gushing over the many, various, and exquisite pleasures that these works provide the eye as well as the soul. We marvel at Ryman's touch, at his attention to detail, at the way the paintings seem to breathe and give palpable presence to the light streaming through the massive windows overlooking Millennium Park. It is impossible to imagine how these could ever have been understood as an aesthetic refusal.

Even the general experience of those earlier signposts of monochrome painting that were intended as endgame stratagems have changed. El Lissitzky, Ad Reinhardt, or Robert Rauschenberg, given their stated intentions to allow us to witness the death of painting at their creative hands, now are infused with the aura of the many new creative expressions that their patricide called into being, such as the seductive works of Larry Bell and John McCracken or the effects of a Turrell light environment. With their lickable encaustic surfaces, Brice Marden's multipanel monochromes, when seen in the retrospective context of his later virtuoso brushwork, appear clearly to be a launching

Untitled, #1, from Blue (NY), 1997; reversal print, painted wood frame; 17 x 13¾ inches.
Courtesy the artist.

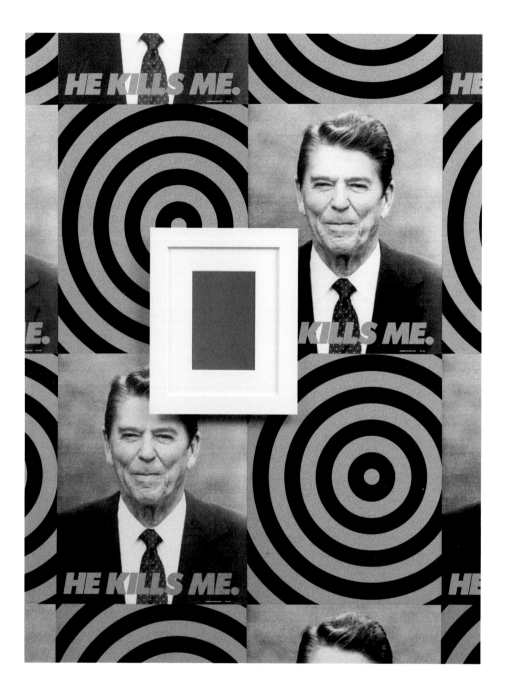

Photograph from Blue (NY), 1997, and *He Kills Me*, 1987, installation view. Courtesy the artist.

pad for ever more painterly paintings, just temporarily hushed. More recent iterations of monochrome from Stephen Prina, Marcia Hafif, Daniel Levine, Joseph Marioni, and Joseph Cohen complicate this discussion. Yet from the start of this discourse to the current permutations, each of the above artists leaves us with a useful question: are these artworks full or empty?

The full/empty dichotomy is at the core of these interpretive dilemmas. How are we to begin discussing an artwork when we cannot agree on whether it is full or empty, drained of content or replete with multiplying associations? Can we answer "both" without being guilty of hopeless equivocation?

It is into this pool that I would like to throw the series of works titled Blue (NY). Moffett is unique among contemporary artists in having a bifurcated career, summarized in an overly simplistic reading as "the activist work" and "the paintings." It is clear that the exhibition that this book accompanies, *The Extravagant Vein*, will forever vanquish that simplifying rubric, but that understanding is still prevalent among casual observers in the field.

It is true that there appears to be a huge gulf between the artist who in 1987 took the face of the president and, by overlaying the phrase "he kills me," made it clear that government inaction on AIDS was murderous, and the one who today weaves wild arrays of paint onto shaped canvases. Yet the narrative of "the AIDS activist turned abstractionist" was never really fully believable.

The experience of HIV hitting the social body—the relentlessness of the deaths and having to accept that so many loved ones were gone for good—is the defining experience of Moffett's and my generation. During the worst period, in the late 1980s, attending memorial services was a more than weekly ritual in both the New York art world and the gay world. As soon as you know the artist to be a gay man born in 1955—and therefore a young man near thirty when AIDS happened—you would have to interpret the abstract paintings through the lens of AIDS even if the activist works did not exist. As one could not even walk the dog in the late 1980s without the activity somehow being inflected by the experience of AIDS, it would be impossible for the ruminative space of the studio to be unaffected.

For several years Moffett did pursue making amazingly compelling graphic images for public consumption around the fraught politics of HIV/AIDS and the systemic homophobia that allowed the virus to proliferate. These street works were, in effect, unauthored, at least in terms of the public that visually consumed them. They appeared anonymously and everywhere. That they were artist-made was visually obvious even if not all the designers intended to make art per se, and their existence in the gallery/ museum structure was highly problematic and vigorously debated.

As a sympathetic outsider—attending ACT UP demonstrations but not going to the organizing meetings—I am still never clear about who in the close-knit society of artists known as Gran Fury created which poster or T-shirt. Yet these profoundly memorable

political posters were the most compelling graphic images intended to incite direct action that one can imagine. They distilled our collective anger during a time when it seemed conceivable that if one screamed loud enough at the right person lives would be saved. When I see the ubiquitous colored ribbons for various causes today and think of the motley group of visual artists who created this epochal shift in the way afflicted communities understand their relationships to medical providers, I wonder what other achievement in the world of art has ever mattered more.

Moffett was producing these artworks in dialogue with other AIDS activist artists—some affiliated with ACT UP, others flying solo—such as Marlene McCarty, John Lindell, Adam Rolston, General Idea, Frank Moore, Anthony Viti, filmmaker Tom Kalin, and Moffett's longtime partner, the artist Robert Gober. Their works functioned as high art in galleries and museums but also served as activist statements similar to those that Gran Fury—which several of the artists mentioned above were part of—was concocting in and out of the art world. In the spirit of the time, a "Silence = Death" T-shirt was as profound an artwork as the neon version in the window of White Columns or the New Museum precisely because it was visible to those who might never enter a museum.

Moffett's work continued to poke holes in received constructions of identity and the ways in which political power is accrued. In a world in which universal heterosexuality was not assumed, images meant to present masculine power were an invitation to those of us who enjoy seeing the contradictions of power exploded, providing an opportunity to pleasurably reread familiar images queerly. Yet I might suggest that Moffett's work faced the issue of diminishing returns that all politically inspired work does as time moves forward. The borrowed power that the audience's anger brings to the work vanishes, and the retrospective weight of history has not yet descended. This is what I think of as the awkward age of all politically inspired art, and the ability to regain power in future times is a rare marker of greatness in the field. Few artists reach the other side and escape that curse without creating a paradigm shift in their studio practice that opens up new areas, and I would suggest that the Blue (NY) series was that genius move for Moffett.

I propose a thought experiment with the Blues that runs counter to the logic of a survey exhibition. Consider them in pure isolation as if they were the work of an artist mono-maniacally making only photographs of blue skies. I would argue that in any single image in this series you will find all the content and emotions, concepts, devotions, pleasures, anger, and mourning present in Moffett's oeuvre as a whole, and in the process your attention will be heightened to better approach all the other diverse works he has made.

I did in fact live with a Blue (NY) photo in isolation. After I moved from New York City to a small apartment in Cambridge for reasons of work, I hung the Blue photograph that I had bought for myself in my kitchen. There were two windows, but they faced only the wall of the house next door. The Blue was a much-needed shot of sky in my life, and I installed it there as a decorator putting color into a drab room.

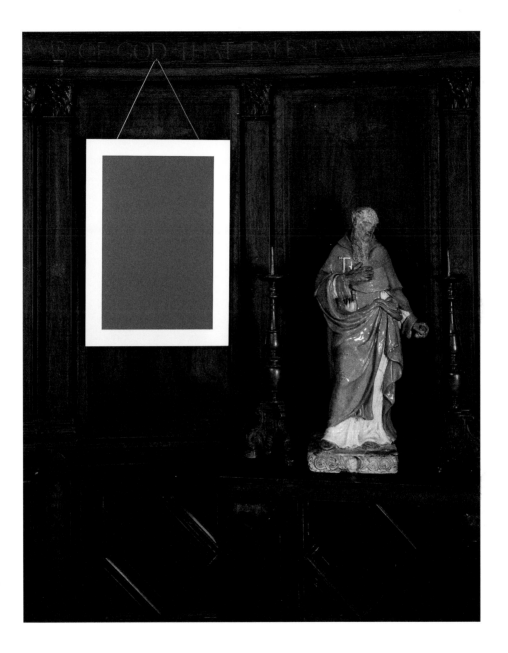

Untitled, from Blue (NY), 1997; Cibachrome, painted wood frame; 27 x 19¼ inches; installation view,
The Cathedral Project, Cathedral of St. John the Divine, New York, 1999. Courtesy the artist.

I didn't realize it, but I was in deep mourning for New York City for at least two years. My first forty years were lived entirely in New York, and I considered myself defeated because I could not find a way to stay there and still move my career forward. New York was where all my best friends and ex-lovers were. Even those who had died were still somehow there. I associated the Blue with the huge sky over the West Side Highway as I would walk my dog down a conspicuously cruise-y section of the city. I would remember my introduction to the sex piers, when my earliest cultural role model, Lance Loud, dared me to look inside. Even though it was late morning on a Sunday and the sex warriors had likely all gone home, I was overwhelmed by the puritanism that only an overly intellectual chubby teenager can know. I demurred to enter the den of iniquity then but went to bed dreaming of what I might have seen or experienced in those caverns. (And today I hungrily devour the beautiful photographs of Alvin Baltrop, which documented what I only dreamed of.)

I remember the police restraining a sobbing man from diving into the water. He was convinced that the reason why his lover had not returned to their apartment the night before was that he had fallen through a hole in the pier during his lusty hunt in the dark. His anguished face is still clear thirty-five years later.

In the decades that followed, I walked those now open, safer, but less sexy expanses of riverfront turned parkland, hoping to meet someone when single and then, when partnered, enjoying one of the few spaces where one could semiconfidently hold hands with a same-sex partner. Now they have been redone and are truly beautiful public spaces used by everyone, gay and straight, in a utopian mix. But still I see ghosts everywhere: Stevie, Kevin, James, Lance, and too many others to name. I can remember where on that lovely promenade I last saw them alive.

There was always the sky, and I see the names and faces of the legendary citizens of the lost Greenwich Village inscribed there, large and bright. When we look toward the sky, our hearts, brains, and souls will project their undigested contents on the inchoate visual events there. We see shapes of crabs, fish, goats, and virgins in the random arrangements of stars. Earth's nearest neighbor, the moon, appears nearly universally as a big, expressive face or, in its crescent guise, as a celestial swing on which heavenly beings are likely to descend.

And what of the ever-changing blues that Moffett fixes for us? Surely a color that palpably rich is no mere phantom—but it is. It is the result of Rayleigh scattering.[1] (The sun isn't yellow either. If we were to leave our atmosphere, sunlight would be perceived as a full-spectrum white.) For some reason, however, humans across cultures respond to sky blue as good, pure, logical, and full of possibility—in other words, heaven, a concept as vivid for agnostics as for believers. Yet here we face another contradiction. The reading of these blue rectangles as heaven implies a potential sensation of purity that comes from experiencing them as unadulterated color. As windows into a particular sky, however, they provoke a messy tangle of emotions. On a nice day by the Hudson River,

we see many devotees of spiritual attainment in meditation. Perhaps a more evolved being might find in Moffett's blues enlightenment, but I am left with messy emotions, which, since I don't pretend to want to live fully in the present, I accept.

The memories, traumas, joys, and all the losses are us. Even when peering, as Moffett invites us to, into a perfect crystalline blue sky, we must struggle to perceive the seductive blue as an atmospheric effect. Even with the poetic-sounding nomenclature of the Rayleigh scattering to help us shape this perception, it slips like mercury from our grasp. We might convince ourselves that the web of stories we see in the sky is neutral, nothing, the void. But as with the monochromes discussed above, that void is awfully full.

As few of us get to leave our earthly atmosphere in our lives, here we return to the rich landscape of blue as metaphor. The atmosphere we see in Moffett's photographs is the invisible substance that we know is always surrounding us in life but that we cannot perceive directly, its visible blue the result of "scattering." In earlier times people lived in a world in which ether filled the spaces between men and explained every unexplained phenomenon. Ether made the world make sense, but it didn't exist. The space between things defines our notion of empty, the ether disappearing from common perceptions of reality and mere air left there. Blue (NY) focuses our attention on the air, and when we do, the emptiness fills.

> Air . . . Air
> Hit me in the face
> I run faster
> Faster into the air
> (I say to myself)
> What is happening to my skin?
> Where is that protection that I needed?
> Air can hurt you too
> Air can hurt you too
> Some people say not to worry about the air
> Some people never had experience with . . .
> Air . . . Air
>
> —Talking Heads, "Air"[2]

When I think of New York City in the 1980s and 1990s, it is this thickly palpable substance of memory and the emotions that those memories produce. I know that the melancholy I experienced staring at this square in my Cambridge kitchen was not the same as that of other people when they saw the photograph. I am sure few even realized that it was a photograph, since it avoids the photographic task of depiction.

The blue was physical not depictive, like a slab of mineral more than a window, and hence a memorial marker of what I could not retain from my old life. Its meaning was fixed for well over a year before I had found a new blue to replace it. (I did find a replacement, soon after I discovered the blue of Provincetown light as described so beautifully in Michael Cunningham's *Land's End*—but that is another story.)[3] The other potential reading then appeared. Life is all about finding the next blue sky and then the next.

There are a great many later works of Moffett's in which the divisions between his two spheres are deliberately blurred. In many, he fills the potential reading of his abstraction as devoid of literal content with the most content-heavy substance imaginable, the beam of a video projection. Video, by its medium-specific nature, records the outside world literally, and even though video is today easily manipulable, the reality effect is still strong. It takes effort to see the painting when the video is on it. The thickly worked surfaces struggle to reassert themselves as good paintings should. The full/empty dichotomy runs through each and every work in the show that comes after the Blue (NY) series.

Yet for sheer clarity in expressing how a monochrome image can be simultaneously full and empty, with that effect created through a device so simple as to feel like a Zen koan, few contemporary artworks can match the Blue (NY) photographs. I know that the one I live with will remain a mirror for all the future emotions I may have. As the distance from my New York life grows vaster, the memories that are gone forever keep expanding, and they all tumble into Donald Moffett's Blue (NY).

Notes

1. Rayleigh scattering is named for the British physicist Lord Rayleigh, who published a paper describing the phenomenon in 1871. As light travels through the atmosphere, it is scattered by small particles. Light at the blue end of the visible spectrum, because of its shorter wavelengths, is scattered much more strongly than light at the red end of the spectrum, and thus we perceive the sky as blue. *Encyclopaedia Britannica*, 15th ed., s.v. "Rayleigh scattering."

2. Talking Heads, "Air," written by David Byrne, from the album *Fear of Music* (1979).

3. Michael Cunningham, *Land's End: A Walk through Provincetown* (New York: Crown Journeys, 2002).

Call the White House
Russell Ferguson

Donald Moffett moved to New York from Texas in 1978, when he was twenty-three. By the mid-1980s he was just beginning to establish himself as an artist in the city when the AIDS epidemic became pervasive. In early 1987 Moffett was one of the first members of ACT UP (the AIDS Coalition to Unleash Power), the most important activist group formed in response to the growing crisis. His work as an artist, too, would become associated with that struggle. What I want to trace here is a certain movement in the work that has followed, back and forth between a tight focus on the specifics of injustice and broader claims to inclusivity and equal citizenship. The two are of course deeply connected, but they also suggest different formal strategies.

It was in 1987 that Bill Olander, a curator at the New Museum in New York, invited a group associated with ACT UP to make an installation in a window of the museum building facing Broadway. Avram Finkelstein, another member of ACT UP, recalled his first reaction to the invitation: "Did they understand that we are not an art collective?" On being assured that Olander did understand that, "I said that the answer was yes, that we would probably want to take that window space and make it into a demonstration. After all, that is what we do at ACT UP. I asked, would there be parameters, and he said no, you can do whatever you want so long as you know what that is."[1] Dominated by a neon pink triangle and the slogan "Silence = Death," along with homophobic statements by public figures and an electronic display of running text, the window installation turned out to be a pivotal point in the emerging response to the crisis. "History will judge our society by how we responded to this calamity," Olander wrote. "Let the record show that there are many in the community of art and artists who chose not to be silent in the 1980s."[2]

The group that had worked on the window, including Moffett, decided to stay together, working under the name Gran Fury. Over the following six years Gran Fury went on to produce many of the most striking images of AIDS activism, including the "Read My Lips" series of images of same-sex couples kissing (1988), "Men Use Condoms or Beat It" (1988), and the well-known "Kissing Doesn't Kill" bus advertisements (1989).

Although Gran Fury included a number of artists, other members were not artists, and the group in general did not identify its work as art. The goal was to create effective propaganda. Gran Fury valued successful communication over self-expression and to that end would borrow visual strategies from any source that worked, whether that was art by Barbara Kruger or an ad campaign by Benetton. Marlene McCarty, another member, described their way of working: "We never, ever, ever came together and said, 'We're going to make art.' We had a whole other mission. Our mission was to get out in as raw and rambunctious a way as we could—to get out certain messages that we felt like were not getting out into the mainstream world, which is why we adopted the mainstream look of advertising."[3] Moffett and McCarty later began their own graphic design firm, Bureau, which they ran from 1989 to 2001, mixing commercial projects with continuing activism.

As an individual and an artist, Moffett also began making photo-text montages to accompany the Age of AIDS column in the *Village Voice* from 1989 to 1992 (p. 165). He worried that art was becoming "more and more like an anxious little peep next to the roar and glamour of commercial film and TV." He wanted his art to have an "integrative link to a larger community."[4] Bitter, pungent, and effective, these messages from the heart of the AIDS epidemic still illuminate and condemn the criminal denial that marked the official response to the crisis. In one piece Moffett quoted a statement from Mathilde Krim, chair of amfAR, the Foundation for AIDS Research, which summed up his and others' anger: "Everything about this epidemic has been utterly predictable, utterly, utterly and completely predictable, from the very beginning, from the very first day. But no one would listen. There are many people who knew exactly what was happening, what would happen and has happened, but no one of importance would listen." The quote sums up the frustration of those who could see the disaster unfolding every day. It also signals a theme that would become central in Moffett's work: the refusal of those in power to even listen to those they were charged with representing.

The Age of AIDS pieces were often more allusive and personal than the work produced with Gran Fury, but they were just as hard-hitting, and they have since been reincarnated as postcards, posters, and photographic iris prints and in other contexts that seem to the artist to be effective. These simple collages, produced in the heat of a crisis, still stand as one of the most effective interventions by an artist into a broader public discourse. Moffett also made text pieces and light boxes that continued to express his anger and outrage.

In 1996, however, Moffett's work took an unexpected turn. That year he showed a series of highly textured monochrome paintings in an exhibition titled *A Report on Painting*. The title suggests an investigation into something that has gone wrong or someone who has gone missing. While the paintings are on one level an experiment in what abstraction can suggest without employing explicit content, on another level they suggest a return to a path not taken. They take up one of the questions raised by the

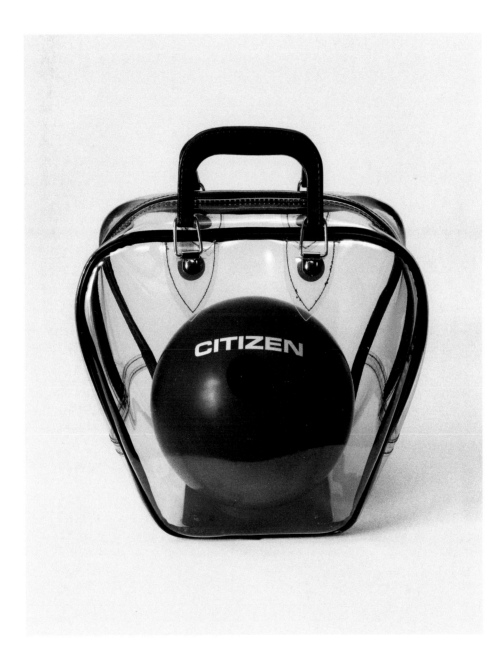

Citizen, 1991; bowling ball: acrylic, polyurethane, vinyl; diameter 8 inches; bowling ball bag: plastic, metal, cotton; 16½ x 13 x 6 inches. Courtesy the artist.

Lot 050195 (Osteolacrima); oil on linen; 20⅛ x 16⅜ inches. Courtesy the artist.

earliest practitioners of abstraction. Can pure formal abstraction convey meaningful ideas to society at large?

The following year Moffett produced a series of monochromatic photographs called Blue (NY). They showed clear blue skies above New York. These works drew on a number of art historical precedents, from John Constable's cloud studies, through Alfred Stieglitz's Equivalents of the late 1920s and early 1930s, and on to the blue monochromes of Yves Klein. In one sense they are just what the title says they are: photographs of blue skies, varying in color but all, or nearly all, absolutely cloudless. They are presented in different formats, with and without mats and frames. But if one aspect of the work is a tendency toward pure abstraction, the series also invokes a directly emotional sense of longing for escape and for something beyond earthly struggles. For Richard Torchia, writing at the time, "The relative silence of these new pictures gives them a quality of resignation that cannot go unexamined."[5] Yet there is also something hopeful about this work, even if that suggestion remains somewhat tentative.

It would be wrong, however, to see this work as marking, say, an optimistic sense that the AIDS crisis was over. It was not over then, and it is not over now. But however we choose to interpret these works, the late 1990s did see a break in Moffett's practice. There is an understandable tendency to want all of an artist's production to flow seamlessly from one body of work to another. But sometimes an apparent break is really a break. Blue (NY) cannot simply be folded into the ongoing pattern of Moffett's earlier work. It has to be taken on its own terms.

The key shift is a move outward from the outraged articulation of a particular group's demands for equality toward a more general evocation of universal experience. The claim is given poignancy by its context of the continuing attacks on any group perceived as different, and on gay people in particular. And indeed, justice for any group that suffers discrimination is rooted in an appeal to a greater shared community of interest. As Moffett's friend and sometime collaborator Felix Gonzalez-Torres once said, "We are part of this culture, we don't come from outer space."[6] We all live and die under these blue skies. In 1999 Moffett gave a particularly American turn to that idea in *a.m., noon, p.m. (4th of July)*, three more blue skies to mark the Declaration of Independence.

It becomes easier to see a form of synthesis between the passionate calls for justice in Moffett's earlier work and the universalizing quality of Blue (NY) in the works that follow, especially the series What Barbara Jordan Wore (2001–2). Barbara Jordan (1936–1996) was a member of the Texas State Senate from 1966 to 1972, and of the United States Congress from 1972 to 1978. A pioneering legislator, Jordan was the first African American woman elected to the Texas Senate and the first African American woman to be elected to the United States House of Representatives from any southern state. Although Jordan had a very specific history in the African American community and in the civil rights movement, that history led her to insist on principles of universal equality and justice, manifest in her commitment to the Constitution of the United States as a

living document that could be a central part of that struggle. In her eloquent speech during the impeachment proceedings against Richard Nixon, Jordan spelled out what the Constitution meant to her:

> "We the people." It is a very eloquent beginning. But when the Constitution of the United States was completed, on the seventeenth of September in 1787, I was not included in that "We the people." I felt somehow for many years that George Washington and Alexander Hamilton just left me out by mistake. But through amendment, interpretation and court decision I have finally been included in "We the people."[7]

Jordan's dignified insistence on being included, on the most basic level simply to be considered a citizen, is something that clearly spoke directly to Moffett, after so many years of powerful people making it clear that they did not consider gay and lesbian people truly equal in society.

The heart of Moffett's work, a triptych of videos projected onto glittering metallic canvas—*Untitled (The Committee)*, *Untitled (The Public)*, and *Untitled (Ms. Jordan)*, all from 2002—shows Jordan giving the speech quoted above. She occupies the central panel, with her audience on the left and her fellow committee members on the right. It is an elegant object, as it should be. Moffett here brings together the specifics of an individual's voice speaking back to power and the absolute formal qualities of gold and silver monochrome. When the projection is turned off, we see only that. But then, when the piece is truly activated, Jordan writes herself into the picture. Albeit sometimes flickering in and out of visibility, she is always undeniably present. Later Moffett would use the same technique to depict gay men moving through the famous cruising area of the Ramble in New York's Central Park. They too emerge into visibility out of the flickering shadows of history and repression. And in turn he has treated the White House itself in the same way (*Aluminum/White House Unmoored*, 2004), granting it no more visibility or legitimacy than any of the citizens it supposedly represents.

What Barbara Jordan Wore weaves together Jordan's personal history and the public context in which she spoke up. And there are things about which she chose to remain silent. Although it is widely accepted today that Jordan was a lesbian, she never spoke publicly about that aspect of her life. As the visual ambiguity of Moffett's piece suggests, the line marking the distinctions between public and private is by no means clear-cut. Politics is not an abstract thing: it is a combination of history, of emotions, of struggles, of memories.

The work pays homage to Jordan. She cared about her clothes and how she presented herself. And what she wore is not trivial: it stands here for just that point at

Call the White House, 1990; Cibachrome transparency and light box; 40 x 60 x 6 inches. Courtesy the artist and Marianne Boesky Gallery.

which everyday personal choices come together with public stances, and it means more than just clothes. As Moffett himself has put it: "What she wore was significant. It was the fashion of forthrightness and courage. She wore the burden of our hope and pride."[8]

The postcards that Moffett produced in the early 1990s were meant literally to encourage individuals to address those in power who claimed to speak for the people. They are from a specific moment, but their demand for the assertiveness of true citizenship still resonates today. "Call the White House," read one. "Tell Bush we're not all dead yet."

Notes

1. David Deitcher, interview with Gran Fury, in *Discourses*, by Russell Ferguson et al. (New York: New Museum; Cambridge, Mass.: MIT Press, 1990), 207–8.

2. Bill Olander, "The Window on Broadway by ACT UP," in *Democracy: A Project by Group Material*, ed. Brian Wallis (Seattle: Bay Press, 1990), 277, 278. Olander died of AIDS in 1989.

3. Sarah Schulman, interview with Marlene McCarty, February 21, 2004, ACT UP Oral History Project interview 044, actuporalhistory.org.

4. Moffett, quoted in Holland Cotter, "Art after Stonewall: Twelve Artists Interviewed," *Art in America* 82 (June 1994): 62.

5. Richard Torchia, *Blue (NY)* (Glenside, Penn.: Beaver College Art Gallery, 1997), 6.

6. Felix Gonzalez-Torres, interview with Robert Storr, *Art Press*, no. 198 (January 1995): 24.

7. Barbara Jordan, "Opening Statement to the House Judiciary Committee Proceedings on the Impeachment of Richard Nixon, July 25, 1974," in *Donald Moffett: What Barbara Jordan Wore* (Chicago: Museum of Contemporary Art, 2002), 38.

8. Moffett, quoted in Elizabeth A. T. Smith, "Donald Moffett, Abstraction, and Barbara Jordan," ibid., 32.

Paintings and Photographs

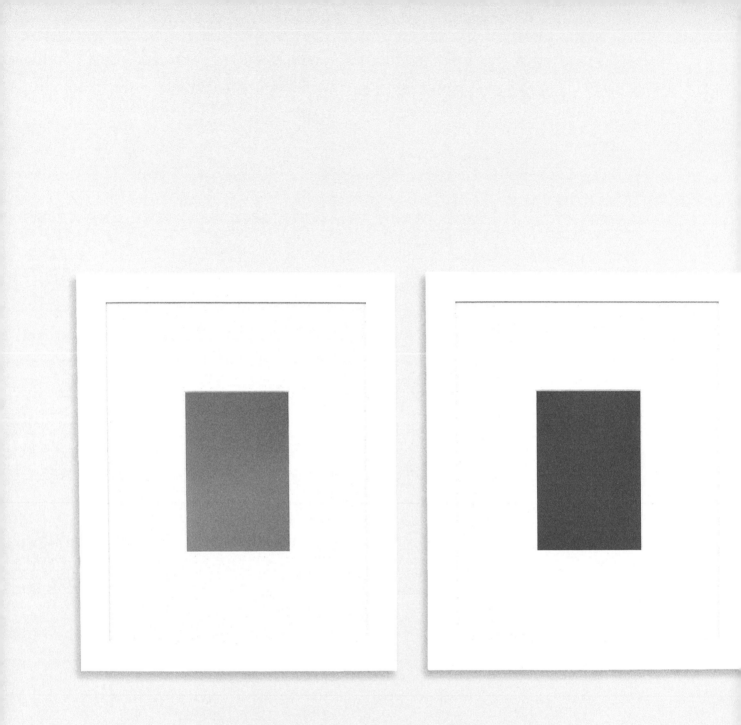

Blue (NY)

Untitled (in four parts), 1997; unique reversal prints; 4 prints, 23 x 19 inches each, framed (overall dimensions variable). Courtesy the artist and Marianne Boesky Gallery, New York.

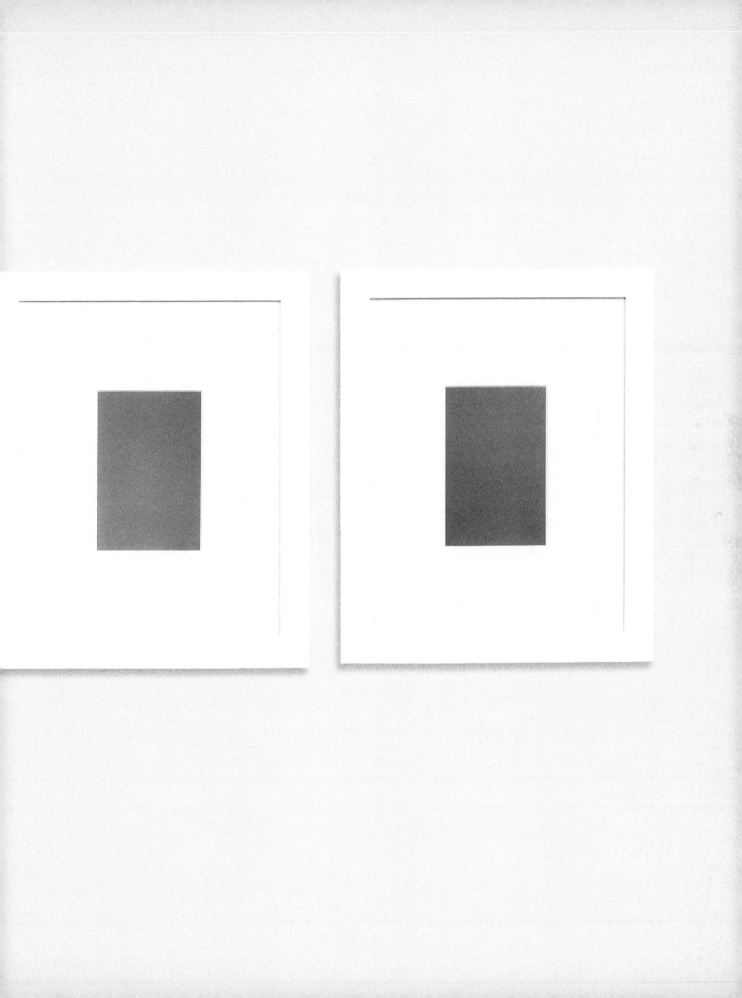

Untitled, 1997; unique reversal print, artist's wood frame;
17⅛ x 14 inches, framed. Collection Siobhan Liddell, New York.

Lost Weekend, 1997; unique reversal prints, artist's wood frame; 3 prints, 60 x 26⅞ inches overall, framed. Courtesy the artist and Marianne Boesky Gallery, New York.

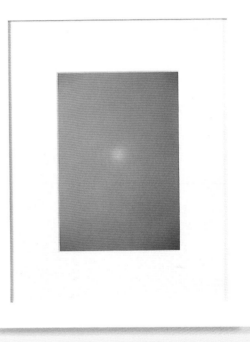

a.m., noon, p.m. (4th of July), 1999; unique reversal prints; 3 prints, 19⅛ x 73½ inches overall, framed. Collection Dr. Alan Fard and Ed Simpson, New York.

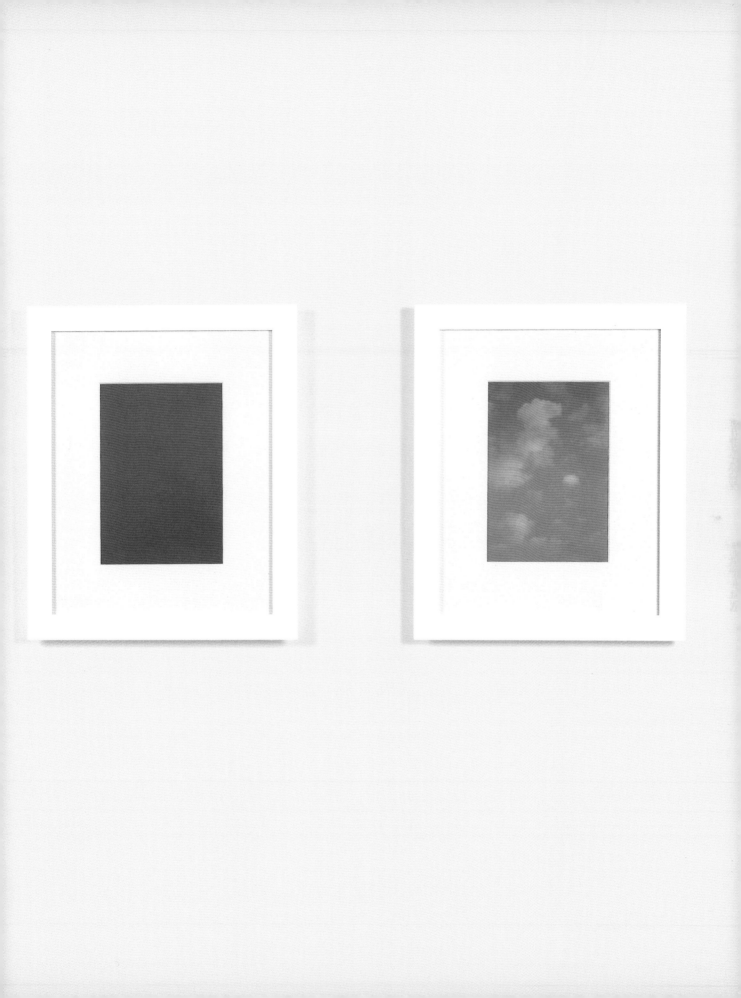

What Barbara Jordan Wore

Untitled (We the People #1), 2001; oil on linen;
74 x 54 inches. Private collection, Dallas.

Untitled (We the People #2), 2001; oil on linen; 74 x 54 inches.
Collection Dr. Marc and Livia Straus, Chappaqua, New York.

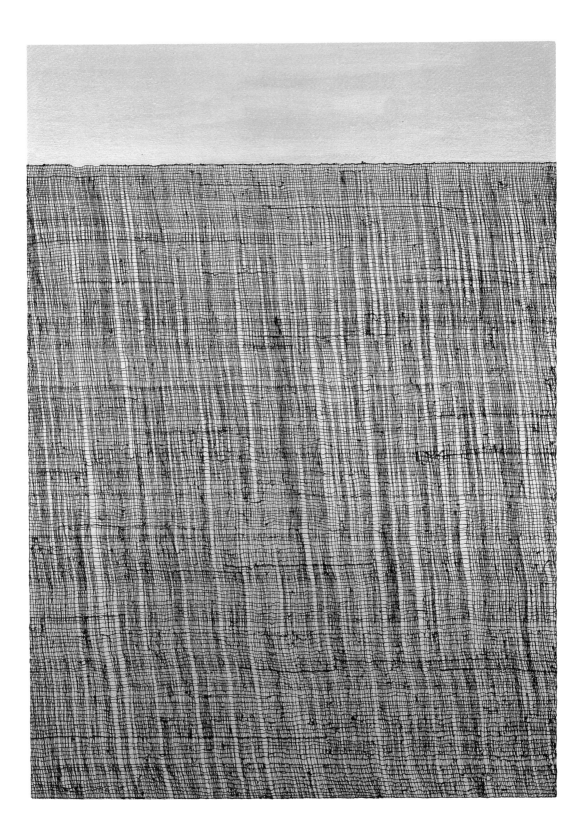

Untitled (We the People #3), 2001; oil on linen; 74 x 54 inches.
Collection Howard and Donna Stone, Chicago.

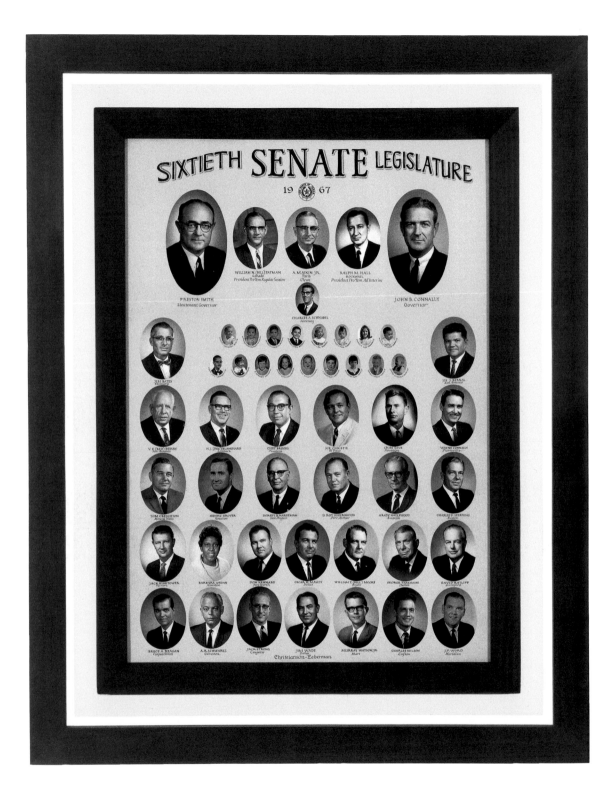

Texas, 1967, 2001; digital chromogenic development print in artist's wood frame;
44¼ x 35½ inches. Museum of Contemporary Art, Chicago, gift of the artist.

Texas, 1969, 2001; digital chromogenic development print in artist's wood frame;
44¼ x 35½ inches. Museum of Contemporary Art, Chicago, gift of the artist.

Texas, 1971, 2001; digital chromogenic development print in artist's wood frame;
44¼ x 35½ inches. Museum of Contemporary Art, Chicago, gift of the artist.

Untitled (The Committee), 2002; video projection, oil and enamel on linen; 45 x 60 inches.
Museum of Contemporary Art, Chicago, restricted gift of Nancy A. Lauter and Alfred L. McDougal,
Judith Neisser, Barbara and Thomas Ruben, Faye and Victor Morgenstern Family Foundation, and Ruth Horwich.

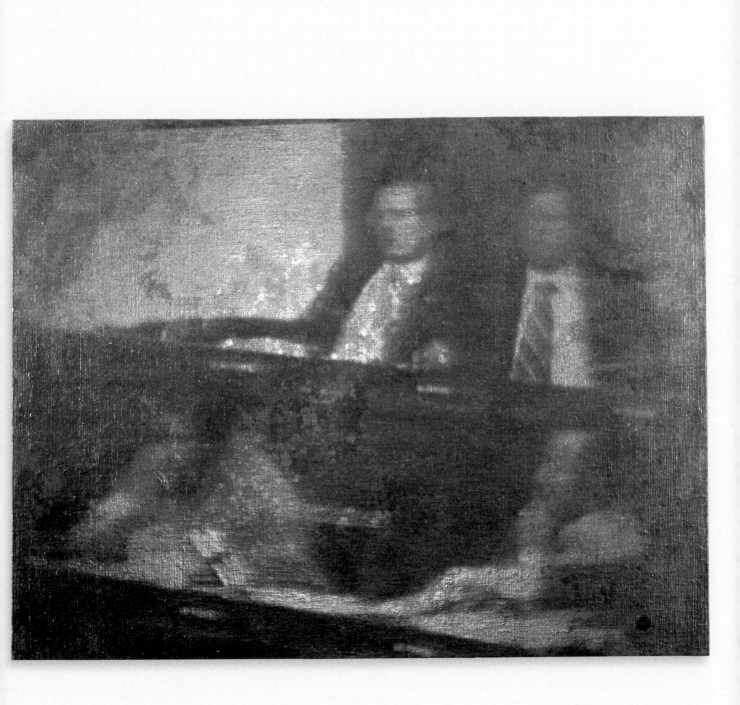

Untitled (The Public), 2002; video projection, oil and enamel on linen; 45 x 60 inches.
Museum of Contemporary Art, Chicago, restricted gift of Nancy A. Lauter and Alfred L. McDougal,
Judith Neisser, Barbara and Thomas Ruben, Faye and Victor Morgenstern Family Foundation, and Ruth Horwich.

Untitled (Ms. Jordan), 2002; video projection, oil and enamel on linen; 45 x 60 inches.
Museum of Contemporary Art, Chicago, restricted gift of Nancy A. Lauter and Alfred L. McDougal,
Judith Neisser, Barbara and Thomas Ruben, Faye and Victor Morgenstern Family Foundation, and Ruth Horwich.

The Extravagant Vein

Gold/Passage, 2003; video projection, oil and enamel on linen;
80 x 60 inches. Collection Tony and Deb Clancy, Atlanta.

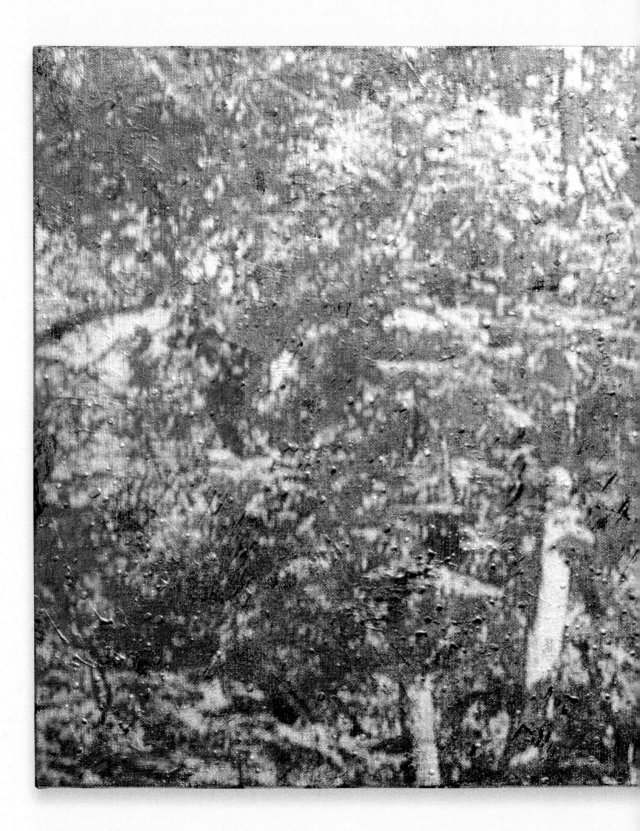

Gold/Landscape #3, 2003; video projection, oil and enamel on linen;
36 x 64 inches. Collection Sharon and Michael Young, Dallas.

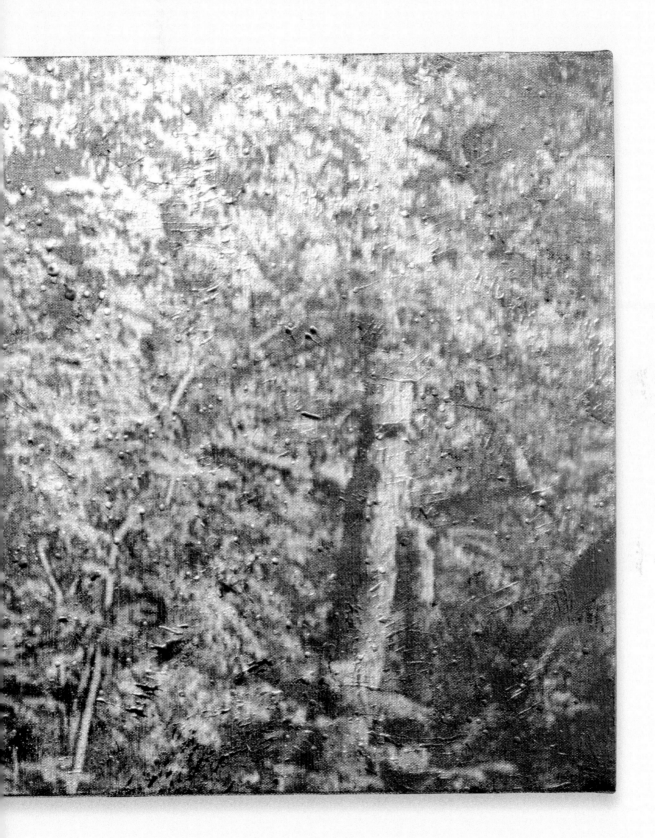

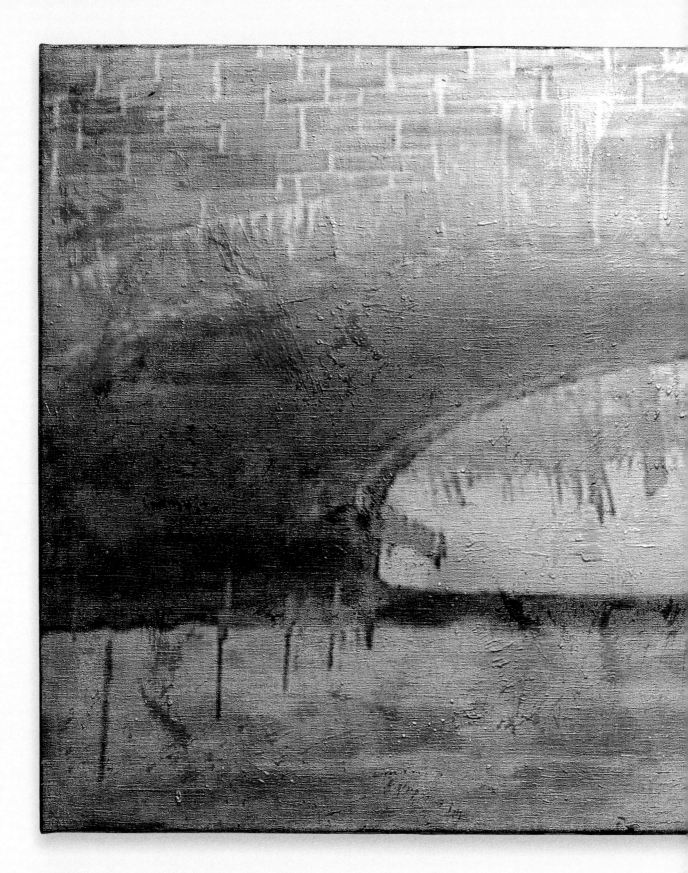

Gold/Tunnel, 2003; video projection, oil and enamel on linen;
54 x 96 inches. Private collection, New York.

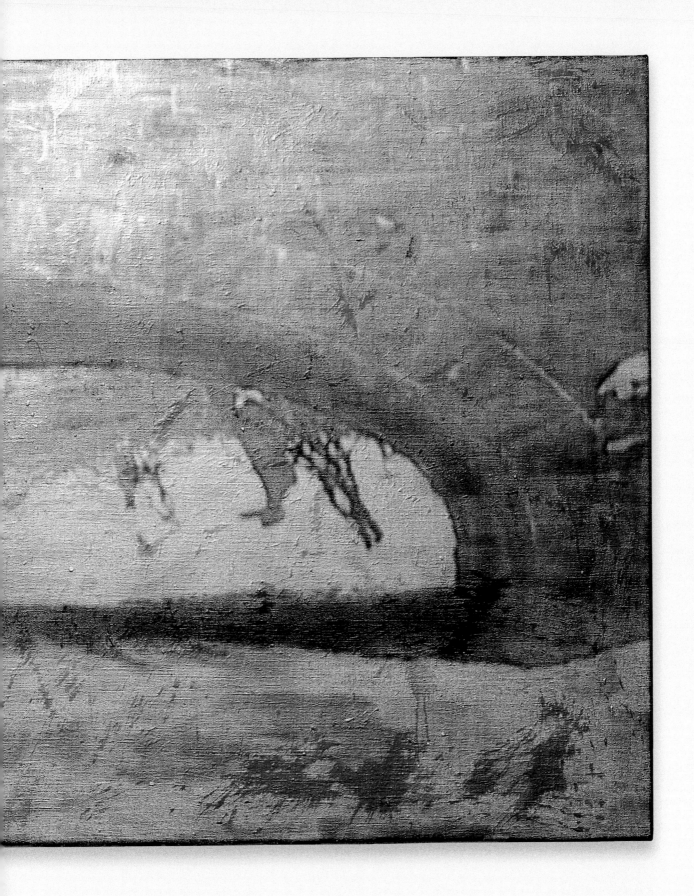

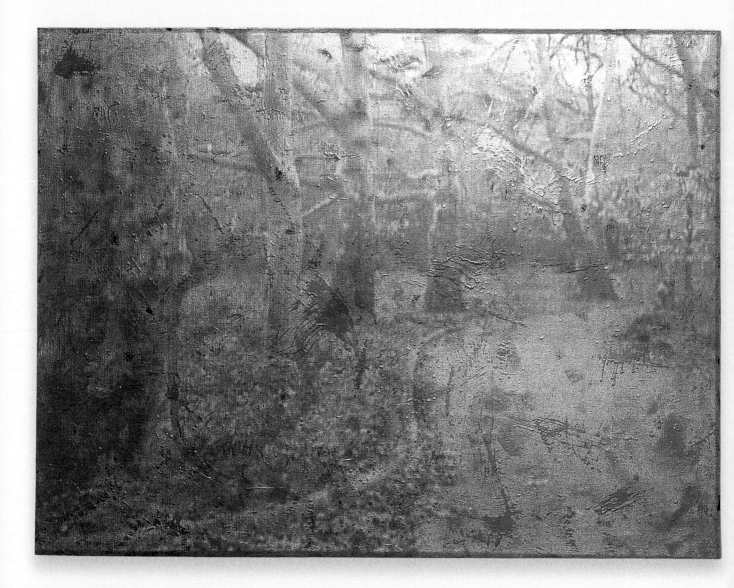

Gold/Tupelo Plains, 2003; video projection, oil and enamel on linen; 2 panels,
60 x 160 inches overall. Collection Alan Hergott and Curt Shepard, Beverly Hills.

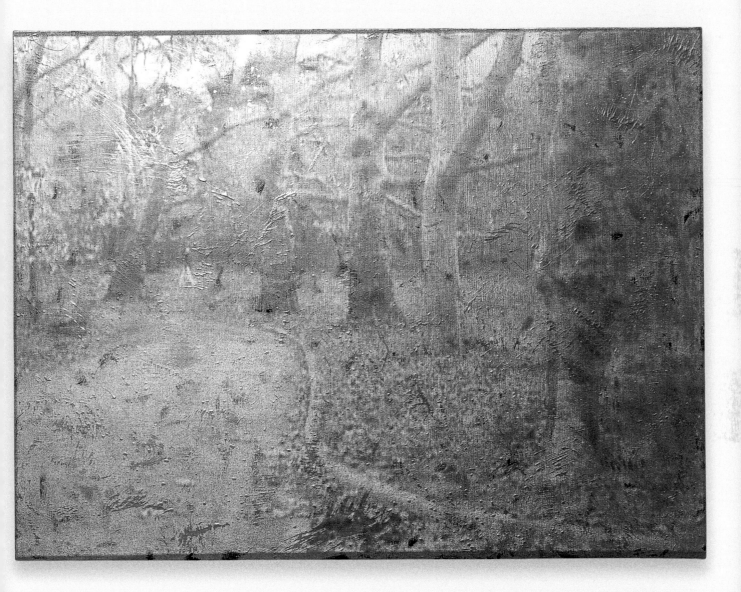

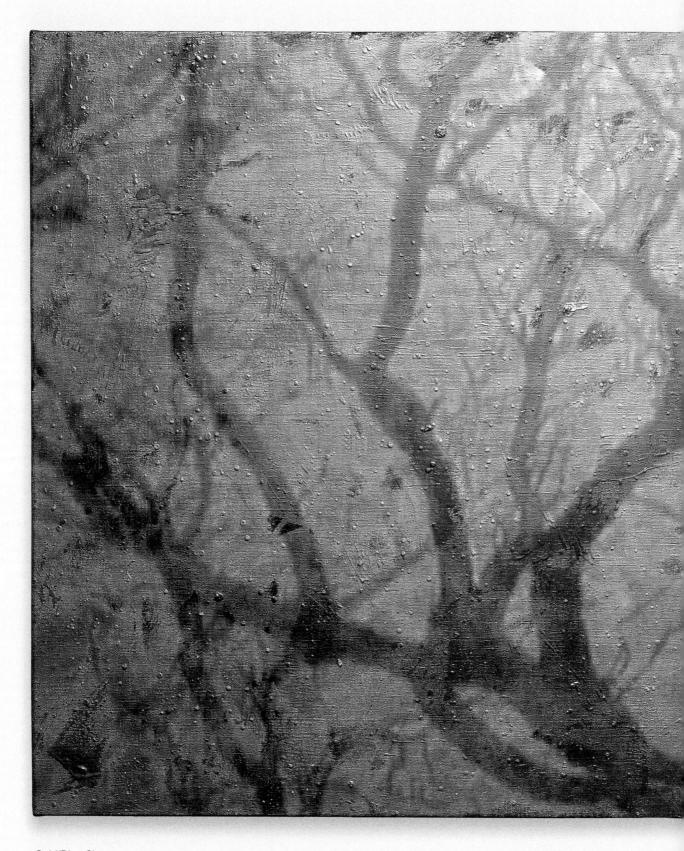

Gold/Blue Sky, 2003; video projection, oil and enamel on linen;
54 x 96 inches. Jeff Stokols and Daryl Gerber Stokols, Chicago.

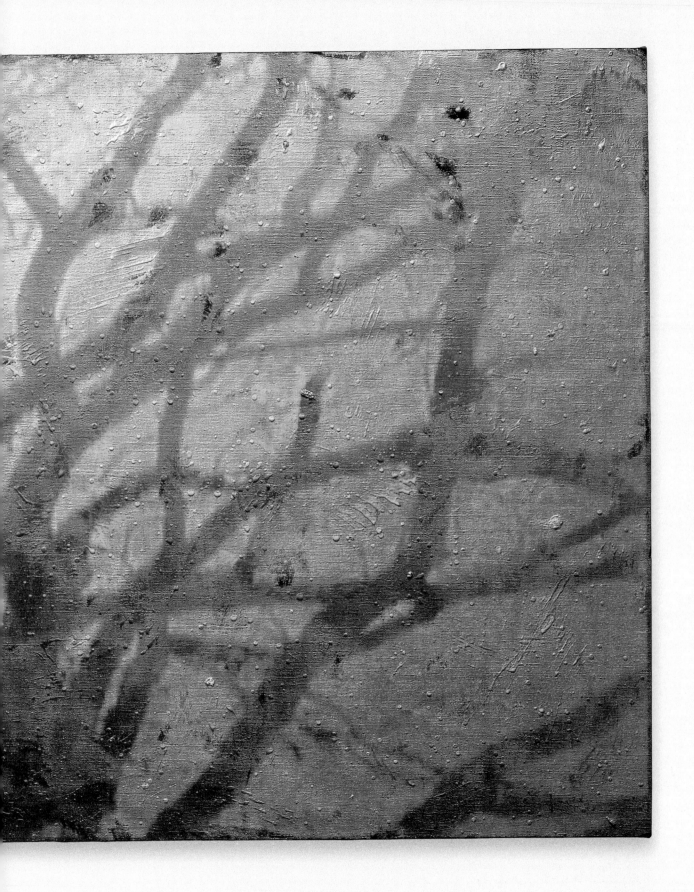

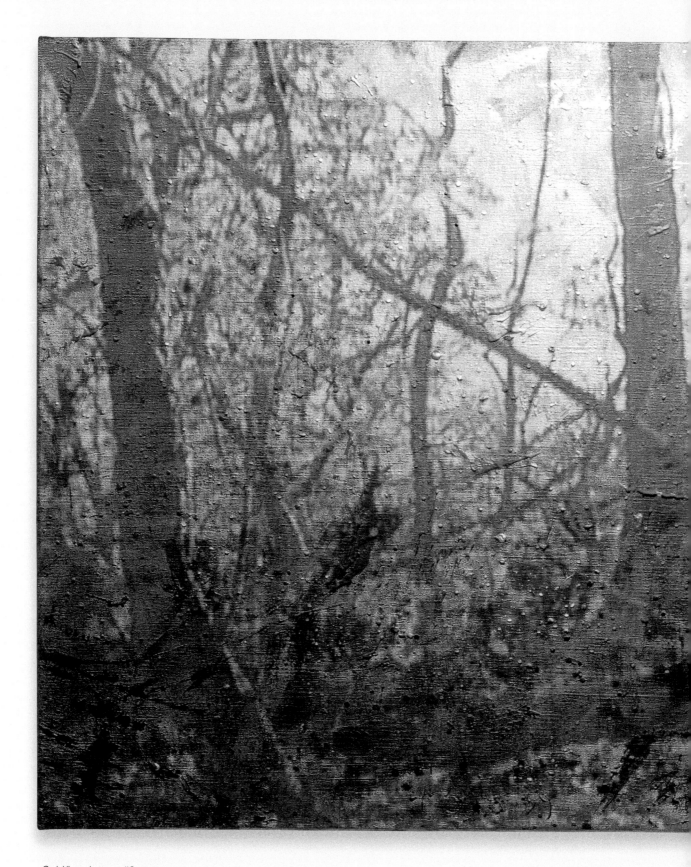

Gold/Landscape #2, 2003; video projection, oil and enamel on linen; 54 x 96 inches.
Courtesy the artist and Marianne Boesky Gallery, New York.

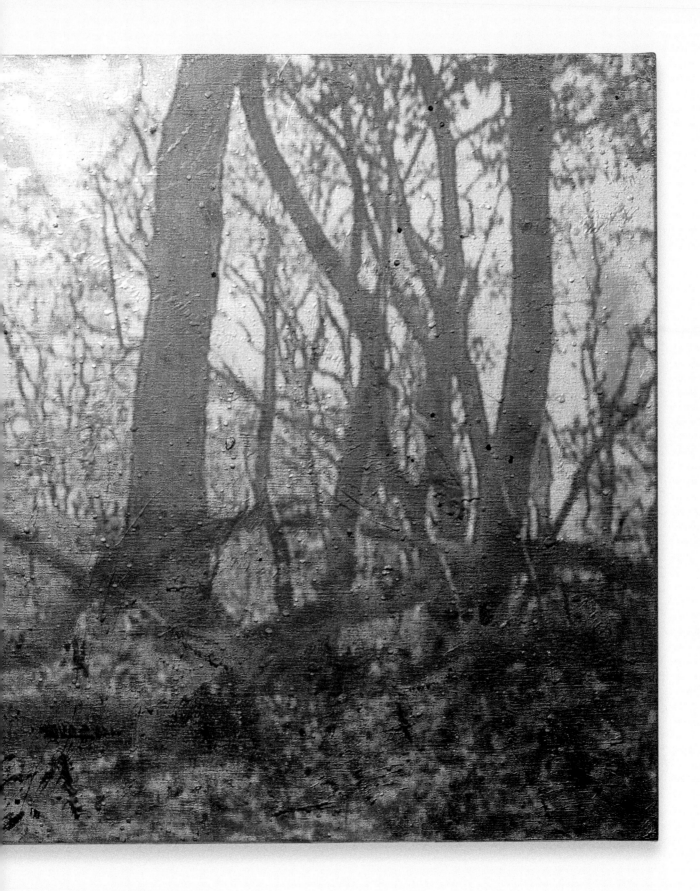

D.C.

Aluminum/FDR and Friends, 2004; video projection, oil and alkyd
on linen; 80 x 60 inches. Collection Teri and Barry Volpert, New York.

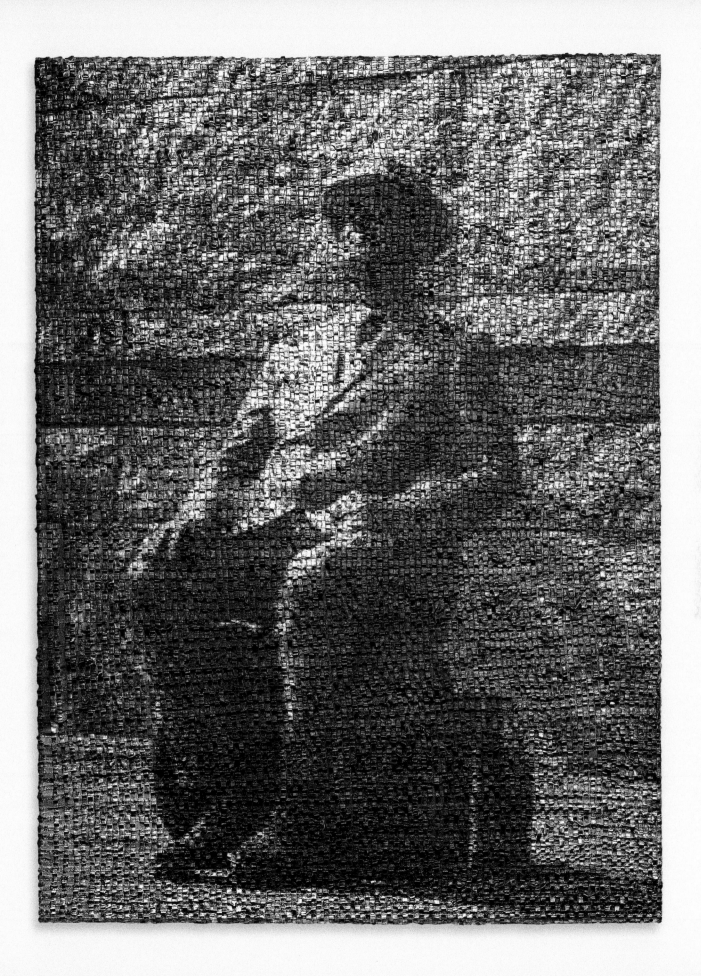

Aluminum/Dupont Circle, 2004; video projection,
oil and alkyd on linen; 60 x 80 inches.
The David Roberts Art Foundation Ltd., London.

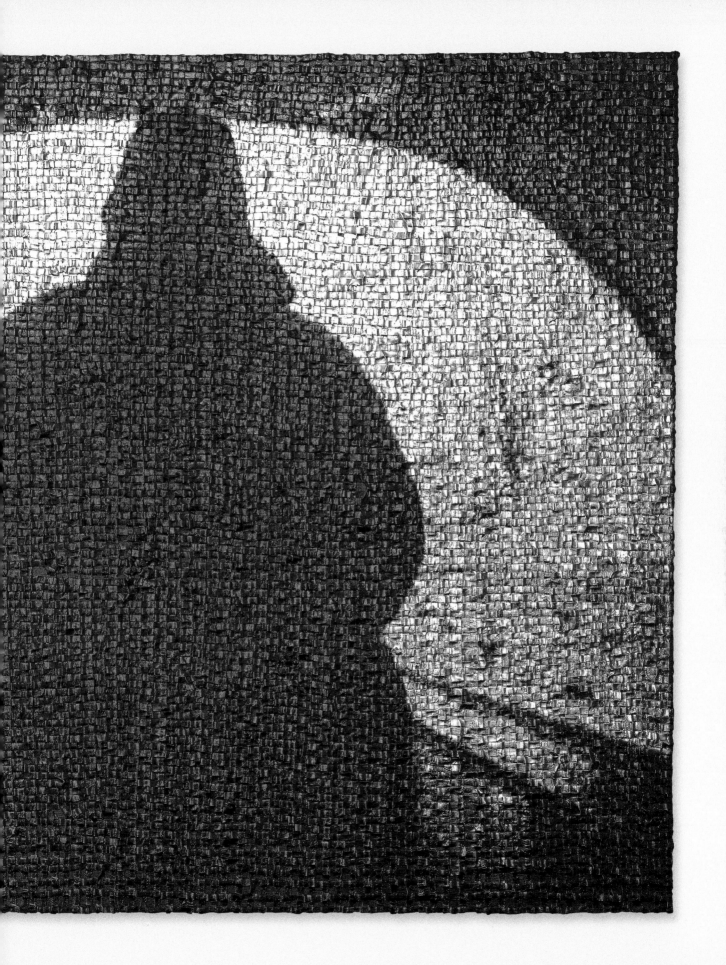

Aluminum/J. Edgar Hoover FBI Building, 2004; video projection, oil and alkyd on linen;
48 x 36 inches. Mickey Cartin/The Cartin Collection, Hartford.

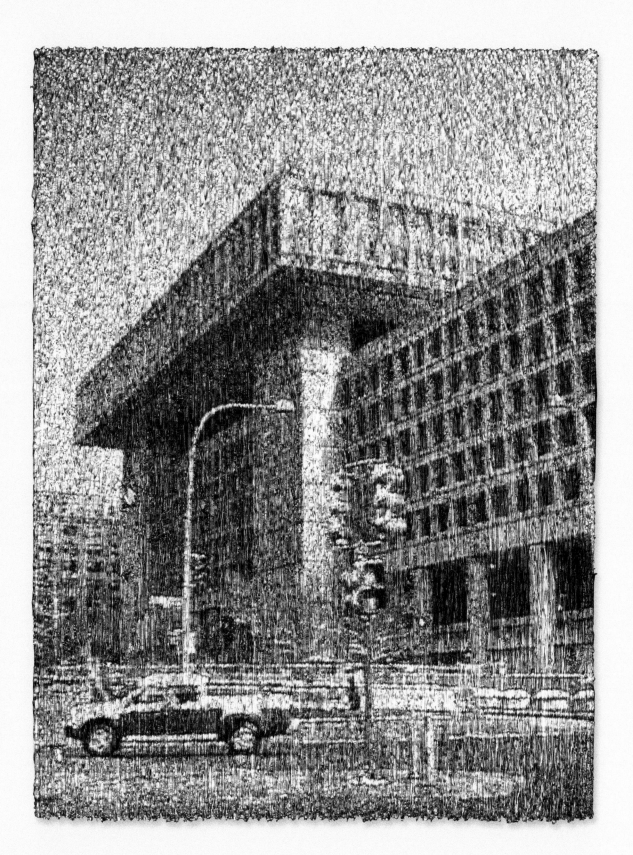

Aluminum/Watergate, 2004; video projection, oil and alkyd on linen;
45 x 60 inches. The Linda Pace Foundation, San Antonio.

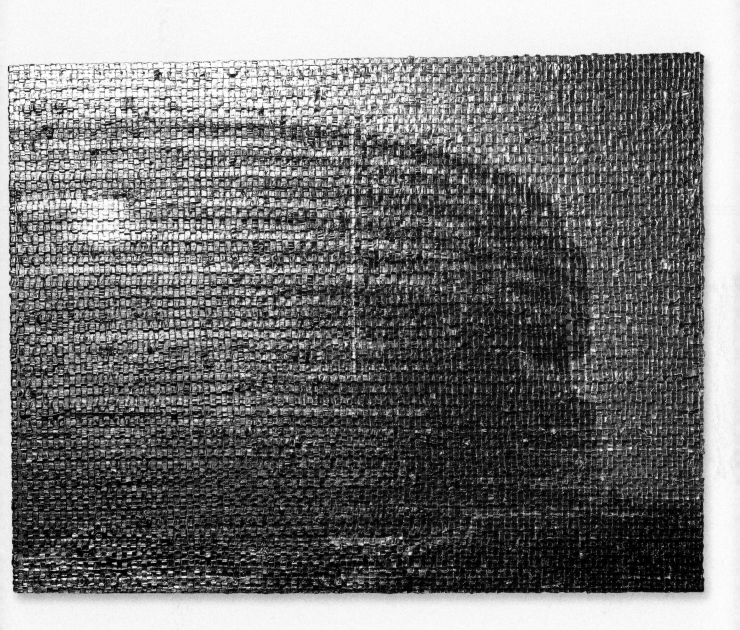

Aluminum/White House Unmoored, 2004; video projection, oil and alkyd on linen; 45 x 60 inches.
Courtesy the artist and Stephen Friedman Gallery, London.

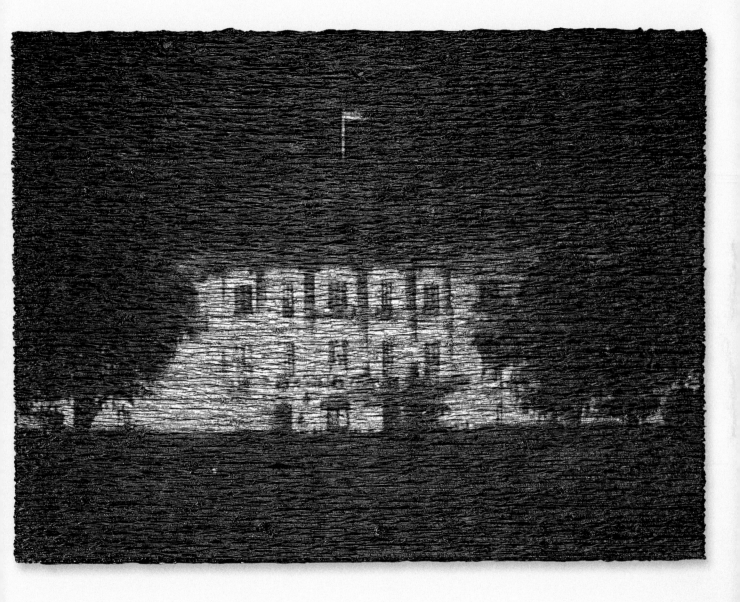

Paintings from a Hole

Untitled/Green Roller (Lot 080104), 2004; video projection, oil and alkyd on linen; 16 x 20 inches. Collection Mickey and Jeanne Klein, Austin.

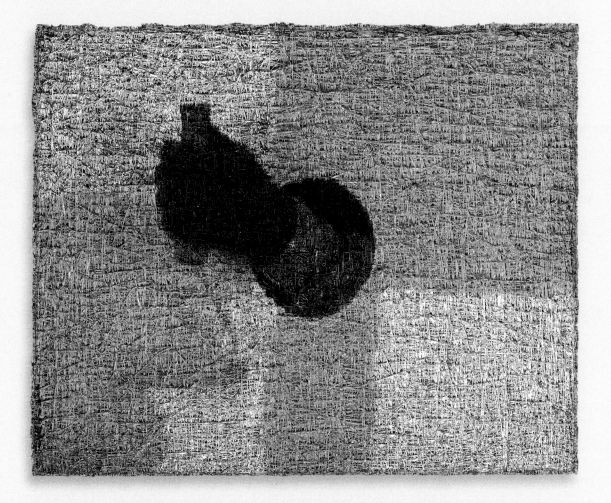

Untitled/Red (Lot 072004), 2004; video projection,
oil on linen; 36 x 48 inches. Private collection, Chicago.

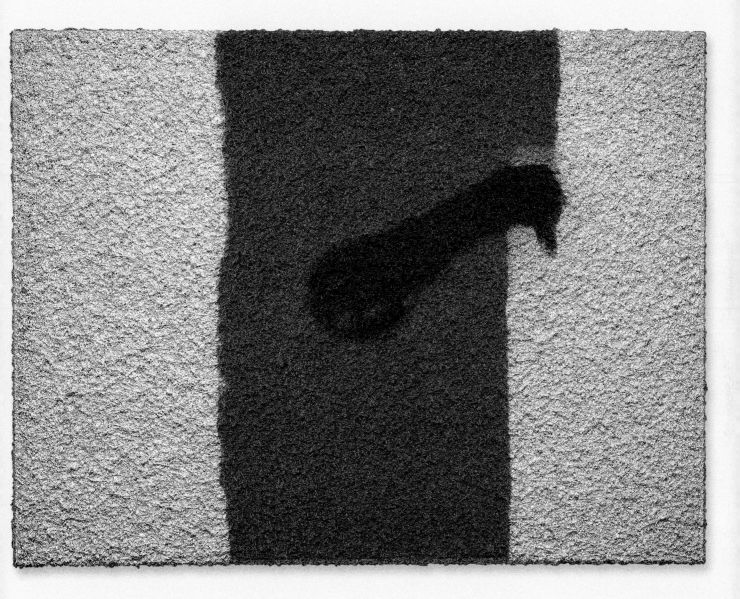

Untitled/Green Brush (Lot 093003), 2004; video projection, oil and alkyd on linen;
25 x 30¼ inches. Collection Adam Clammer, San Francisco.

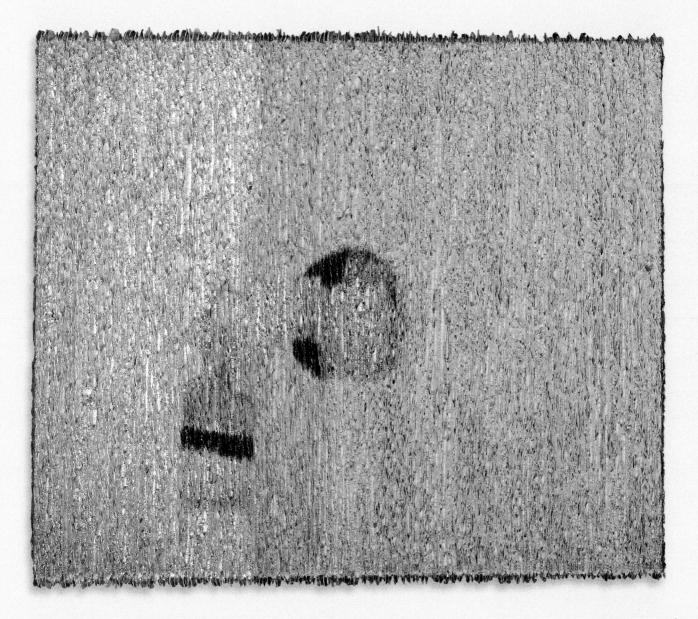

Untitled/Cobalt (Lot 072204), 2004; video projection, oil and alkyd on linen; 30 x 40¼ inches. The Rachofsky Collection, Dallas.

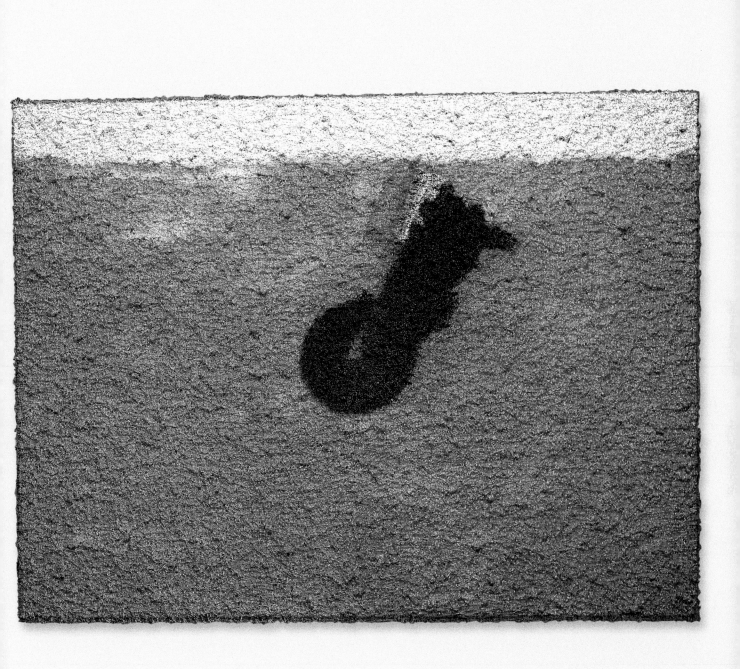

Untitled/Chartreuse (Lot 071704), 2004;
video projection, oil and alkyd on linen; 36 x 48 inches.
Private collection, Ross, California.

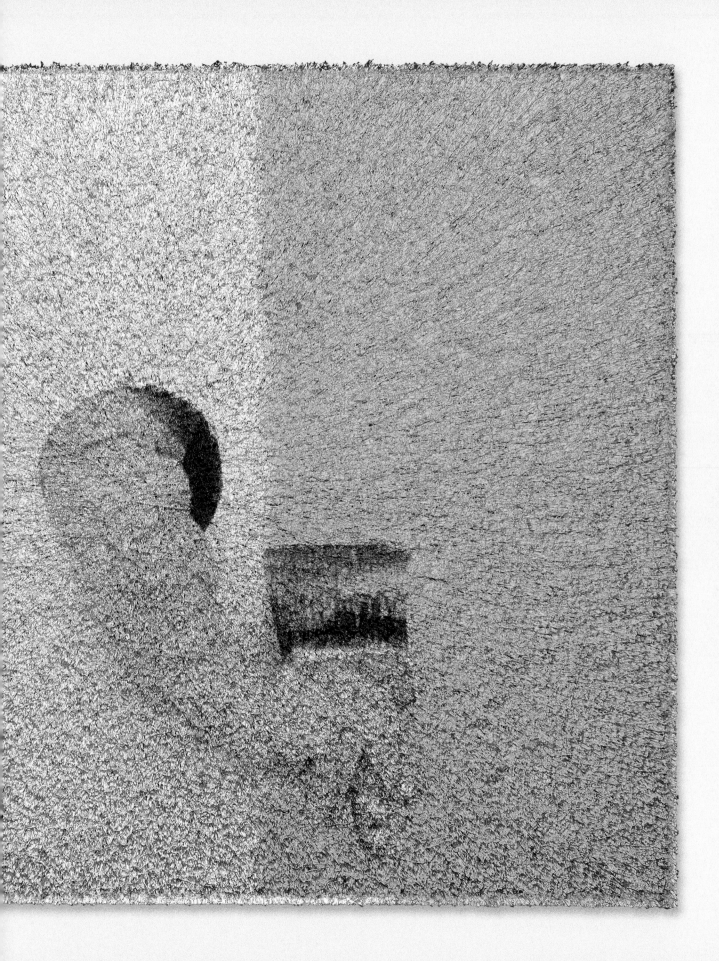

Untitled/Black (Lot 070504), 2004; video projection,
oil and alkyd on linen; 30 x 40½ inches. Collection
J. Ben Bourgeois, Los Angeles.

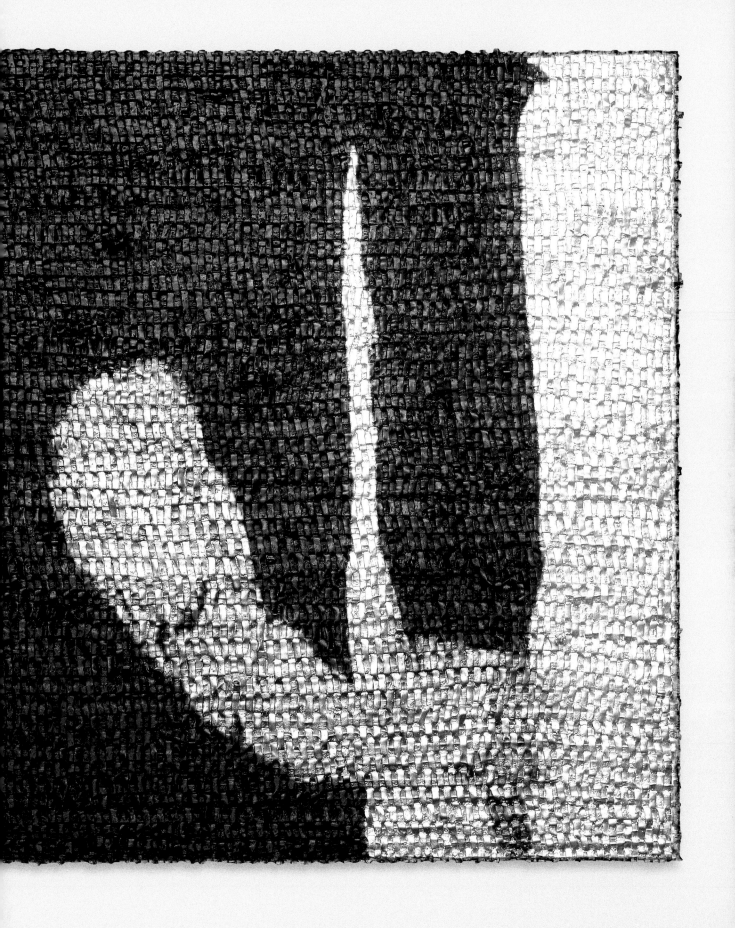

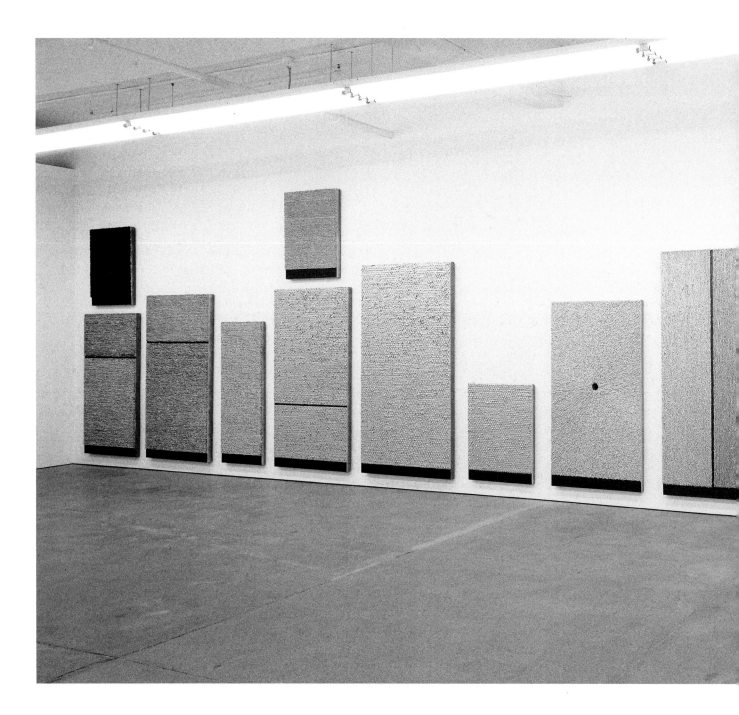

Hippie Shit

Hippie Shit, 2005, installation view,
Marianne Boesky Gallery, New York.

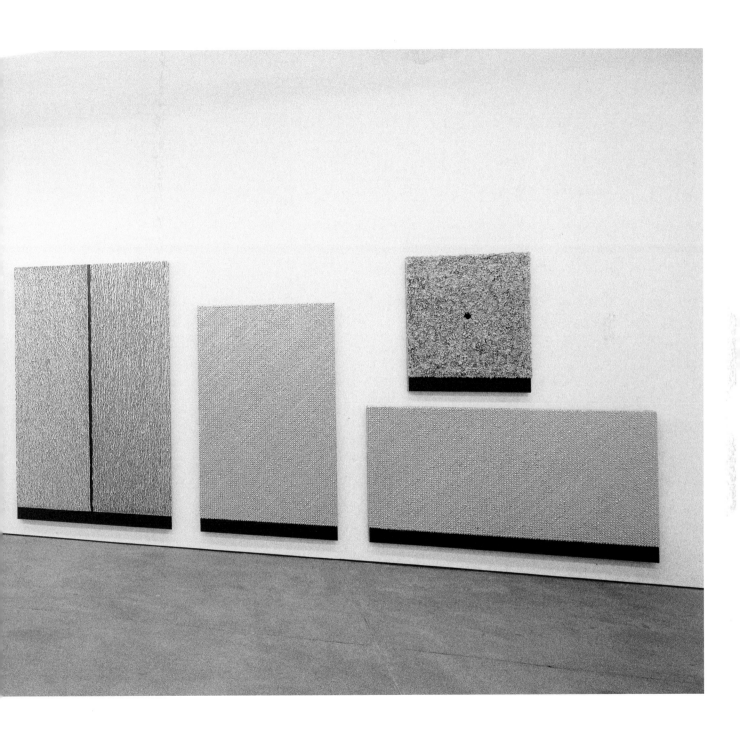

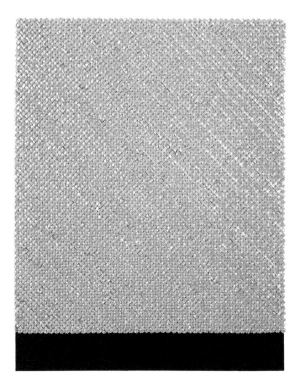

Lot 070705, 2005; oil and alkyd on linen; 35¼ x 28 inches.
Collection Peter Marino/Peter Marino Architect + Associates,
New York.

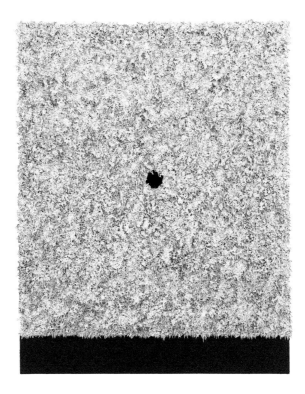

Lot 080105, 2005; oil and alkyd on linen; 35¼ x 28 inches.
Collection Shelley Fox Aarons and Philip Aarons, New York.

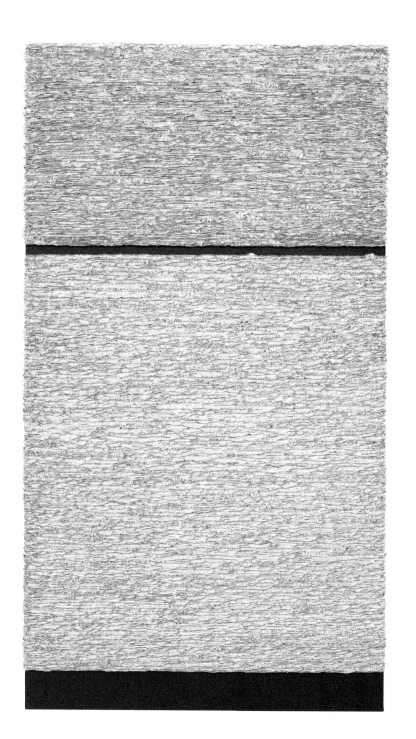

Lot 022005, 2005; oil and alkyd on linen; 64 x 36¼ inches.
Collection Charles and Nathalie de Gunzburg, New York.

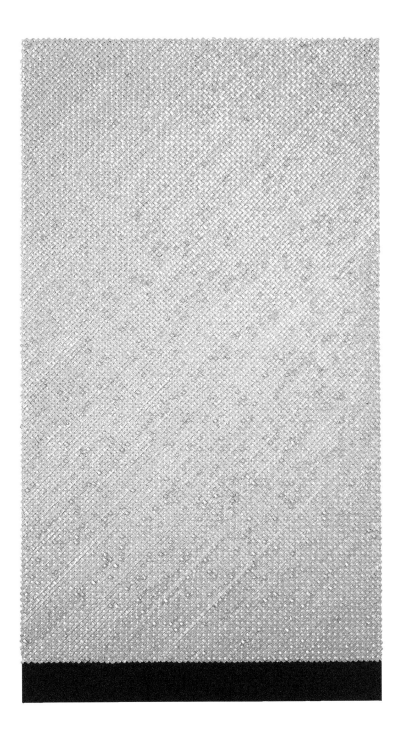

Lot 082105, 2005; oil and alkyd on linen; 64¼ x 36 inches.
Courtesy the artist and Marianne Boesky Gallery, New York.

Lot 062005, 2005; oil and alkyd on linen; 80 x 44 inches.
Courtesy the artist and Marianne Boesky Gallery, New York.

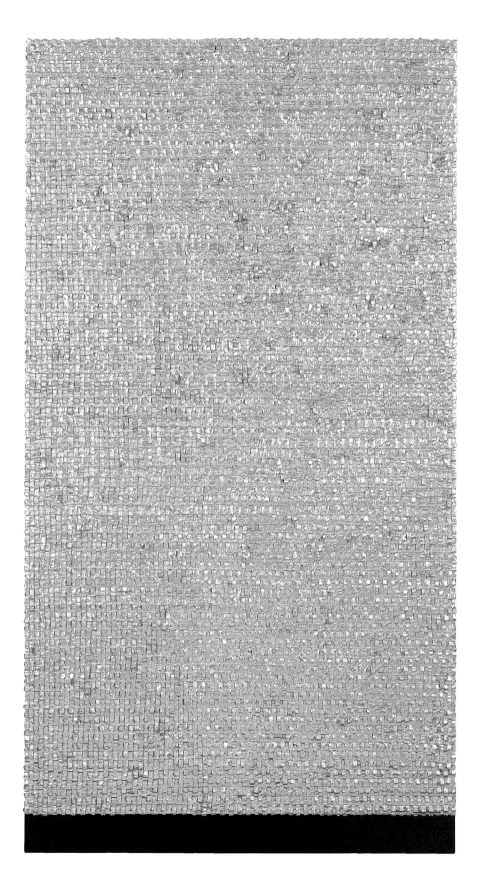

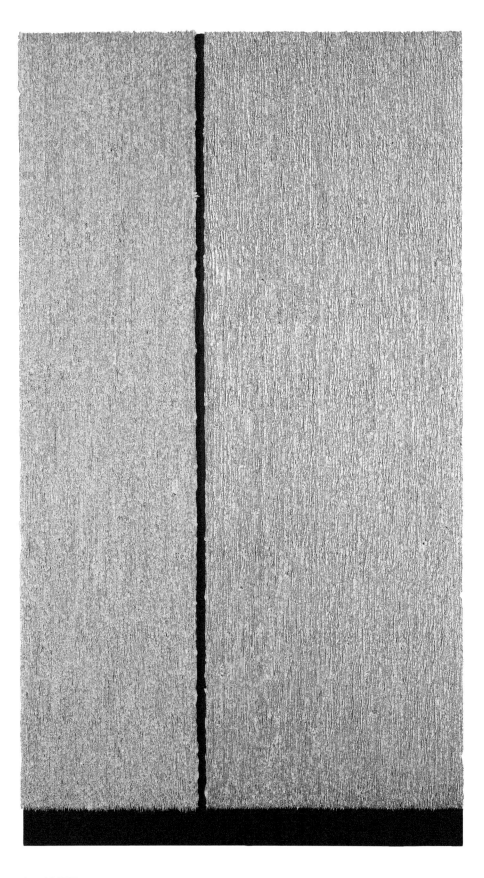

Lot 081505, 2005; oil and alkyd on linen; 80 x 45 inches.
Private collection, New Jersey.

Lot 091405, 2005; oil and alkyd on linen; 36 x 64 inches.
Collection Milton Dresner, Michigan.

Impeach

Impeach, 2006; DVD-A with DVD-A player and five speakers; duration: 2:20 minutes.
Courtesy the artist and Marianne Boesky Gallery, New York.

Donald Moffett: IMPEACH
Running Time: 2:20 minutes

On December 18, 1998,
Rep. John Lewis of Atlanta
argued metaphorically against the
impeachment of Pres. Bill Clinton.
The civil rights vanguardist slowed
the congressional proceedings
for approximately one minute before
the vote was called and the matter lost.

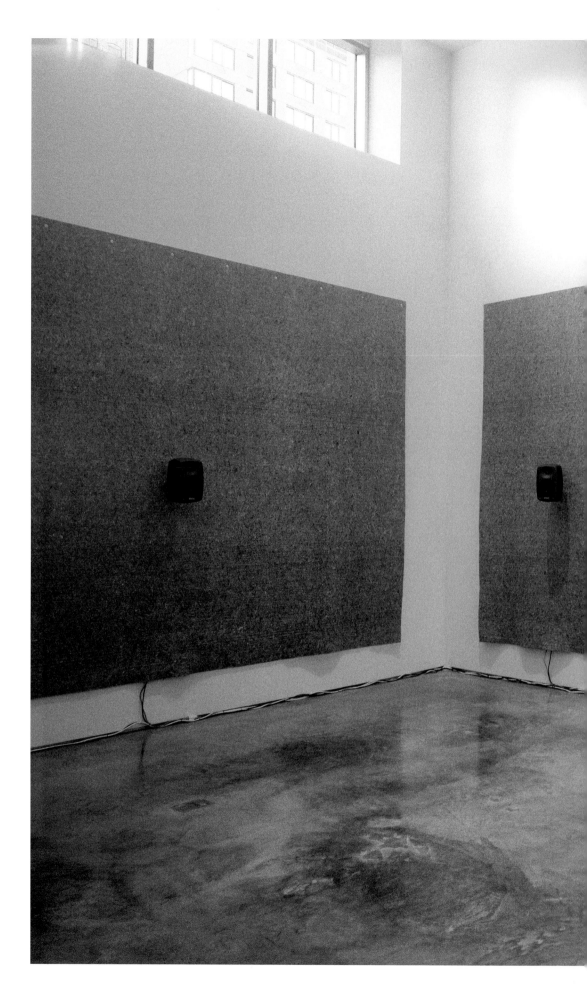

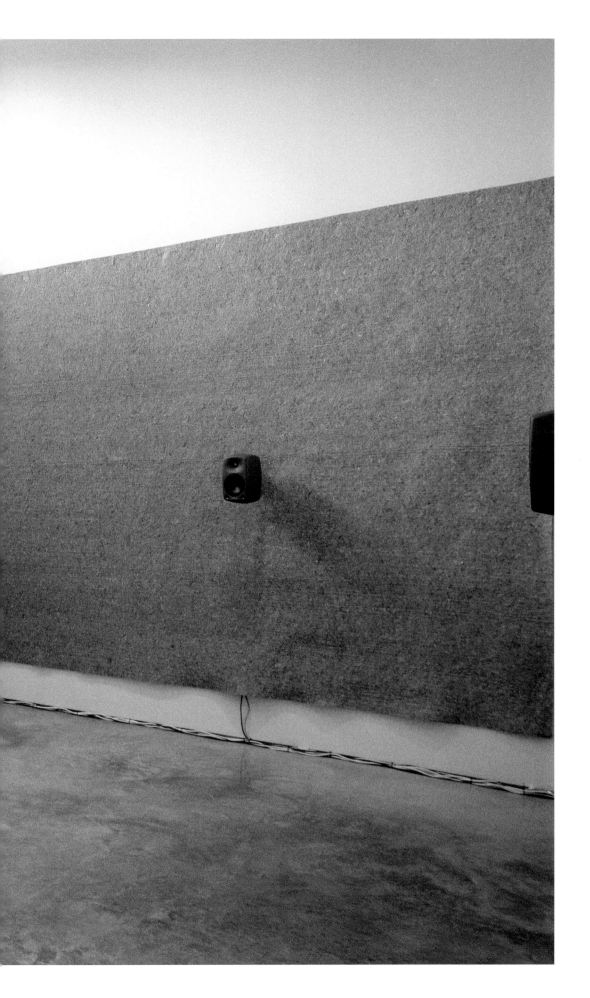

Gutted

Lot 020207 (O), 2007; acrylic, rayon, aluminum, and galvanized tin zipper
on cotton duck, wood stretcher; 35 x 28 inches. Private collection, London.

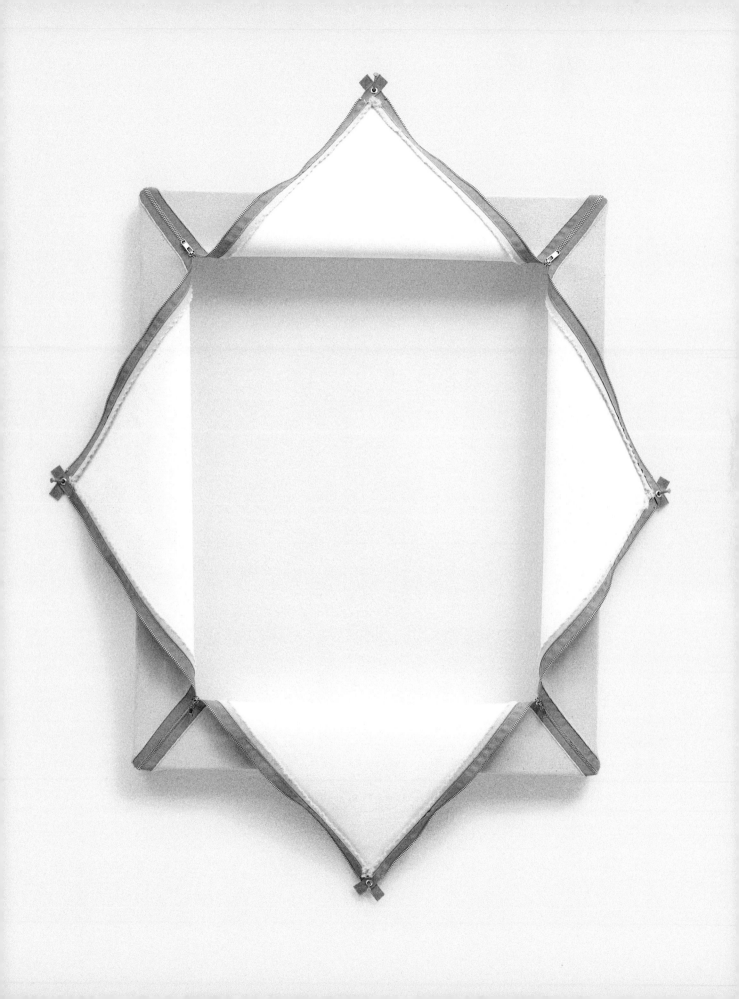

Lot 102907 (X), 2007; acrylic, polyvinyl acetate with rayon, and steel zipper on linen, wood stretcher; 54 x 44 inches. Collection Adam Clammer, San Francisco.

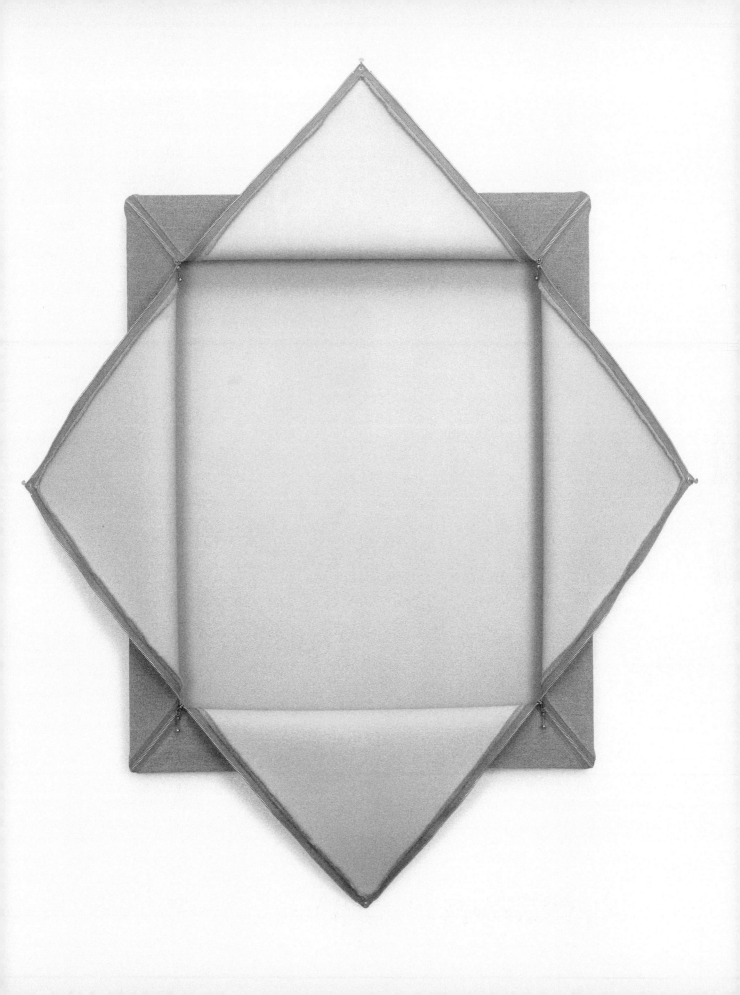

Lot 110107 (X), 2007; acrylic, polyvinyl acetate with rayon, and steel zipper on linen, aluminum stretcher; 76 x 100 inches. Collection Meryl Lyn Moss, Chicago.

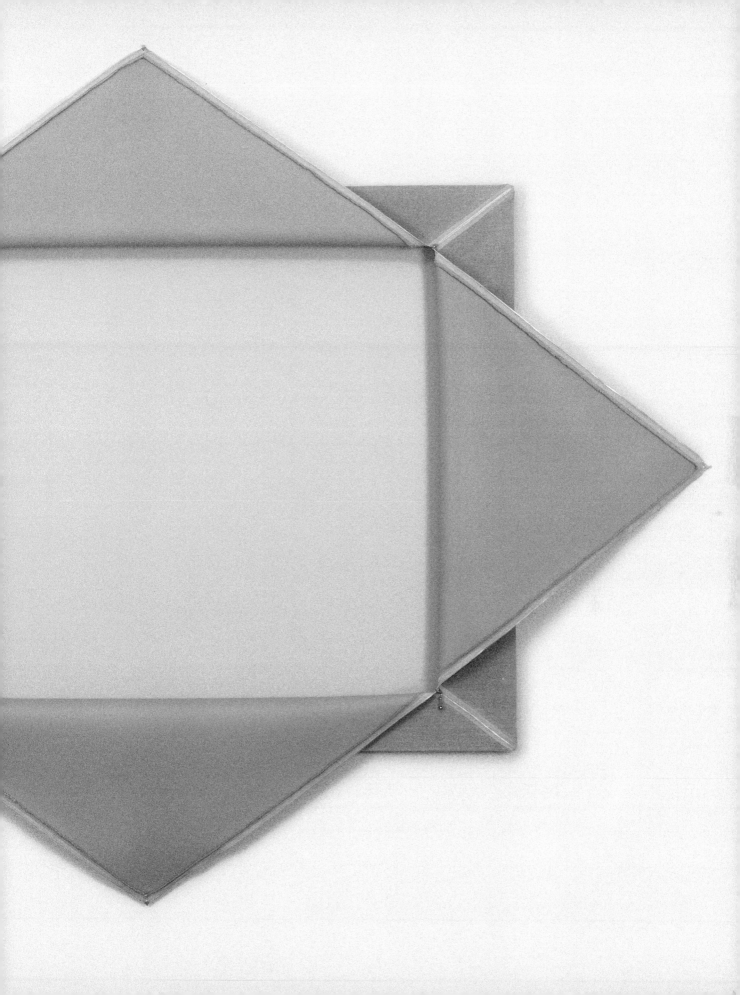

Lot 102807 (X), 2007; acrylic, polyvinyl acetate with rayon, and steel zipper on linen, aluminum stretcher; 72 x 72 inches. Courtesy the artist; Marianne Boesky Gallery, New York; and Anthony Meier Fine Arts, San Francisco.

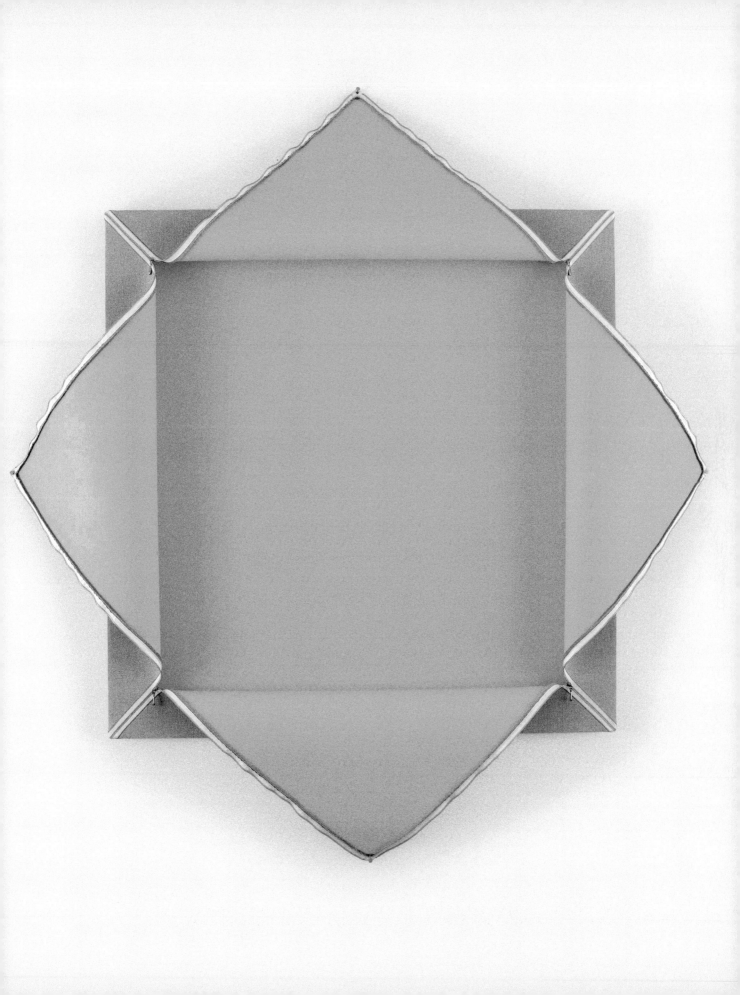

Lot 060707 (O-Black), 2007; acrylic, polyvinyl acetate with rayon, and steel zipper on linen, wood stretcher; 35½ x 28½ inches. Courtesy the artist and Marianne Boesky Gallery, New York.

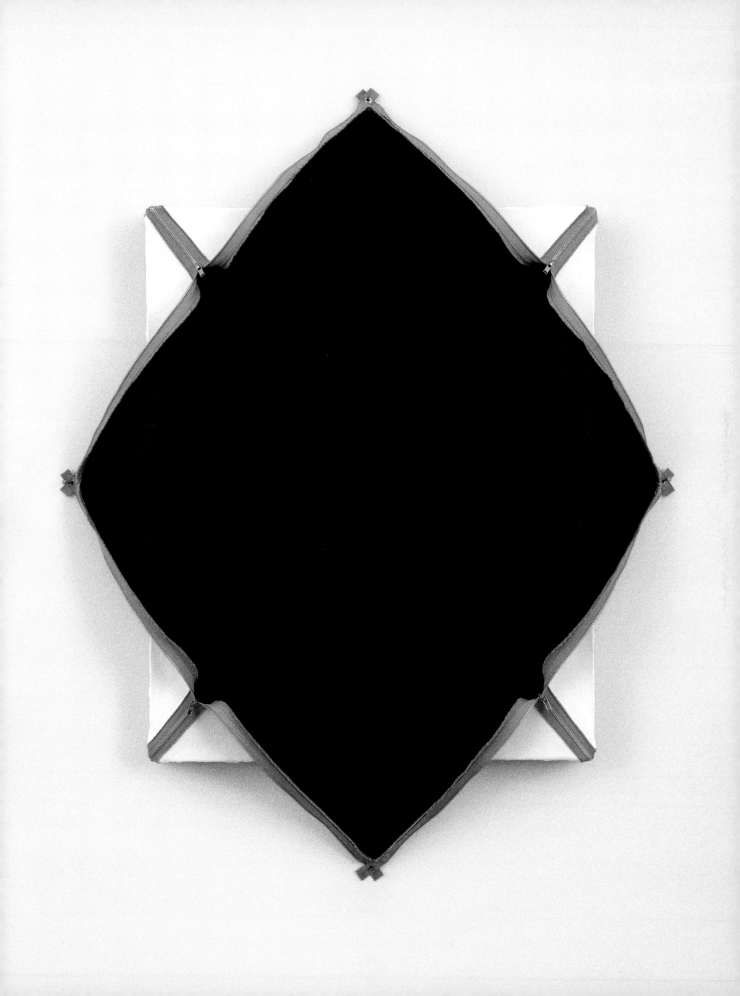

Lot 051408 (X), 2008; acrylic, polyvinyl acetate with rayon, and steel zipper on linen, wood stretcher; 54 x 44 inches. Private collection, New York.

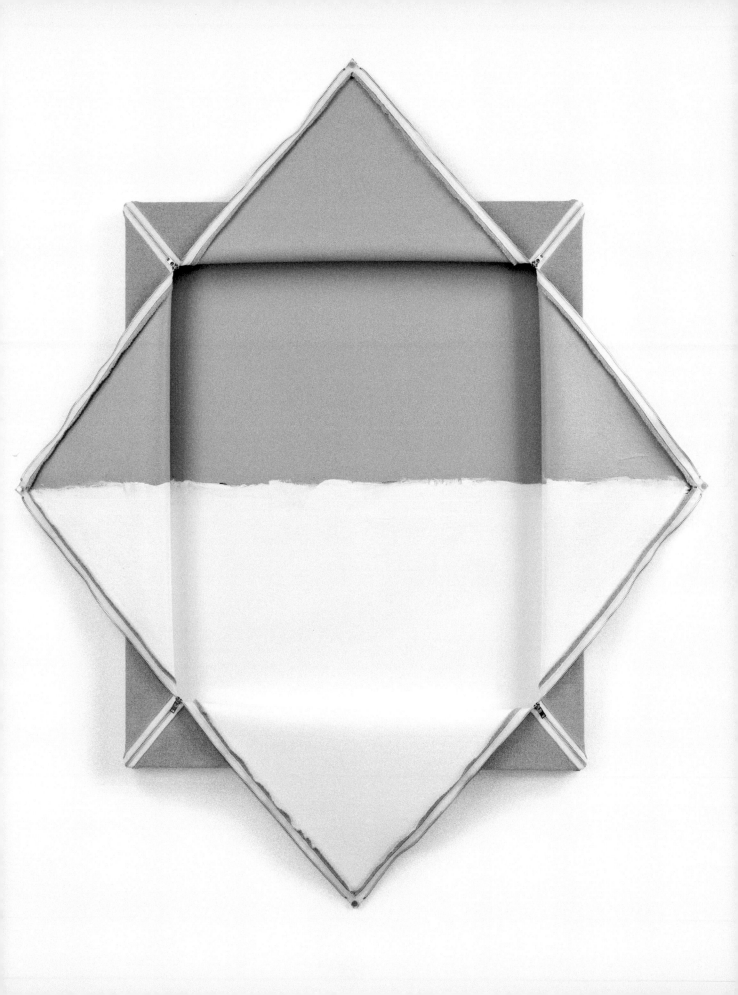

Fleisch

Lot 032407 (11–11o), 2007; oil, rayon, aluminum, rabbit skin glue, and polyvinyl acetate on linen;
72 x 60 inches. The David Roberts Art Foundation Ltd., London.

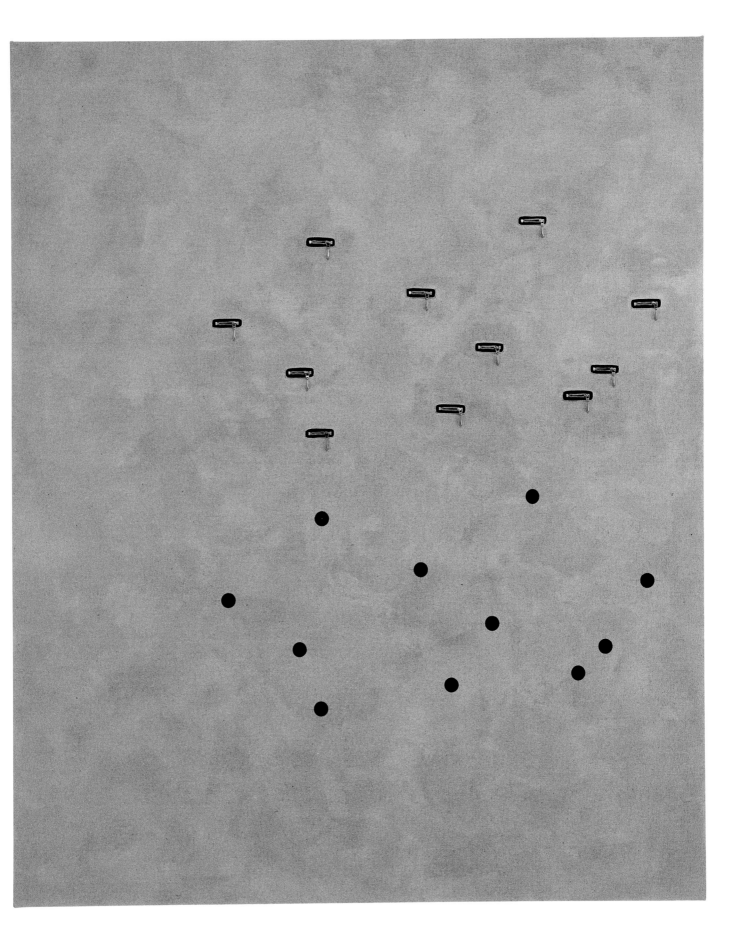

Lot 081907 (Xoooo), 2007; oil, cotton, aluminum, rabbit skin glue, and polyvinyl acetate on linen; 24 x 20 inches. Collection Clo and Charles Cohen, Los Angeles.

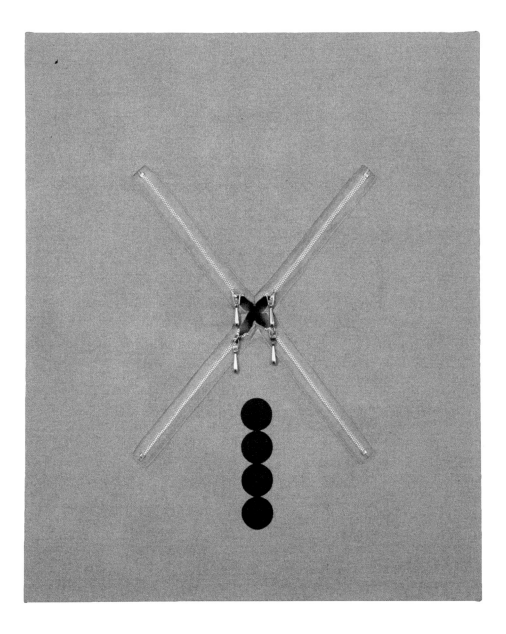

Lot 022407 (O-O), 2007; oil, charcoal, rayon, aluminum, rabbit skin glue, and polyvinyl acetate on linen; 24 x 20 inches. Courtesy the artist and Marianne Boesky Gallery, New York.

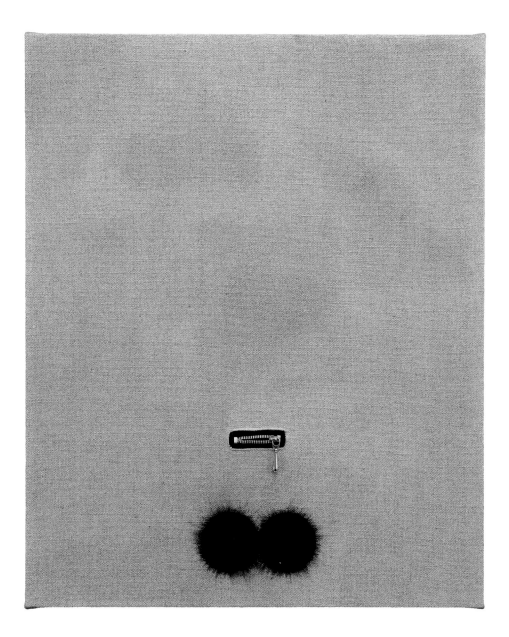

Lot 030807 (Oo), 2007; oil, charcoal, rabbit skin glue, and polyvinyl acetate on linen; 24 x 20 inches. Courtesy the artist and Marianne Boesky Gallery, New York.

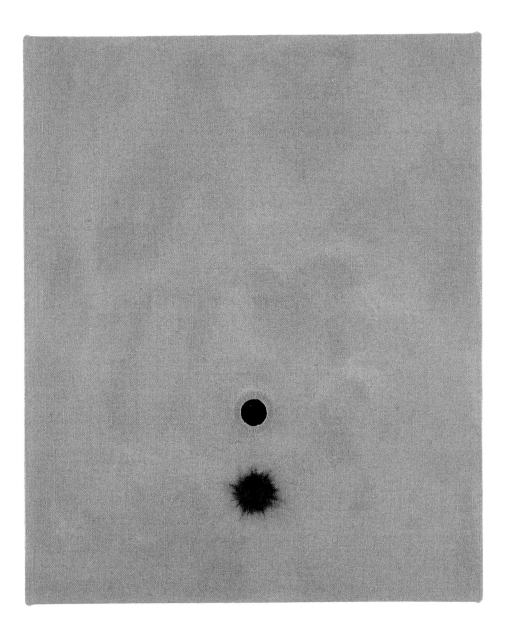

Lot 081907 (IOo), 2007; oil, cotton, aluminum, rabbit skin glue, and polyvinyl acetate on linen; 24 x 20 inches. Courtesy the artist and Marianne Boesky Gallery, New York.

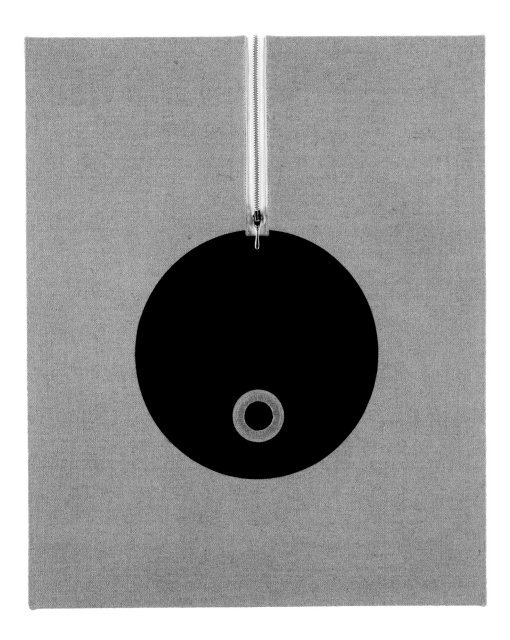

Lot 091507 (O5o_), 2007; oil, rabbit skin glue, and polyvinyl acetate on linen; 24 x 20 inches. Courtesy the artist and Marianne Boesky Gallery, New York.

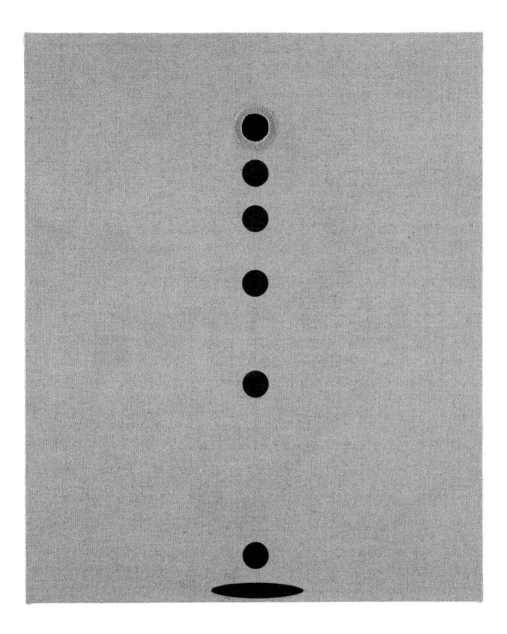

Lot 091607 (I12O13o), 2007; oil, cotton, aluminum, rabbit skin glue, and polyvinyl acetate on linen; 24 x 20 inches. Courtesy the artist and Marianne Boesky Gallery, New York.

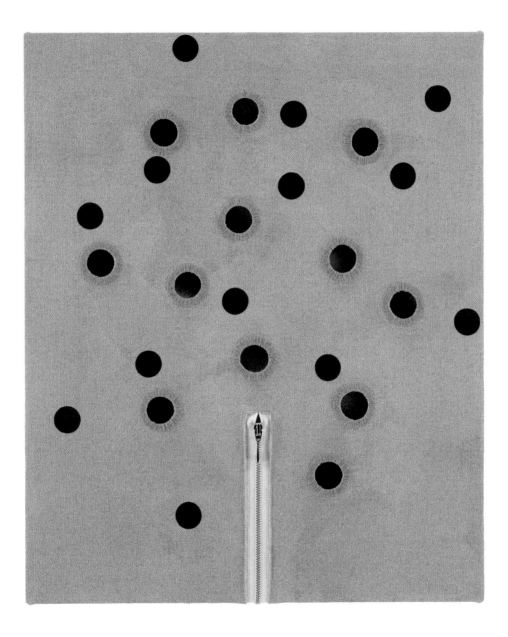

Lot 092107 (X15o), 2007; oil, cotton, aluminum, rabbit skin glue, and polyvinyl acetate on linen; 24 x 20 inches. Courtesy the artist and Marianne Boesky Gallery, New York.

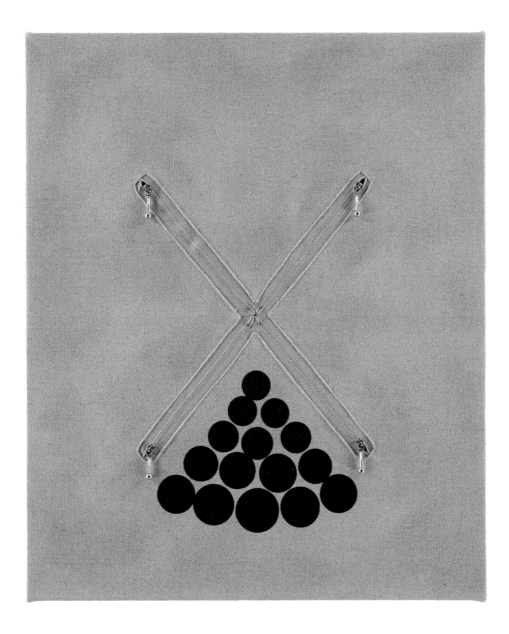

Lot 092207 (O), 2007; acrylic, rabbit skin glue, and polyvinyl acetate on linen; 24 x 20 inches. Collection Agnes Gund, New York.

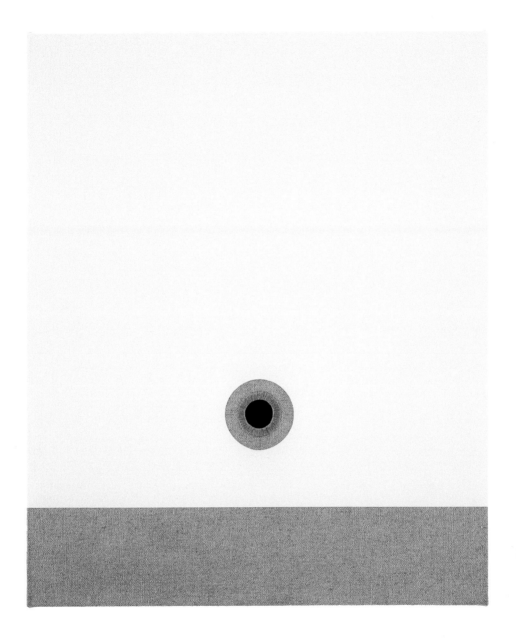

Comfort Hole

Lot 010510 (3o), 2010; oil on linen with wood panel support;
17 x 17 inches. Collection Chris Hill, San Antonio.

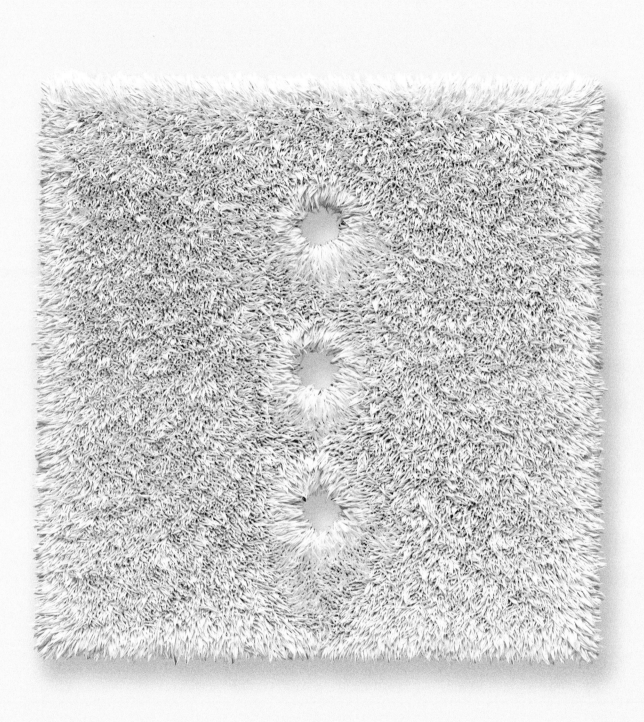

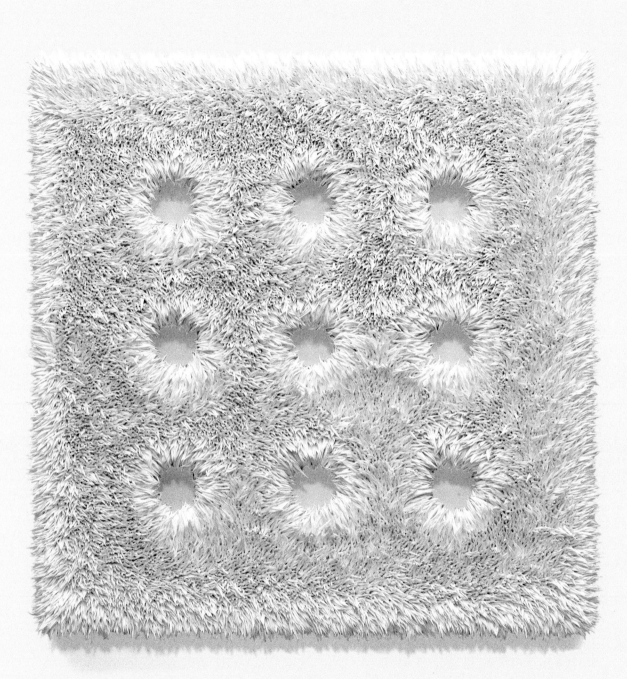

Lot 121709 (9o), 2009; oil on linen with wood panel support;
17 x 17 inches. Private collection, Houston.

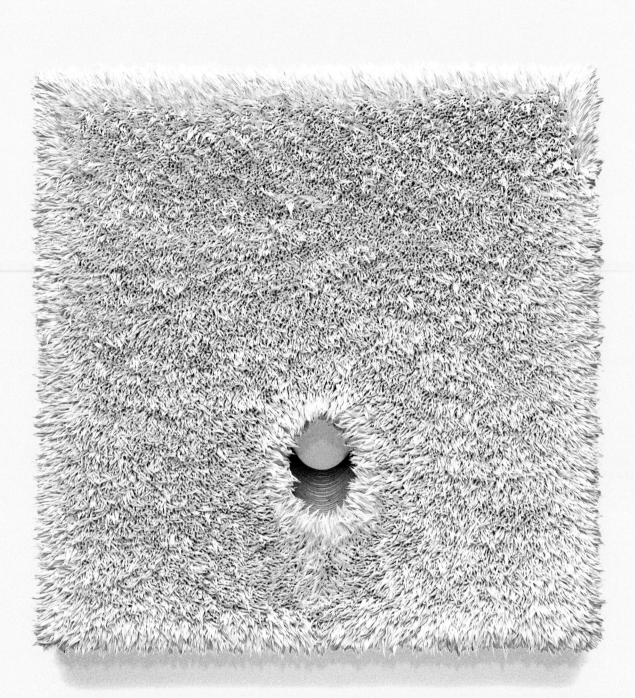

Lot 011710 (O), 2010; oil on linen with wood panel support;
17 x 17 inches. Collection Lora Reynolds and Quincy Lee, Austin.

Lot 012010 (Lucky Pierre), 2010; oil on linen with wood panel support;
16 x 16 inches. Collection Jennifer and John Eagle, Dallas.

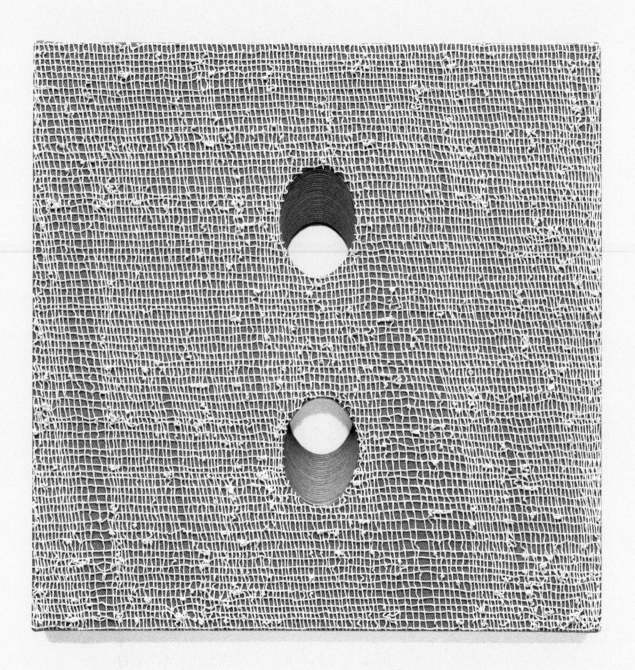

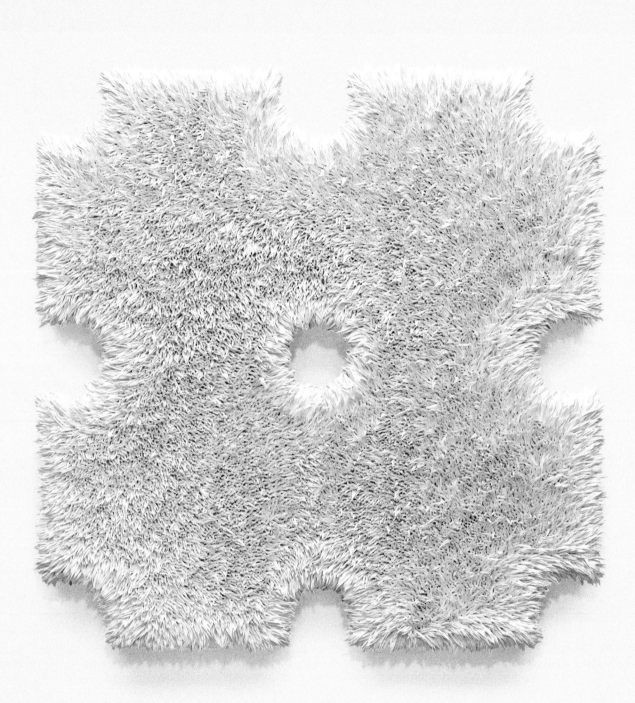

Lot 122109 (o8c), 2009; oil on linen with wood panel support;
17 x 17 inches. Collection Jennifer and John Eagle, Dallas.

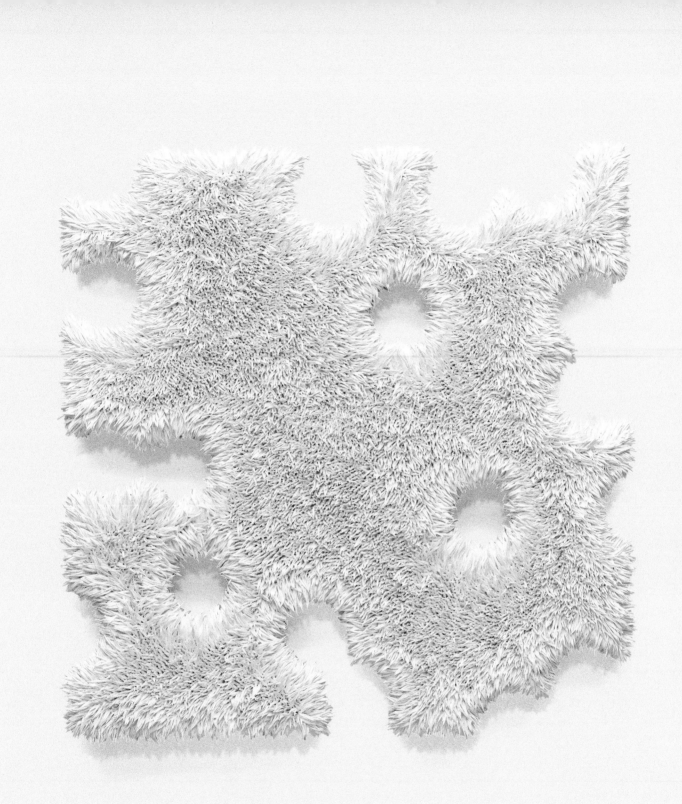

Lot 121909 (18/o), 2009; oil on linen with wood panel support;
17 x 17 inches. Collection Mickey and Jeanne Klein, Austin.

Lot 120309 (4/0), 2010; oil on linen with wood panel support;
31 x 25 inches. Collection John and Lisa Runyon, Dallas.

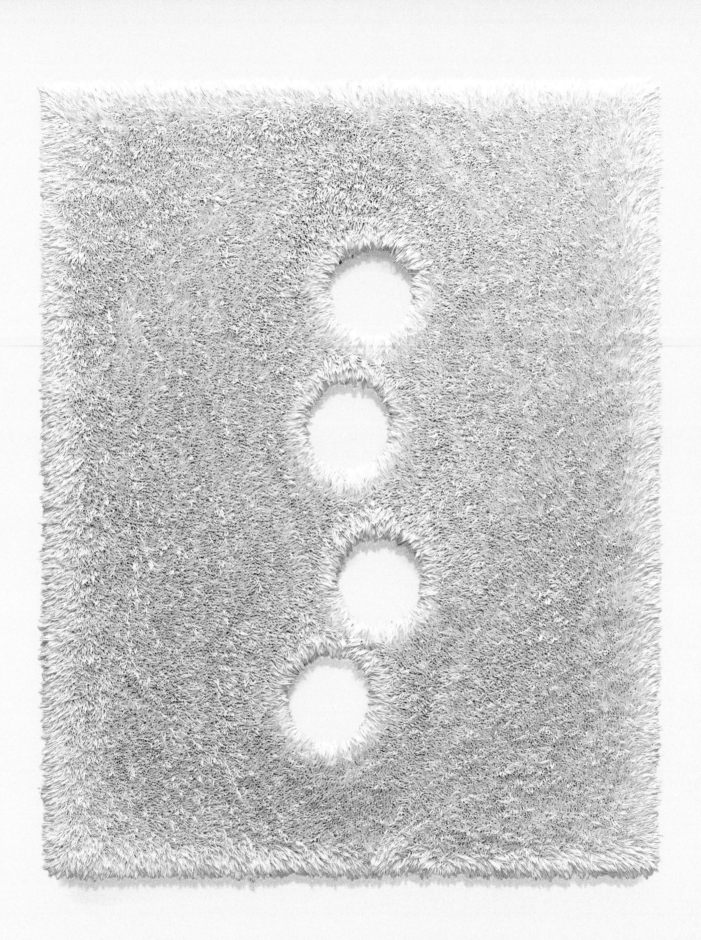

Lot 072310 (4/0), 2010; oil on linen with wood panel support;
31 x 25 inches. Private collection, New York.

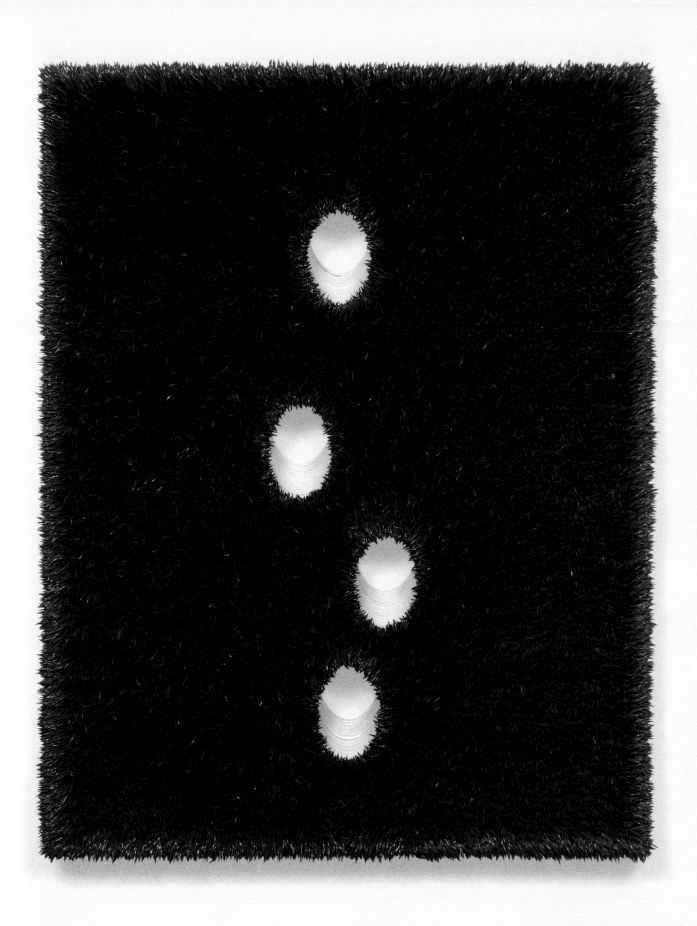

Before, During, and After
Donald Moffett in Conversation with Douglas Crimp

Douglas Crimp: I looked through a number of reviews of your shows during the past decade, and they almost always mention your work with Gran Fury. So I'd like to resist the inevitable opener to our discussion, about our mutual involvement in ACT UP. Of course we will eventually come to that moment, which played such an important part in both of our biographies and careers—for my part, and I imagine for yours, AIDS activism irrevocably changed me. But we both had lives and careers before ACT UP, so I'd like to start there. When I was arranging to visit you in your Staten Island studio, I insisted that I'd have to be back in Manhattan early because I had tickets to see Diana Vishneva dance *Giselle* at the Met that evening. This led to your telling me about working at Lincoln Center after you arrived in New York and seeing a lot of opera and dance. No doubt we were watching George Balanchine's ballets at the New York State Theater on many of the same evenings in the years before we knew each other. Tell me about when and why you came to New York and what you did in those first years. I should confess that my interest is more than informational: I'm currently working on a memoir of my own first years in New York. It's called *Before Pictures*, because the narrative precedes the 1977 *Pictures* exhibition at Artists Space, which is how I came to be known. I guess you could say that *Pictures* is my Gran Fury. It follows me wherever I go.

Donald Moffett: "Before" is definitely a big place. I missed *Pictures* by a hair. I came to New York in 1978 and settled into the Vanderbilt YMCA to find the party and address my motivating fantasies of

living in NYC. I was twenty-three. And I found it— seedy and sexy. The city was on the verge of bankruptcy, and there was a distinct (and appealing) air of rot and desperation. But I was also a hound for culture, half-starved from how little of it was available in Texas at that time. I knew no one when I got here, so my bright idea for getting a job was going to the general manager of American Ballet Theater, whose name was Joyce Moffat. I thought I could get in the door by sharing close to the same last name. She did see me but had nothing for me. However, she made a call to the New York State Theater. They had a job for me in the subscription department, and I thought I was semi-set for surviving here—and with free tickets to night after night of events all over Lincoln Center. Balanchine was the intellectual heavyweight of the whole place (at least), and I was lucky to be there.

But the reason I came was to make art. Balanchine was an important doorway for me through high modernism, but at this time dance was also a major force downtown, where modernism was being chewed up in profound ways. Marcia Siegel was writing brilliantly for the *Soho Weekly News*. Then dance was integral (generally and to art specifically) in a way that it isn't now. Dance and art were not estranged, and one fed the other—at least for me. But you say that now you are seeing a new field of players and possibilities. I hope so.

I want to go on the record with my own "Before" in another way, too. This survey has necessitated a review of most of my artwork, and things have tumbled out that I had almost forgotten. One batch of drawings barely precedes the explosion of the

AIDS epidemic and the art and critical language that very quickly erupted in response to it. You and I were both part of that sudden and frantic eruption that, as you say, changed us completely. But that little batch of drawings I found is so "Before" that I had decided to call a small book of them just that. They are downright Jungian. Little did I know when I drew them that there would be no time or place for such private indulgences, or for the ballet, for so many years to follow.

DC: It's true that when you got to New York in 1978 there were closer connections between art and dance. This spring and summer I saw two wonderful reminders of that fact: Trisha Brown revived her first proscenium work, *Glacial Decoy* (1979), which had a beautiful decor by Robert Rauschenberg of projections of his photographs, and Lucinda Childs revived *Dance* (also 1979 and also her first proscenium work), with a score by Philip Glass and a film by Sol LeWitt. LeWitt's film, projected on a scrim at the front of the stage, doubled (and sometimes trebled or even quadrupled) the live dance. I had thought that sort of close collaboration of artist, composer, and choreographer (the legacy, by the way, of Diaghilev's Ballets Russes, whose centenary was celebrated in 2009) was a thing of the past, but I'm happy to be proved wrong: Jenelle Porter recently organized an exhibition at the Institute of Contemporary Art in Philadelphia called *Dance with Camera*, which demonstrates a return to artists' interests in working with dancers. But in general I too lament the overspecialization of today's art scene. It seems like the massive expansion—and globalization—of art has brought with it a new kind of parochialism or provincialism.

But let's go back to "Before." I'm intrigued by what you're turning up of your early work. What are those "Jungian" drawings? What motivated them? What art were you paying attention to when you came to New York? I realize that this is an absurdly broad question when asked about any artist's first years in New York. The answer in a place so rich in art as New York is likely to be: everything. The Met, MoMA, the Guggenheim, the Whitney. Marcia Tucker founded the New Museum of Contemporary Art

right around the time you arrived. P.S. 1 had opened in 1976. The alternative space movement was thriving—Artists Space, Franklin Furnace, the Kitchen. It must have been daunting. It was a time when the watchword was *pluralism*, so it was hard to figure out what was what. Whose work were you most interested in? Was there a particular scene that you gravitated toward? Are your Before drawings really private, or can you connect them to other things you were seeing?

DM: I wonder if the "parochialism or provincialism" that you mention is more of a duck-and-cover reflex from the crushing weight and "duty" of globalism. Is this your way of describing on a broader scale what I call in painting "the dinky narrative," which has been so rampant during the last few years? These terrible little stories seem so immune to or willfully ignorant of the larger issues that fill the world. I can't say that I don't understand the impulse, but that doesn't make the result any less impoverished. I think that puniness of mind might preclude collaboration or the openness essential to transdisciplinary curiosity.

But to again tackle the "before": My move to New York and the making of the Before drawings are separated by a half dozen years. The world shifted significantly for me in those intervening years such that it feels like two worlds. In the process, the art and artists that interested me shifted too. One thing I've recollected of what and who drove me where in my first years in New York is that it was mostly women. In dance (and I use the term loosely), there was Trisha, Simone Forti, Deborah Hay, Yvonne Rainer (who is in a category all her own). I remember clearly an evening of dance/performances that included Forti in the garden at MoMA. Everything else on the program built up to a climax in or around the pool, but Forti started right off with the money shot. The first thing she did was ungracefully plop herself in the pool and then got out to perform wet whatever was on her rich mind. It was a simple, memorable act and a realignment of expectations that feeds me still.

In art, there were Elizabeth Murray, Alice Aycock, Lynda Benglis, and Jackie Winsor. They all satisfied my fractured formalist impulses. And across the

From the "Before" drawings, 1985; graphite on paper; 17 x 14 inches. Courtesy the artist.

divide, there was Ree Morton (speaking of the early days of the New Museum), Yoko Ono, and Warhol. I recklessly throw Warhol into the mix as the fey foil to what I knew I couldn't stomach then. All the attention (or so it seemed) was on a handful of male, mostly figurative painters and their hyper-hetero boasts. Even then, it all seemed doomed to me as a subject other than to critically maul. But I've softened in the intervening thirty years. Somewhat perversely, I like some of that work now but very selectively.

But what I was looking at carefully then was different from what was going on in my own work. That I have to blame on Terry Winters. I have a second degree in biology, and Terry's work in those years effortlessly nourished my twin interests in art and biology. I tried to push my way into his space but could not do anything but "little Terry Winters." After buying a plane ticket with the money my parents gave me for a TV, I spent time in Europe traveling and drawing. Those drawings were worthwhile, but they were still too, too Terry Winters—and not half as good as his. So when these notebooks were stolen from a crummy co-op studio I was renting a share in, I decided it was time to move along, and in every way. I was doing psychotherapy and just turned inward for imagery—when the self still had priority, before the communal body broke out with plague. This is the work I'm now referring to as "Before," and these drawings owe a big debt to the charred and cloistered interior of Jackie Winsor's *Burnt Piece* (1977–78) at MoMA, even though you'd never know it. Whereas her piece is so abruptly formal and forensic, my drawings are messy with wobbly figures of men and women, babies, dead dogs, and deer.

(Speaking of Marcia Tucker, the New Museum, Ree Morton—I was just in a cab riding down Fifth Avenue and saw that at Fourteenth Street the whole southeast corner is demolished. A huge vacant lot runs through to Thirteenth Street. I was momentarily disoriented and couldn't remember what had been there. It was a forgettable building to be sure, but it was also the building that housed the first New Museum, where I saw the Ree Morton show that Allan Schwartzman and Kathleen Thomas curated in 1980. Poof. Gone. No big deal, but still . . . Poof. Gone.)

And what about you, Douglas? Your "Before"? When did you move to New York, and what were you looking at before *Pictures*? Can you give me an idea of how you got to *Pictures*. Or am I asking for a book-length answer that will be published next year?

DC: Yes, that *is* my memoir: I'm writing about my first ten years in New York, and I'm afraid it will be more than a year before I complete it. One thing you said resonates with a sentence that I wrote for a chapter called "Back to the Turmoil," which is about a small show I did of Agnes Martin's work and a visit I paid to her outside Cuba, New Mexico: "As I look back now, it occurs to me that one way I dealt with my ambivalence about being open about my sexual interests was to devote much of my writing to women artists—Benglis, Darboven, Hesse, Jonas, Martin." Something else you say resonates. I like your coinage "the dinky narrative" of painting. In my interview with Philipp Kaiser for the catalogue of the three-museum show in Basel in 2002, *Painting on the Move*, I said that I thought painting's contemporary achievement was modest but went on to say that "perhaps modesty is itself a significant, even ethical accomplishment under current circumstances."[1] What I had in mind was the excessive demands placed on art by certain critics, who, in their continuing belief that art's task is to revolutionize the world, fall into what Walter Benjamin called Left melancholy. I also very much like your phrase, as applied to the late 1970s–early 1980s work of Murray, Aycock, Benglis, and Winsor, that they satisfied your "fractured formalist impulses." I want to return to that when we discuss your recent work, but for now, Terry Winters: He's an artist I know less about than I'd like to. My strongest encounter with his work was his stage designs for Trisha Brown's *El Trilogy* from 1999–2000. You say it was your dual interest in art and biology that attracted you to Winters's work in those years, but "fractured formalist impulses" certainly applies to Winters's *El Trilogy* designs and also, I think, to some of his early paintings. It also applies to the work of many artists of your generation who were attracted to the rigor of minimal art but wanted to "soften" it, "sissify" it—Felix Gonzalez-Torres

most obviously, Tony Feher, Roni Horn. The relation to Minimalism is very different in Jackie Winsor's work. There's certainly nothing sissified about those tough, labor-intensive constructions she was making in the 1970s. The question that comes to mind in all of this is: to what extent did being queer enter into your thinking about the kind of art you wanted to make back then? I don't think the early 1980s was a very easy time to be queer in the New York art world. "Men, women, and babies," you say. "Dead dogs and deer." What was that about?

DM: Sissy? Roni Horn? She's gonna kick your ass.

Was it "sissification"? I do remember being alarmed the day Felix told me that from then on he was only doing poetry in his work. And obviously he meant it, and it is the later, lyrical work that has become his most famous and most embraceable. No more Mr. Tough Guy (or Bad Guy). Is poetry sissy-ish? I recently read Tom Healy's book of poems *What the Right Hand Knows*, which answers that question with the biggest kind of NO. And Tony Feher? I'll always regret not trying to buy or trade for what I remember as an early work of his in which he fucked some wet cement and the hardened depression was the sculpture—small enough to carry around with you (if you are the type to carry around a twenty-pound cement block) but large enough to leave a lasting impression of the tool Tony used to make it. In fact, I still love that piece, the pleasing brutality of it, the morbid chill. It said a lot about sex at a time when sex was getting complicated again (no matter what the party line was). But this is all much later, in the late 1980s or early 1990s.

But to get back to Jackie Winsor. No, her work does not feminize Minimalism in a formal sense, and there was no language there that I wanted to transpose into a queer idiom, but it was the stance of her work, the weight, the immovability of *Burnt Piece* that I admire(d). There are two specific things that I took from it: (1) "don't push me," and then if some schmuck does, (2) "don't budge." This was a worthwhile lesson for a sissy from Texas, but it was the reverse of what you refer to as "sissify." The power of Winsor's piece whispered something to me about being a man.

You are certainly right to question how I get from Jackie Winsor to "men, women, babies, dead dogs, and deer," but I think I can do it. I can draw a very specific bridge from that hard cube to the near hysteria of my drawings, and it runs right through the photograph that was made famous in one of those books everyone was reading in the eighties—was it a Zone book?—of a woman fighting her own drawn-out execution in a locked box in the desert. The futility in that shot was motivating to me in a perverse way. Winsor's cube is the furious charred echo of this ancient exotic cruelty. There is a fury in both that provoked me.

Okay, so maybe that's clear, but then to throw my extrapolation of images into the mix might be a little obtuse, but here goes: Damage. Pathologies. Punishment. Self-punishment. Flaming interiors. And remains. No, it is not tidy. It is not curatorially convenient. Bile never is. My interior house was spewing (I hate to say it) archetypal characters with the help of an aggressive, sadistic psychotherapist, and it was quite a bonfire, albeit contained. However, it would very abruptly burn out about the time GRIDS (how über-modern!) imposed new rules for living, dying, and making art. That would be the dividing line between my before and my after. Years later, but related to this confluence of images and artworks, Michael Nesline (a sharp-tongued copywriter in Gran Fury) would sum it all up nicely by offhandedly describing his interior as "this little lump of coal that is my heart."

It was hard to be gay in the art world then (and it's not now?), but there was Warhol, on the one hand (fey and famous), making art that passed and insinuated itself everywhere, and then, on the other, there was Joe Brainard (who was not fey but very narrowly known) making the tiniest little fey art imaginable. Joe I knew a little, and Warhol I met in passing. They were a lopsided frame but important to me as I tried to figure out what to do.

DC: You got me: "soften" and "sissify" are wrong; "queer" or maybe "add implicit or even explicit content to" would be better, although not necessarily. It's not only a case of content; sometimes it is a question of bringing out the decorative qualities of the abstraction. But often, as in the wonderful case

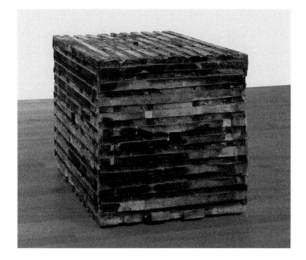

Jackie Winsor, *Burnt Piece*, 1977–78; cement, burnt wood, and wire mesh; 33⅞ x 34 x 34 inches. The Museum of Modern Art, New York, Gift of Agnes Gund. © 2011 Jackie Winsor. The Museum of Modern Art/Licensed by SCALA / Art Resource, NY

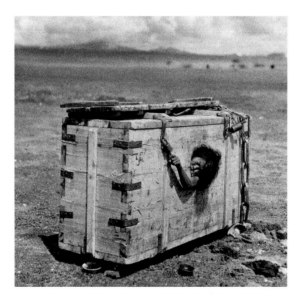

Stéphane Passet; *Mongolian Prisoner in a Box*, 1913 (detail); autochrome; 3½ x 4¾ inches. Musée Albert-Kahn.
© Département des Hauts-de-Seine—Musée Albert-Kahn.

of the Feher you mention, it is queering by adding content. It reminds me of what Yvonne Rainer says when she writes about her move from dance to film in her memoir *Feelings Are Facts*: "Ignored or denied in the work of my 1960s peers, the nuts and bolts of emotional life shaped the unseen (or should I say 'unseemly'?) underbelly of high U.S. Minimalism. While we aspired to the lofty and cerebral plane of a quotidian materiality, our unconscious lives unraveled with an intensity and melodrama that inversely matched their absence in the boxes, beams, jogging, and standing still of our austere sculptural and choreographic creations."[2]

I can't believe I never put GRIDS (Gay Related Immune Deficiency Syndrome—the first acronym for what would later be renamed AIDS) together with the modernist grid before—I, who did an early show of Agnes Martin's work and edited Rosalind Krauss's famous essay "Grids" for *October*. That surely counts as repression on my part. Anyway, it's a good segue to AIDS and ACT UP, where we first met. When did you join? Were you in the group that made *Let the Record Show* for the window of the New Museum?

DM: What a perfect quote by Rainer as segue to what happened next—to both of us and thousands (and then millions) of others. I missed Larry Kramer's evidently spectacularly angry speech at the Lesbian and Gay Community Services Center in March 1987 that sparked the beginning of ACT UP, but it didn't take long for me to get with the program. I heard about his speech immediately, but it wasn't until I saw the float that ACT UP made for the gay pride parade soon after that I got the message. That float was so *not* what the right likes to show and caricature of a gay pride parade. It was grungy and gruesome with a lot of barbed wire. This was in the days of William F. Buckley's barbaric idea to tattoo buttocks and quarantine people with AIDS. But that float was not just grotesque; it was also filled with the most beautifully amped-up gay men and women you could ever hope to see. I'd been doing my own street-protest wheat-pasting thing with the *He Kills Me* posters—"he" being Ronald Reagan—mainly creeping around at night putting them up with my

generous friend Michael Moran. Once I saw that float, I knew I was missing out on something good and important. From then on, I was there for the weekly Monday night ACT UP meetings for the next several years.

Speaking of creeping around at night, I wonder if you recall one of the first times we met. I don't really remember having met you before this, but it doesn't make sense that I was able to arrange this rendezvous if we hadn't. You were already very well known in the small but expanding universe of ACT UP (which had many artists but many other members who were not and might not have known your work before then). I think it was shortly before I took the Reagan poster to ACT UP that I got it in my mind that I just had to get one of the posters into your hands. Somehow you agreed to meet me on the street one night on the West Side in the twenties or thirties. I think you were leaving a meeting or something, but there I was at the appointed hour with my poster rolled up for you. I'm very glad I did it, and I'm very glad you took it, but I remember to this day a wary, deeply skeptical look in your eye (even in the dark) as you accepted my gift. Now that I think about it, maybe you were just thinking, "Now I have to schlep this tube home"? Or worse, "I have to schlep this tube around with me for the rest of the night—and then home"?

So Larry was able to galvanize a movement, but before that there was pervasive frustration and fear. A lot of us felt it and were ready when Larry fired the first shot. Friends and acquaintances where dying left and right, and you did not know what to do, but you just knew you had to do something. In times of crises, artists have historically asked themselves, "What can I do?" Sometimes they have found answers. I had made the *PORK* poster for the street in early 1987 out of revulsion over Robert Bork's nomination to the Supreme Court. Weirdly, it has a tiny commemoration on it to Nathan Fain, a friend who had died of AIDS. It was an inappropriate place for such a memorial because anyone who knew Nathan knew that he didn't give a shit about such pedestrian politics. He was an editor at *After Dark* and cared deeply about specific politics, gay politics. I couldn't quite corral my own swirling emotions into the large

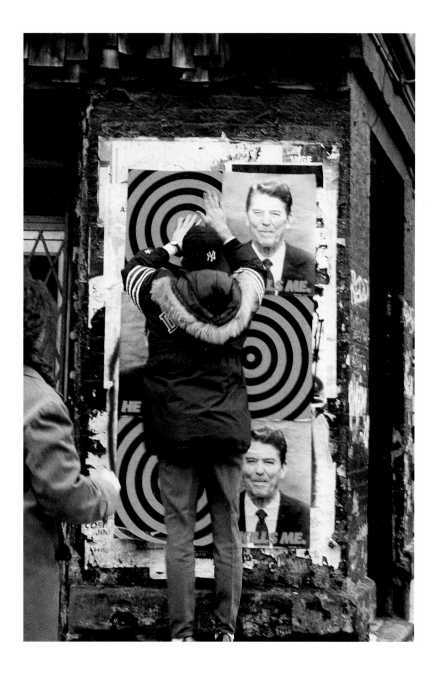

Outdoor installation of *He Kills Me* posters, New York, 1987. Courtesy the artist and Bureau, NY.

Pork, 1987; offset lithograph; 24 x 36 inches. Courtesy the artist.

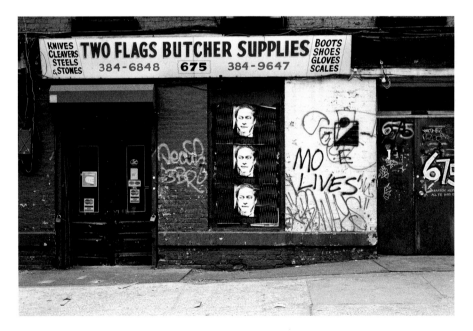

Outdoor installation of *Pork* posters, New York. Courtesy the artist.

message, but it was punching through in six-point type as a misplaced subtext on the bottom of that poster. At the same time, Bob Earing—a wonderful friend and lover and talented young producer for PBS/Channel 13—was dying at my house. So although Bork was a worthy target, he was small potatoes compared to the enormity of my grief and despair and anger. Many of us needed a suitable target for our anger (and our talents), and that inescapably soon became the government and those who ran it.

As I write this, I am reminded that my story of personal tragedy is *so* not unique. This same basic narrative was replicated countless times across the city and in San Francisco and elsewhere (first in the hundreds, then in the thousands). But to offer one eerie anecdote about how it was then: When Bob needed too much help to live alone, he moved in with me and my near-sainted roommate, Mary Day, one of my oldest friends from Texas. It was a tiny 450-square-foot apartment in an old building in Chelsea that had been all chopped up. The walls between us and our neighbor were paper-thin. This neighbor was a gorgeous model type, not just normal pretty but a Rob Lowe kind of pretty—and mean. He was disturbingly mean, a snob, barely spoke to us, and acted like he thought we were trash. One night we overheard him tell someone on the phone (someone, evidently, he was very close to) that he just found out that he was HIV positive. Then it started: for the rest of the night, the most heartbreaking, uncontrollable wailing and cries of despair you can possibly imagine. It was the end of his life as he had perceived it, and within a few months he was dead. It was devastating—mean or not mean.

But there were many who felt smothered by the onslaught of AIDS. Despair was everywhere and thick. And then there was Larry. He basically asked us, were we all just going to lie down and die or were we going to fight for our lives? ACT UP was the answer to that question, and Gran Fury was an offshoot of ACT UP. Gran Fury was a place where people could go who maybe couldn't or wouldn't participate fully at the ACT UP meetings. Those meetings were intense, full of alpha behavior. As I know you remember, they were messy and democratic and long. Gran Fury wanted to make visual

material, and we knew how, so we did—at times consenting to the scrutiny of the ACT UP membership, and sometimes independently of ACT UP altogether.

I was there at the beginning of Gran Fury, before it was Gran Fury. The first meeting to discuss the New Museum offer was at Keenen/Riley Architects' offices and included maybe twenty people. Terry Riley had volunteered the space. Terry was an avid participant in the early work of Gran Fury. (Terry went on to become the director of the Architecture and Design Department at the Museum of Modern Art for fourteen years and oversaw the design and completion of the Taniguchi addition to MoMA.) This meeting started what would become the *Let the Record Show* installation in the New Museum window on Broadway (when the New Museum was on Broadway). This was also the start of what would become Gran Fury, although we didn't know it at the time. When the New Museum piece was completed, a group of about ten or twelve people decided that we had to continue. This group settled into what was soon to be named Gran Fury. It was John Lindell's brilliant idea to name the collective after the NYC police detectives' car of choice—an unstylish Plymouth with its subtle striving for continentalism through its affected spelling. And not only that, our fury *was* grand. It was big, and we liked that out front in the name.

Douglas, this leads me to ask you to describe how you knew when you had to so radically shift gears and dedicate yourself to the work you did around the AIDS crisis—with all of its downside. Can you shed some light on that here?

DC: It's another story of repression—for a dangerously long time. I was on my way to Fire Island that fateful Fourth of July weekend when I read the *New York Times* story about "gay cancer" (their version of the story that had been broken by the Centers for Disease Control's *Morbidity and Mortality Weekly Report* about Kaposi's sarcoma and pneumocystis pneumonia in gay men). I remember a piece the following week in the *Village Voice* that said the *Times* had published the story deliberately to ruin gay men's holiday weekend, which was my feeling too.

A homosexual disease?—clearly impossible, since homosexuality is a cultural construct; thus also the absurdity of GRIDS, a "gay-related" disease syndrome. The sense that the whole thing was a plot to make gay men stop having sex, or having "too much sex" (however much that might be), was my way of repressing or at least compartmentalizing my fear. Of course, I avidly and worriedly followed all the debates that raged in the *New York Native* (whose paranoid editorial policy made dismissing the whole thing easier, even if the saner voice of Larry Mass was also published in that newspaper). I was skeptical of Larry Kramer, whose "x number and counting" pieces were published in the *Native*. I was put off by Larry's rhetorical hyperbole, and I'd read his novel *Faggots* and hated its antipromiscuity rant. Although Larry certainly played a significant role in the founding of both the Gay Men's Health Crisis and ACT UP, I am exasperated by the constantly repeated, oversimplified statement that "Larry Kramer founded GMHC and ACT UP." There were other men who helped found GMHC, men who stuck with it as Larry didn't, and more important, it takes many people to start and sustain an activist organization like ACT UP. Larry's speech at the Lesbian and Gay Community Center was indeed the initial impetus, but the political savvy that ACT UP became known for was that of a bunch of seasoned activists, many of them women, and others for whom activism became a quick study because we were in crisis mode.

Before ACT UP, though, in 1985, I went to Berlin for a year of research and tried to forget about AIDS—unsuccessfully. I broke out in a rash one day and, in the process of finding out what it was, was given an HIV test without my consent or even being informed. (It wasn't even called HIV then; it was HTLV, for human T-cell lymphotropic virus.) When I went to get my test results, the doctor prefaced his remarks by saying, "You know, there's a disease of the immune system . . . " "Of course I know about AIDS," I said, utterly terrified. "No," he replied, "your HTLV test was negative, but it looks like you have lupus." Further clinical testing proved that to be wrong, and a special dermatology clinic I went to never could figure out what was causing my rash.

Back in New York, my friend Hector Caicedo had been diagnosed and was getting sick. Another friend, René Santos, had died even before I went to Berlin. It was late in the game, but I started having safe sex. And I starting thinking I should publish something about AIDS in *October*. Initially I solicited two or three articles. I asked Martha Gever to write about Stuart Marshall's early video about AIDS, *Bright Eyes*, and Leo Bersani to review Simon Watney's book *Policing Desire: Pornography, AIDS, and the Media* (that became his famous essay "Is the Rectum a Grave?"). I thought maybe I'd write something too, so I set about learning as much as I could. I saw the pilot video for *Testing the Limits* at a gallery and, impressed, contacted Gregg Bordowitz, a member of the Testing the Limits Collective. Gregg told me, "If you want to learn about AIDS, go to the ACT UP meetings." I took his excellent advice. It must have been around the same time you began going, in the summer of 1987, a couple of months after the first demonstration on Wall Street in March, and I rarely missed a meeting or demonstration for the next four years. The several articles turned into a double-size special issue of *October*, which was rereleased as the book *AIDS: Cultural Analysis / Cultural Activism*.

Like you and many other members of Gran Fury, I wasn't a vocal contributor to meetings, and I never joined a committee. I figured what I could best contribute would be writing, lecturing, and eventually even teaching courses on AIDS and queer politics, and that's pretty much what I did between 1987 and 1995. I began to feel my way back into thinking and writing about art in the late 1990s, but a decade of work on AIDS, queer theory, and cultural studies changed my intellectual approach irrevocably.

Funny, I don't remember the street-corner handoff of your *He Kills Me* poster. Probably what you thought was a skeptical look on my part was just my shyness. You might not believe me, but I was intimidated by the men in ACT UP. You all made me feel old and a bit out of it. Anyway, that poster might very well have been the genesis of what I think was my most important contribution to ACT UP, my book *AIDS Demo Graphics* (1990), a history of ACT UP New York's

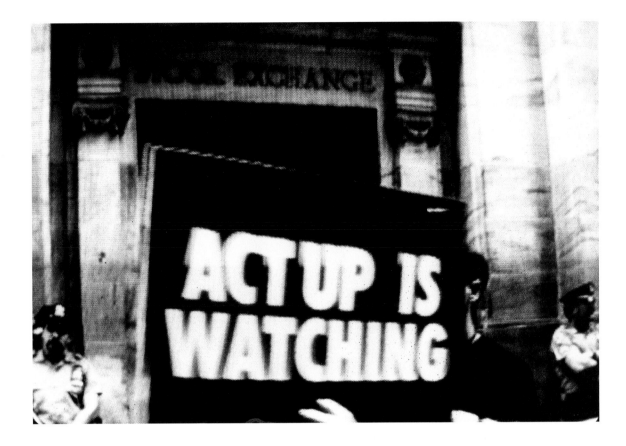

ACT UP, *Wall Street*, 1987; video still. Courtesy the artist.

Donald Moffett and Marlene McCarty of Bureau. From the *I.D. Forty
International Design Magazine*, January–February 1993.

first two and a half years told through the incredibly
inventive activist graphic production of the group.

Did you put your career as an artist on hold dur-
ing your ACT UP days the way I did my career as
an art critic? Or maybe I should put that differently:
Did you channel your art interests entirely into AIDS
activist work in those years, or did you continue to
make other work too?

DM: Somehow making art continued through the
whole thing. Not only that, but Marlene McCarty
(also a founding member of Gran Fury) and I founded
Bureau, a design company, in 1989 to support our-
selves and our art practices, and in the process we
supplied the studio for much of Gran Fury's produc-
tion. Also, between 1989 and 1992 I was doing
weekly spot illustrations for the Age of AIDS column
edited by Richard Goldstein in the *Village Voice*.
Looking back on it, my ability to do all of these things
must have been the result of my relative youth. In
1989 I was thirty-four and evidently robust. As I've

reviewed the work for the survey, I've found that
1990 and 1991 were incredibly productive years for
me. I made a lot of art, some of which is in the sur-
vey. Marlene and I would stop work (but not talking)
at 4:30 p.m. and start drinking vodka martinis. By
this time we were sharing space with Keenen / Riley
Architects, and sometime after breaking out the
vodka, several of us from each of the studios would
head for Quatorze, a bistro on Fourteenth Street
with a great bartender. Somehow all the drinking did
not slow down our productivity, and it definitely lubri-
cated an ongoing conversation about art, architec-
ture, AIDS, and politics. But not to overromanticize
this soused period: it all came to a grinding halt a
few years later.

My artwork during this time paralleled the con-
cerns of Gran Fury and ACT UP but used the more
recognizable forms of art—even as you were articu-
lating an expanded field for art that included the
practices of Gran Fury and so many others. Or do I
have it wrong? Was your intent not necessarily to

redraw the boundaries, even though that is surely what happened? I know definitely that this could never have been your primary intent, which was rightly the crisis and telling or writing what you saw and knew and learned.

Also, it seems necessary to mention—although we don't have to—your stunning renunciation/repudiation of art at various times and in various ways. My personal experience (which rocked my world) was another event that I doubt you'll remember (unless you recall seeing my jaw hit the floorboard of the car). We were driving back from a demonstration in D.C. There was a car full of us, but I think I was driving, and you were in the passenger seat. Everyone was exhausted from the day, and you and I were talking quietly up front. I confided in you that I was considering going back to school to get an MFA. I asked your opinion on art schools, and you said bluntly, "Don't ask me, I hate art." I never went back to school and wonder if your comment went into the pro or con category as I reached that decision.

But to get back to your question, it actually played out weirdly and unexpectedly. I made a lot of art during the heady days of Gran Fury and ACT UP, but when ACT UP began to lose focus and purpose, things started slowly to crumble. Gran Fury was taking a huge toll on all of us. And by 1993 we were

fitfully trying to call it a day. We felt like we could no longer keep up with the crisis as we recognized that the catastrophe was global. Oddly—or maybe not—my art career and art making sputtered at nearly the same time, as I drank more, produced less, and dropped or flubbed opportunities. Exhausted, I retired to the quiet of my studio to repair and refuel (without the vodka) and restart, even to reinvent my work. It took some years, but I emerged again in 1996. I did a show of small, seemingly abstract paintings at Jay Gorney Modern Art. I retroactively titled the show *A Report on Painting*—modest and grandiose at the same time. I now say that I've had two careers: the one before 1993 and the one after 1996. The second one luckily continues.

You're such a hard-ass about Larry, and of course you're right. But from another angle, Larry's artistic achievement, in addition to his activist contributions (no matter how mythologized), will always be central to me. Going all the way back to Ken Russell's *Women in Love* (1969) with a screenplay by Larry, the scene of Oliver Reed and Alan Bates wrestling nude on the bearskin rug in front of the fire will forever reverberate in my mind. Every few years I get fixated on it, and not too long ago I thought I knew what to do with this attachment. (First I had to invent the paintings with projected video.) I wanted to make a

Donald Moffett, *What Now, My Love?*, illustration for *Village Voice*, July 7, 1992.

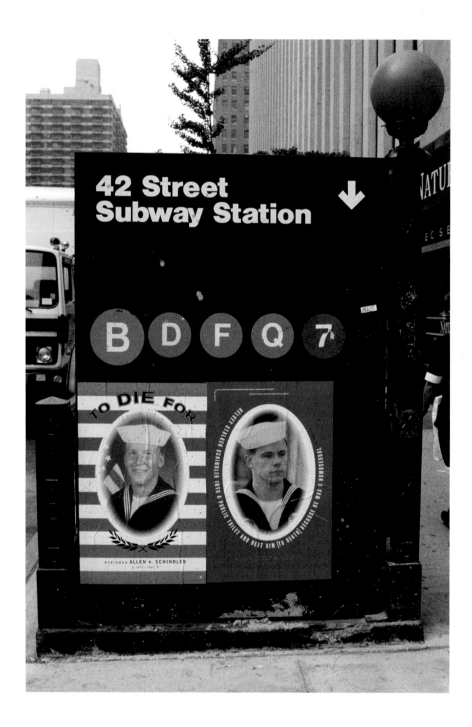

Bureau, *In Honor of Allen R. Schindler,* 1993; offset lithograph. Outdoor installation, New York.

series of paintings with light loops that incorporated all of the outtakes from the shooting of the wrestling scene. I called Larry to ask about them. He said it was so long ago that it would be impossible to find them, if they were even kept, and the studio had changed hands so many times in between that I could forget about it. He welcomed my use of the footage that is part of the film, but I haven't been able to make sense of the paintings in the same way that I had imagined. The project has hit a dead end again, but I'm sure I'll continue working on it way back in a part of my brain that is usually hidden from me.

DC: I guess there was a moment when I did say, "I hate art"—so many people remind me that that was my position. It was stupid of me to say it, and it was never true. I think what I was expressing was antagonism to the art *world* at a time when I felt there was no longer a place in it for me. When I was pushed out of *October*, it was like being kicked out of the club that had provided me with an art-world identity. I was deeply traumatized and very angry, and for a while the only safe places for me seemed to be ACT UP and the developing field of queer theory. I guess I let my anger do to me what Larry Kramer's did to him: I became hyperbolic. Maybe I was also responding to the fact that I'd been called "an art-hating Stalinist" by Dennis Cooper for my polemical demand, in the *October* AIDS issue, for activism in art's response to AIDS. So I took on the moniker I was given.

I remember your work with Marlene in Bureau, of course. You two not only did some wonderful book and poster designs but also made important activist work. Your dual poster in response to the gays-in-the-military debates and the gay-bashing murder of a young sailor, *In Honor of Allen R. Schindler* (1993), was crucial for my analysis of those debates in my essay "Don't Tell." You and Marlene made that work for *The 42nd Street Art Project*, and it was censored, wasn't it? Can you remind me of what happened? And you also made an earlier series called Gays in the Military (1990). That body of work precedes Clinton's presidency and the debates that resulted in the "don't ask, don't tell" policy. How did you come to make it?

DM: Yes, Bureau was thrown out of *The 42nd Street Art Project*, which was funded by the 42nd Street Development Project, Inc., and the City's Economic Development Corporation. We had settled on the *In Honor of Allen R. Schindler* diptych because the Times Square Armed Forces Recruiting Station was right there, and we wanted to honor Schindler, who was in the navy and had recently been killed by a shipmate for being gay. The corporate interests funding the event didn't want to have anything to do with this. We made the posters anyway and wheat-pasted them all over Times Square the night before the opening. The next day, we rented a hideous white stretch limo for the art collective Bernadette Corporation, who dressed up like prostitutes and handed out the posters at the press preview. The corporate interests didn't like that either.

You are right about the early 1990s timeline. I made three sets of altered prints called Gays in the Military, and they all preceded the hateful and discriminatory policy referred to as "don't ask, don't tell." The oppression of gay people in the military was fierce before that change in the law and a motivating issue for me long before it was passed. Before that sick compromise was written into law, the Uniform Code of Military Justice was the weapon of choice to target, criminalize, and dishonorably discharge gays and lesbians from the armed forces. My works involved discreetly embedding abject subtexts into historical portrait prints. The texts are all extreme distortions and absurd yet spring from the fears and vivid imagination of the accusers, the oppressors, those who write the rules for the military and the laws of the state. The last set is a suite of four prints called Nom de Guerre. Along with some other work, I showed them at the much-maligned 1993 Whitney Biennial curated by Elisabeth Sussman, Thelma Golden, Lisa Phillips, and John G. Hanhardt. In all the brouhaha that the biennial generated, my nasty prints quietly survived under the radar, although someone smeared chocolate from Janine Antoni's nearby *Chocolate Gnaw* sculpture all over another one of my works. This shitty little act of vandalism perfectly amplified my point about people's vivid and oftentimes ugly imaginations about gays and lesbians—whether conscious or not.

Bureau was an unexpected and somewhat irritating success—even with Marlene and me both trying to keep it under control (and at arm's length) so we could have time and energy for our own individual artwork and Gran Fury. However, it was also phenomenally rewarding. We had great opportunities to do socially engaged work, and when it was strictly commercial, we would still push it in that direction as far as possible. The driving philosophy of the studio was to do the work that larger studios normally might have done pro bono, but we wanted to get paid for it, and paid well. We did this so we could then give the client and the issue(s) our full attention. It hardened the relationships with the clients. They could make demands, and we had to perform on schedule, without apologies, delays, or excuses. Both sides won. We got to work full-time on issues that we regarded as essential. The client got a powerhouse studio that jumped when they said jump. We worked for the United Nations, Doctors Without Borders, GMHC, the American Civil Liberties Union, Princeton's School of Architecture, the Andy Warhol Foundation, and the Open Society, among many others. We worked with very talented designers at Bureau, including Mats Hakansson, Conny Purtill, Mike Mills, Claudia Brandenburg, Connie Koch, Andy Capelli, and Keira Alexandra. They've all gone on to have great careers in graphics, television, and/or film. Sheila de Bretteville recruited Marlene and me for several years to teach a graduate lab at Yale about our methods and practices for social engagement within the framework of a commercial design studio. With producers Christine Vachon and James Schamus's encouragement, we created a niche within the independent film world and reinvigorated the art of title design. We worked on some wonderful films of the period, including Tom Kalin's *Swoon*, Todd Haynes's *Safe* and *Velvet Goldmine*, Cindy Sherman's *Office Killer*, and Ang Lee's *Ice Storm*. After Bureau closed up shop at the end of 2001, Marlene continued, and still continues very selectively, to do film titles for some directors, including Todd and Tom. I just checked today, and our website at vbureau.com (*v* for virtual) still lives on the Internet even though we more or less abandoned it in 2002. I don't think Marlene or I have ever gone to the

e-mail contact site, so no telling how many people we've pissed off by never responding to any question or contact. All in all, I wouldn't have missed any of it for the world, but it was a big, muscular beast that, at the time, felt like it was eating us alive.

DC: I can't resist just one final remark on "don't ask, don't tell" now that it's been officially overturned: I'm one of many men (only men were drafted) who *used* the military's discriminatory policy against homosexuals (that's what we were called then) to escape the draft during the war in Vietnam. It was a very official (it required a letter from a psychiatrist) and, at the time, very dangerous way of coming out, but it was a lot less dangerous than fighting in Vietnam. To this day I'm thankful that I had that escape route. That, together with my pacifism, makes me extremely ambivalent about this "gain" in human rights.

I'd like to hear about the exhibition at Jay Gorney Modern Art in 1996. What works did you show, and why did you call it *A Report on Painting*?

DM: I'm truly glad the exemption worked in your favor during that terrible war, but coming from a military town, as San Antonio was often referred to, I am very sympathetic to those gays and lesbians who operate with another worldview that doesn't preclude military service. To me, this repeal is as significant as allowing women to serve and Truman's 1948 executive order ending racial segregation in the armed forces. Andrew Sullivan recently commented on a TV talk show that the gays and lesbians in the military are the most conservative of all. He said that when the U.K. lifted the ban on homosexuals in the military none of them came out. I'm sure he was exaggerating, but I was reminded that the people this repeal protects probably aren't much like you or me. But then again, I really don't know.

Even though a very abrupt transition, let me respond to your question about the show at Jay's. I showed six paintings, all small, all monochromatic, and all with dense, deep surfaces of extruded oil paint. The titling of the paintings was still unresolved and more complicated than the naming system I would adopt shortly thereafter. For this show, each

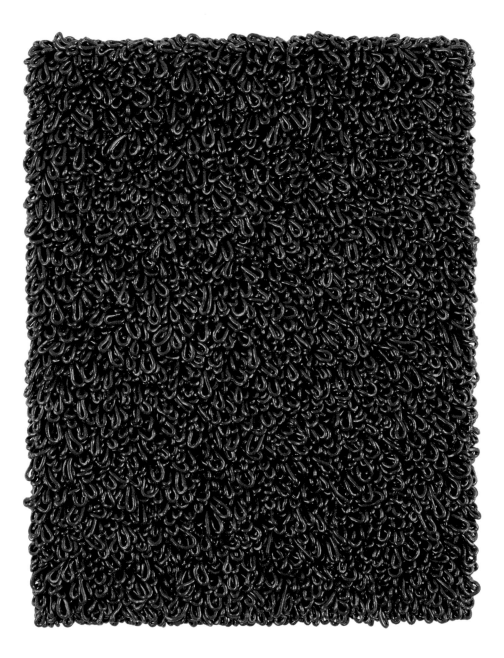

Lot 041495 (Blood Loop), 1995; oil on linen; 14¼ x 11⅜ inches. Courtesy the artist.

painting was given a category title followed by a lot number. The category title is what eventually fell away. There was a batch of "Surrender" paintings (all white), "Blood Loop" paintings (almost all alizarin crimson), and a few called "Osteolacrima"—a word I first found in a dream. It is not a word at all but, when pieced together from Latin, means something like "bone tears." It fit, but it was also limiting and probably pretentious (but I hate to be too judgmental toward my own unconscious for fear of offending it). So the category thing drifted away except for the lot numbers, which persist right on through to the work I'm doing today. The word *lot* has dozens of definitions, and most if not all of them work for me. The six numbers following are simply the date in numerical form without punctuation, which corresponds to my ongoing sketchbooks that hold all the details and production notes on the paintings in chronological order. The sketchbooks are also scrapbooks where I stuff the little pieces of paper and texts that I endlessly collect from all sources if they say anything to me about what I'm doing (or think I'm doing) in the studio.

As for the title of the show, *A Report on Painting*, it came after the fact. Sometimes I can't pinpoint the name of a show until it is over or at least until I've had a chance to look at the show once it's up. I did the same thing with *Paintings from a Hole* (a 2004 show I made for Anthony Meier Fine Arts in San Francisco)—which is exactly the title the show should have had before it opened, but I just didn't know it. I didn't think of it until afterward. After looking at this show in Jay's very small project room with six small paintings, it somehow felt less like an exhibition than a report. The show was an honest and modest reporting of what I'd been intently studying in my studio. I had been making paint stand up rather than lay down, asking (or rather forcing) it to do something unnatural. But also I was tossing my lot in with a nonfigurative minority—or so it felt. I had not softened on meaning or content, but I wanted to try another language for getting there. Not too long ago, I saw a group of huge gray paintings by Ellsworth Kelly at the Matthew Marks Gallery. I was told that they were made in the 1970s and that he considered them his antiwar paintings. They were defi-

nitely within the imaginary field of battleship gray and gunmetal gray. This work made total sense to me and rang true in every way. I believed them. And I thought they were a valid protest, a somewhat subversive form of protest.

Only in revisiting the title *A Report on Painting* now does it sound grandiose. Of course, I didn't mean *all* painting (which is what it sounds like), just mine. But you've got to give me credit that *A Report on Painting* is a lot better than *A Report on My Painting*.

DC: It doesn't seem grandiose to me anyway, especially not in the context of modestly scaled works shown in a project room. I have many questions about this moment. Giving a title to a group of paintings that make up a show suggests that you decided consciously to work in series, which has been the case since that moment—even earlier, actually, since the Gays in the Military works are a series too. And then the monochrome, which has a very complex history in modernism, one that is read through a very particular political lens—I'm thinking especially of Benjamin Buchloh's understanding of the monochrome as the negation of painting. His heroes (and needless to say they're heroes, not heroines) are Rodchenko, Richter, Palermo, perhaps early Kelly. I don't think I know the gray Kellys you mention, but it's fascinating that he thought of them as antiwar paintings. I'm sure you know that Kelly worked in a camouflage battalion during World War II. I heard him interviewed about it on National Public Radio in 2007. He didn't design camouflage colors and patterns though; he built inflatable-rubber fake armored vehicles to deceive the enemy about Allied troop movements. But this returns me to what I said clumsily before about "sissifying" Minimalism and then corrected to "queering" or "adding implicit or explicit content to." Kelly's battleship gray is referential if very elliptical (and not very queer). But getting paint to stand up when it wants to lie down—"something unnatural," as you put it—that's damned queer, and hilarious. But back to the issue of the monochrome that you introduced into your work with *A Report on Painting*: formally, texturally, your work makes me think more of postwar European examples than American ones—Klein, Manzoni, and Fontana more

than Reinhardt, Kelly, Ryman, or even Warhol's "blanks." The Blue (NY) photographs you did a year after *A Report on Painting*: Was Klein on your mind? Or was it Derek Jarman? Both?

DM: On Kawara, actually, because I think good art is subject to and contingent upon an understanding of the social and political histories in which it is made. Having abandoned the universalists' prescriptive that timelessness was essential to a great work of art, Kawara names a specific day, a specific date, as the core tangible (along with color, font, and scale but to a lesser degree) in his paintings. The strategy tosses it back to the viewer to do the work (or pleasure) of contextualization. The viewer has a personal understanding of the date, but the recollection will probably be of a social or political or more generally historical tenor—a mush or a hash of the three. Kawara often goes further, with the daily newspaper component standing alongside or behind the painting, which is assigned the heavy lifting of specific recall if necessary.

In like manner, there is the fascinating project by Richter that Buchloh had a hand in called *Eight Gray (Acht Grau)* (2002). These are the enameled mirror pieces commissioned by Deutsche Guggenheim Berlin for the exhibition space on Unter den Linden. Could this series—its placement and underwriting and its engineering—be any more twenty-first-century German? The extreme precision of fabrication and installation, its infinite self-reflective physical nature, and its gray moodiness (although transportable) are all perfectly balanced in support of its time and place. I think of them as northern European landscapes (or lakescapes) on the order of the great nineteenth-century model but genius in their twenty-first-century transposition and personalization of the genre.

Which gets us back to the Blue (NY) photographs. If you accept my premise that place and time—the social and the political—actually position a painting and support or define its terminology, then Blue (NY) is a genuine expression of this. The photographs are about as monochrome as you can get (except for a couple in which some clouds are visible). In his essay on monochromes Rudi Fuchs determines that the sky is the only true monochrome

found in nature, since it does not include texture like the blue of a sea, even at its most calm, or a field of grass with its innumerable hues as light and wind define the individual blades.[3] The sky is just pure light bouncing around (and off of tiny atmospheric particles—although this fact doesn't seem to dissuade Fuchs). Nonetheless, there is an emptiness and beauty and response to the sky that are irrefutable.

The Blue (NY) series came about when a couple of things came together in a particular way. President Bill Clinton was in office after years of disappointment under Reagan and Bush 1. The first antiviral cocktails were working, and HIV-positive people were surviving and thriving. My partner, Robert, and I moved in together as an experiment of sorts when an extraordinary (rent-stabilized and affordable!) penthouse unexpectedly fell into our laps as a two-year sublet. It was in a prewar high-rise on Washington Square in the heart of Greenwich Village and had incomparable views (and balconies) north, south, and west. It had leaded-glass casement windows, so all day, every day, I was seeing framed patches of perfect blue sky. As agnostic as I am, I took it as an omen, an answer, and a real stroke of good luck, and I ran with it.

When Blue (NY) was first shown at Arcadia University (formerly Beaver College), the director of the gallery, Richard Torchia (also an artist), arranged to show Derek Jarman's final feature, *Blue* (1993), after the opening. It was a great addition to the spectrum of considerations and colors that were loaded into the gallery. It is an essential film, not to be missed, and yes, I thought about it all through the making of Blue (NY) and have ever since.

DC: So Blue (NY) is like the Irving Berlin song "Blue Skies": "Skies were gray but they're not gray anymore." They do have that quality. The blue of a blue sky is an especially cheerful blue. But could we return, for the moment, to the monochromes of *A Report on Painting*, because I'd like to hear about your use of extruded paint, about how you arrived at such a perverse application of paint (it's what led me to ask about Manzoni as a possible reference). Together with your complex and suggestive use of holes in the canvas, and your digital projections on

paintings, extruded paint is one of the most distinctive features of your work.

DM: If you think you can scare me by quoting lyrics from the great American songbook after I've referenced Kawara, Buchloh, and Richter, you can't. Try Ella Fitzgerald's 1957 scat-filled version of "Blue Skies," and you'll find more than just blue sky—something more about the wordlessness and boundlessness of nature itself.

As for the extruded paint, I squirt. More precisely, I mostly milk paint through any kind of thing that will form and control the paint as I attempt to make it stand and present itself as 3-D instead of trying to represent in paint the visual effect of 3-D, a traditional use of oil painting. I like your use of *perverse*. It fits. When I was burned out at the end of 1993, I knew I had to catch my breath with a diversion. Never far from some sort of conceptual riddle, I had thought about cycling through the traditional roles that homosexuals have historically been assigned or chosen. I had the thought of going to hairdressing school. Interior design was an idea for about one minute. I'd used up flower arranging early in the 1980s by bluffing my way into a freelance gig setting up a big party at Lincoln Center. I said, sure, I had experience trimming flowers for the table arrangements. I lacerated my thumbs with those deadly little scalpels they use, and the blood on the white tablecloths and lilies ended that effort (badly). But in the end I pursued cake decorating. I went to cake-decorating school. It was fantastic, and I loved it. Very soon after I started, though, I realized that frosting was reminding me of paint. I started moonlighting in my studio with some of the same tools and experimenting with different paints. The process was invigorating.

When I first started showing the paintings that came out of this experimentation a few years later, I used to tell this story, but I found that people tended to cut off their consideration of anything more about the paintings at that point. It was like they thought, "Oh, I get what tool was used to make this, and that's as far as I need to go." I stopped telling the story because I thought it was little more illuminating than knowing what brush a painter used in making a painting. Maybe I was fooling myself. But you

ask so directly that I thought I'd tell the story once again. I hope I don't regret it.

DC: I don't see why knowing your technique should stop anyone thinking further about your paintings any more than knowing that Jasper Johns uses encaustic or Andy Warhol uses piss stops us from thinking more about those artists' works. And cake-decorating school—it really *is* fantastic. How many artists have that in their educational background? But since you've been able to make so much of the technique, to make such a variety of surface factures, and since you've subsequently invented other new ways to remake paintings' surfaces—sewing zippers on them, projecting digital images onto them—it's hard to imagine anyone getting stuck on your cake-decorating stint. The first series of paintings with projections that I saw were those in *The Extravagant Vein*, and I was completely knocked out by them. I remember walking into the gallery and, not seeing any movement at first, thinking that you'd turned to landscape painting. I suppose you could say those works *are* landscape paintings—the landscape being the Ramble in Central Park, which among other things is a gay cruising area—but of course the landscape image is shot on video and projected onto the mottled gold surface of the painting/screen. I know the first series you made of these projection paintings was related to What Barbara Jordan Wore. What led you to them?

DM: I'm glad you said it: "painting/screen." No one who has discussed any of the four projection projects I've done has put it together that simply or with more graphic perfection. I projected video onto the surface of a painting to push it in the direction of a screen—the most ubiquitous, active, two-dimensional surface of our daily lives. Additionally, I wanted to complicate the potential of a painting by bringing my own light source. The light source I brought was in the form of a projected video. It destabilized what is oftentimes fretted over and fetishized in the gallery: the control and color of light. My light was busy, uncontrollable (in any traditional sense), and colorful (in what generally would be considered the most unwelcome way).

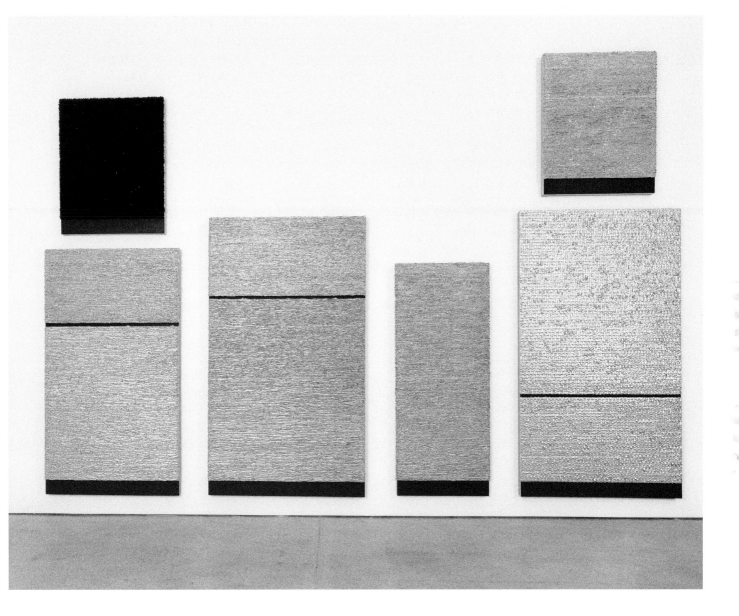

Hippie Shit, 2005, installation view, Marianne Boesky Gallery, New York.

It was the red dress that Barbara Jordan wore at the Watergate impeachment proceedings that led me there. I've watched the tape of her speech a hundred times. One time it occurred to me to project this historically significant moment onto a painting and be done with it. I have a little stick drawing of when it occurred to me at Jordan's archives housed at Texas Southern University in Houston (her undergraduate alma mater).

At the time, I was working on a show called *What Barbara Jordan Wore* for the Texas Gallery in 2001. The components of the show, along with the title, had come to me instantly and clearly (a vision, one could say if one were the witchy type—an event that had never happened to me before and hasn't since): three paintings (traditionally lit) and three photographs. In the middle of making this show, Elizabeth Smith, then the chief curator at the Museum of Contemporary Art in Chicago, asked me to do a project there, and I immediately started working on what I thought would be *What Barbara Jordan Wore (Part 2)*. That's how the Texas Gallery show got "(Part 1)" attached to its title. It was at the MCA with Elizabeth's encouragement that the projection pieces were first realized. In the end, with the new paintings, the form of the MCA show was so radically different from part 1 that we settled simply on *What Barbara Jordan Wore*.

DC: Apart from the invention of the video-on-painting technique, *What Barbara Jordan Wore*, in comprising an ensemble of elements, is a good example of the many strategies you've used to complicate mono-chrome painting. Already in 1999 you included carpet monochromes on the floor of the gallery where you showed *The Ten Commandments* in Los Angeles, and the following year, for *The Incremental Commandments* in London, you created a complex installation that included chairs placed in front of the paintings and a sound track. I didn't see those two shows, but when I saw *Hippie Shit* at Marianne Boesky Gallery in 2005, the cramped space, the paintings hung close together and low to the ground, the nerve-jangling music, and the harsh fluorescent lighting completely disoriented me. It was something of an assault on painting itself, and at the same time it made the paintings literally reverberate. I found it both excruciating and exhilarating—certainly unlike any painting show I'd ever seen.

DM: Hold up there. I beg to differ with that "nerve-jangling music" part. Those were three accomplished harmonica players doing "What's Going On," immortalized by Marvin Gaye; "(What's So Funny 'Bout) Peace, Love and Understanding," written by Nick Lowe; and "For What It's Worth," made famous by Buffalo Springfield. We recorded them at Saint John the Divine for its divine acoustics. Your sensors were confusing the brain-numbing, retina-destroying flicker of the fluorescents with those sweet, soulful renditions of three of our great antiwar anthems. At the time of *Hippie Shit*, the U.S. was at war in Iraq, and Bush 2 had asked us to go shopping. Now that's what I call nerve-jangling.

However, your point is plenty accurate: I complicate painting.

Notes

1. "A Conversation between Philipp Kaiser and Douglas Crimp," in *Painting on the Move*, ed. Bernhard Mendes Bürgi and Peter Pakesch (Basel: Schwabe, 2002), 178.

2. Yvonne Rainer, *Feelings Are Facts: A Life* (Cambridge, Mass.: MIT Press, 2006), 391.

3. Rudi Fuchs, "Monochrome," trans. Beth O'Brien, photocopy of article in the artist's archives.

Works on Paper

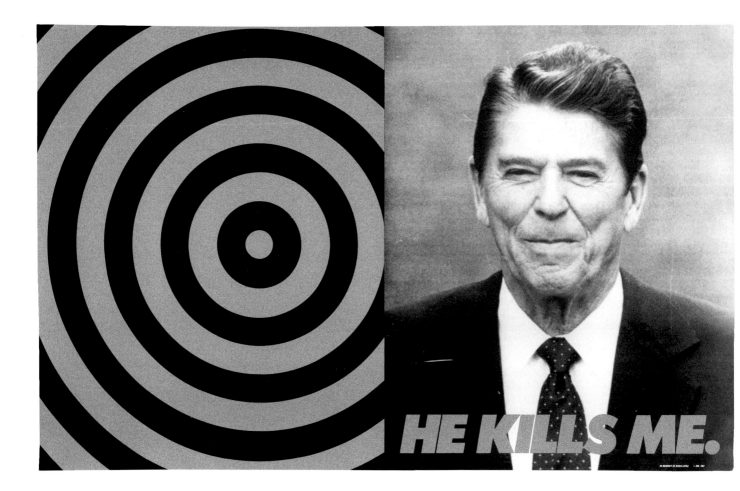

He Kills Me

He Kills Me, 1987; offset lithograph;
23½ x 37½ inches. Courtesy the artist.

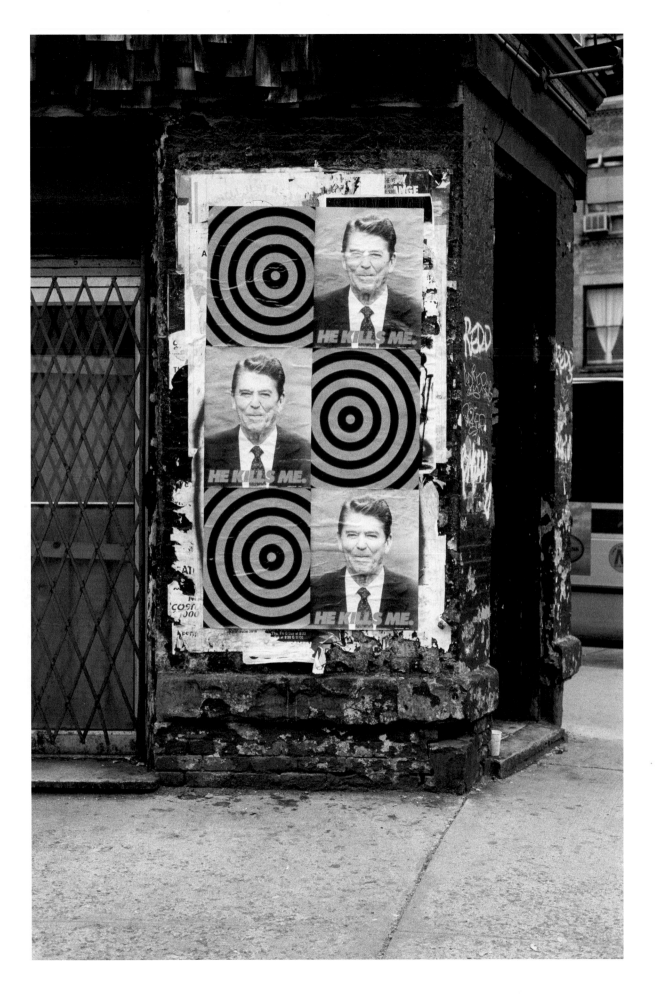

Gays in the Military

Gays in the Military III, 1990; ink and transfer type on paper, artist's wood frame; 13½ x 11 inches framed. Collection Scott Watson, Vancouver.

U. S. Grant

Eng'd by E.R.Hall & Sons, New York.

BRILLIANT WAR STRATEGIST, FIERCE BOTTOM

Presented by
Comrade Amos N. Van Norn.

Gays in the Military II, 1990; ink and transfer type on paper, artist's wood frame;
13½ x 11 inches framed. Collection Scott Watson, Vancouver.

HERO, SURE SHOT, REALLY THICK

Gays in the Military I, 1990; ink and transfer type on paper, artist's wood frame;
13½ x 11 inches framed. Collection Scott Watson, Vancouver.

COMMENDATION FOR VALOR, REVERED COCKSUCKER, TITMASTER

Gays in the Military IV, 1990; ink and transfer type on paper, artist's wood frame;
13½ x 11 inches framed. Collection Scott Watson, Vancouver.

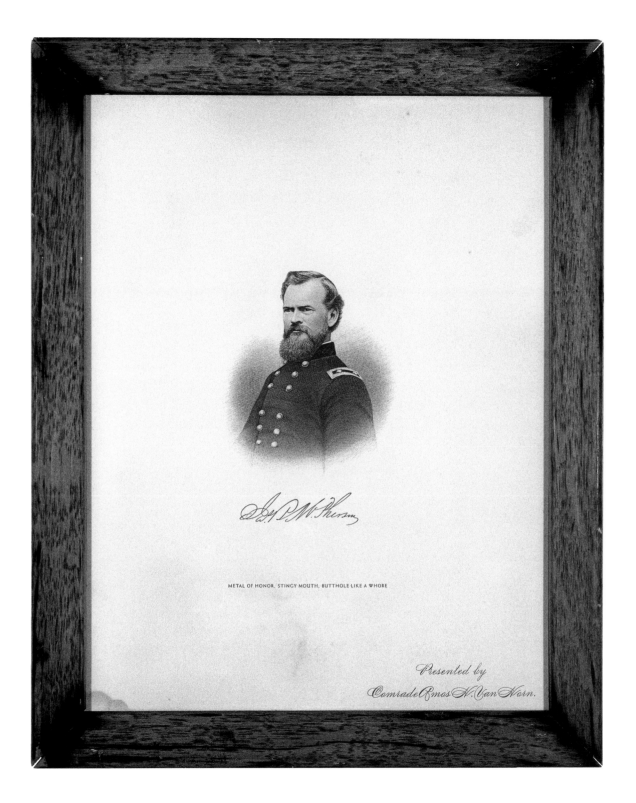

METAL OF HONOR, STINGY MOUTH, BUTTHOLE LIKE A WHORE

Presented by
Comrade Amos H. Van Norn.

Gays in the Military V, 1990; ink and transfer type on paper, artist's wood frame;
13½ x 11 inches framed. Collection Scott Watson, Vancouver.

Nom de Guerre

Nom de Guerre: Trigger, 1991; ink and transfer type on paper, artist's wood frame; 20¾ x 18¼ inches framed. Private collection, Houston.

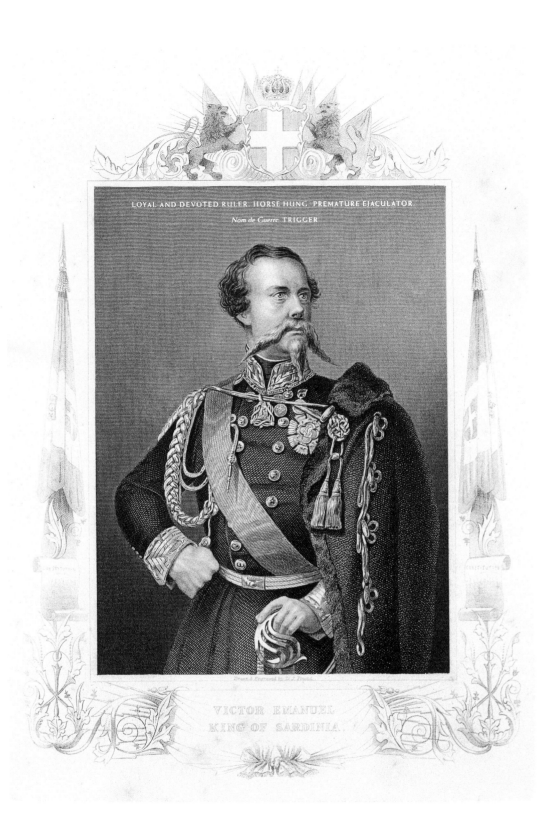

LOYAL AND DEVOTED RULER, HORSE HUNG, PREMATURE EJACULATOR

Nom de Guerre TRIGGER

Drawn & Engraved by D. J. Pound

VICTOR EMANUEL
KING OF SARDINIA.

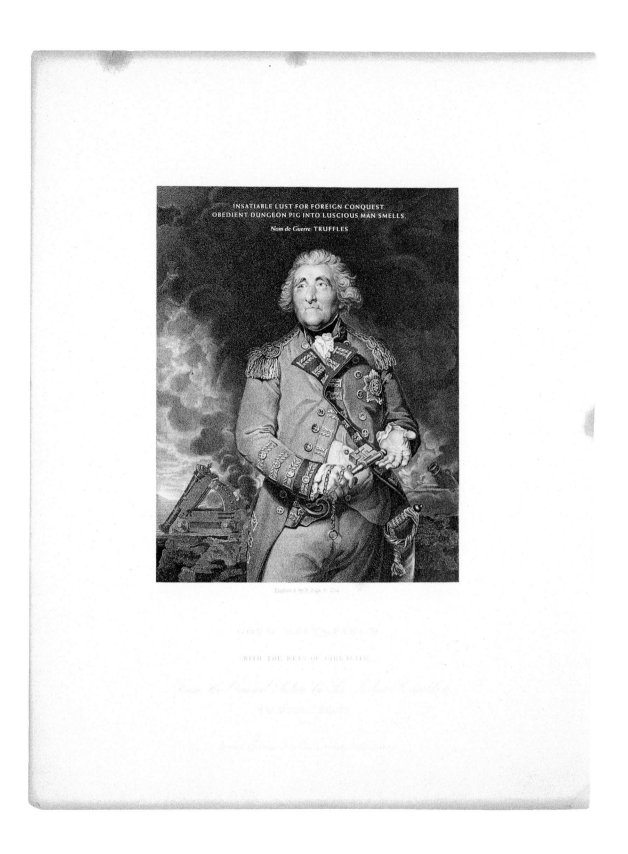

Nom de Guerre: Truffles, 1991; ink and transfer type on paper, artist's wood frame; 20¾ x 18¼ inches framed.
Whitney Museum of American Art, New York, Gift of Emily Leland Todd, 93.50.

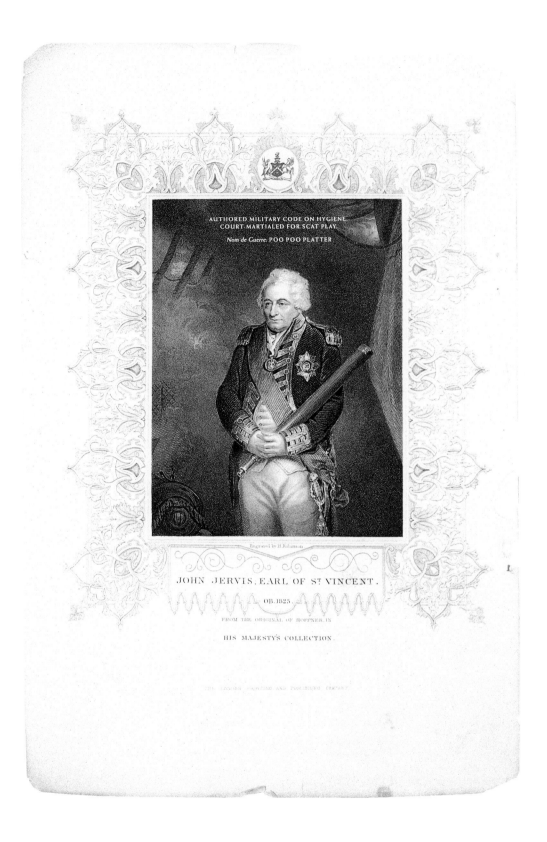

Nom de Guerre: Poo Poo Platter, 1991; ink and transfer type on paper, artist's wood frame; 20¾ x 18¼ inches framed. Jennifer McSweeney, New York.

Nom de Guerre: La Treen, 1991; ink and transfer type on paper, artist's wood frame; 20¾ x 18¼ inches framed. Collection Museum of Fine Arts, Houston, Gift of Michael A. Caddell and Cynthia Chapman.

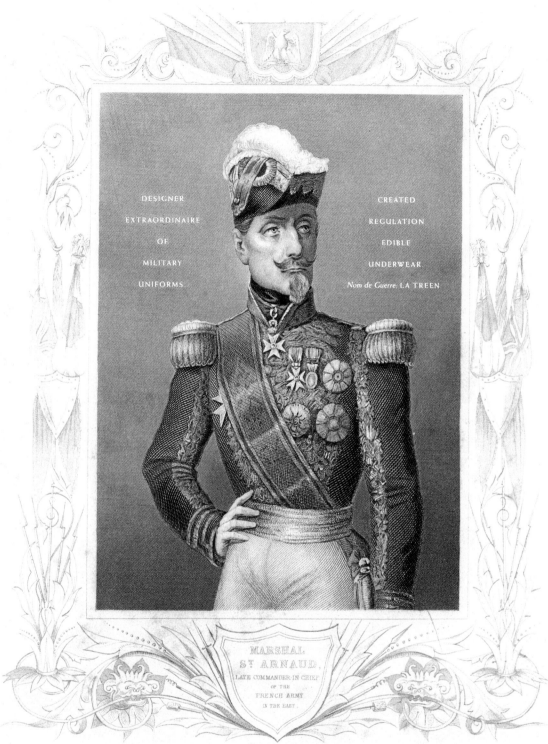

DESIGNER
EXTRAORDINAIRE
OF
MILITARY
UNIFORMS

CREATED
REGULATION
EDIBLE
UNDERWEAR

Nom de Guerre: LA TREEN

MARSHAL
ST ARNAUD,
LATE COMMANDER-IN-CHIEF
OF THE
FRENCH ARMY
IN THE EAST.

Engraved by D.J. Pound

Mr. Gay in the U.S.A.

Mr. Gay in the U.S.A., 2001; graphite on paper, linen tape; 16 drawings, 11 x 17 inches each, 2 drawings, 11 x 8½ inches each. Mickey Cartin/The Cartin Collection, Hartford.

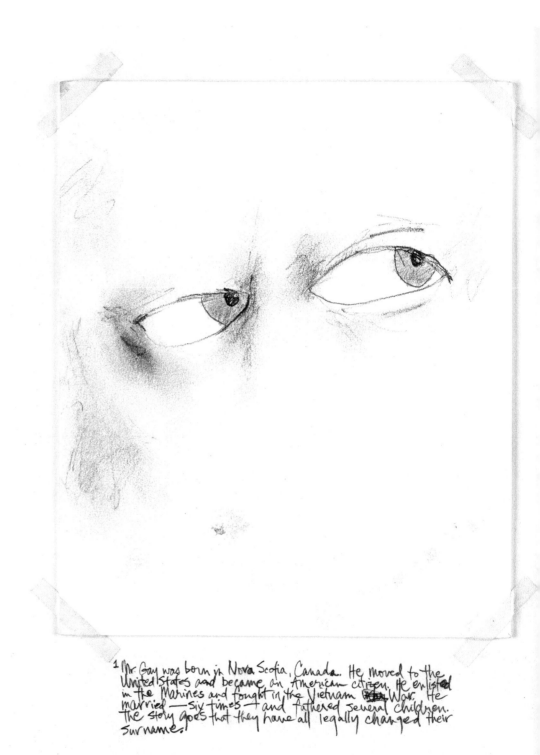

[1] Mr. Gay was born in Nova Scotia, Canada. He moved to the United States and became an American citizen. He enlisted in the Marines and fought in the Vietnam ~~War~~ War. He married — six times — and fathered several children. The story goes that they have all legally changed their surname.

Mr. Gay in the U.S.A.

On Sept 22, 2000, Ronald Gay[1] walked into a gay bar in Roanoke, Virginia for the first time. He drank half a beer and then opened fire on people he had never met. He killed Danny Lee Overstreet and shot 6 others, gravely wounding several of them. He calmly walked out. He was ~~a~~ arrested within minutes and did not resist. He said he was tired of people making fun of him because his name was Gay.

Earlier this year, Ronald Gay plead guilty to all the charges brought against him. And on July 23, 2001, Mr. Gay was sentenced to four life terms to run consecutively. These drawings document aspects ~~#~~ of the sentencing in Courtroom #3, Roanoke City Circuit Court.

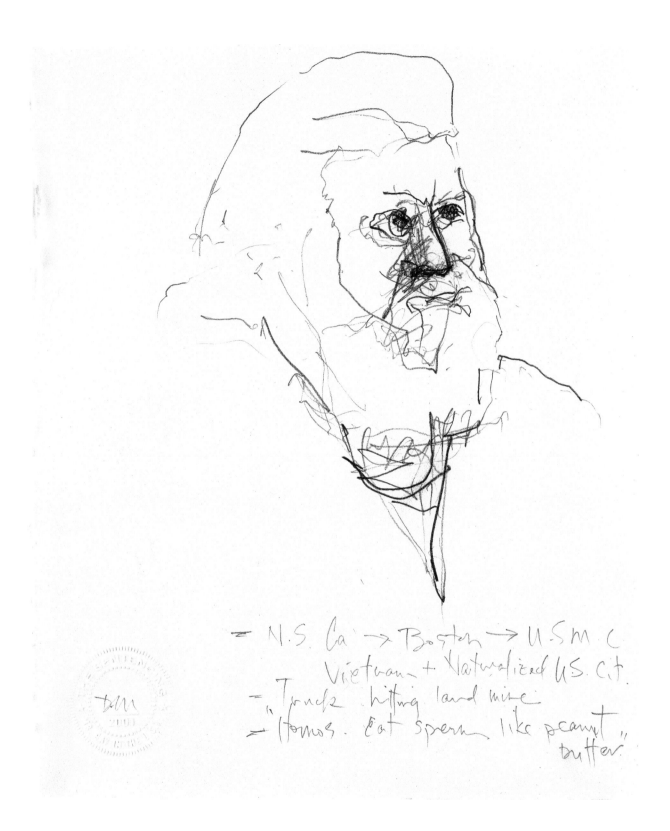

= N.S. Ca → Boston → U.S.M.C
 Vietnam + Naturalized U.S. Cit.
= "Truck hitting land mine"
= "Homos. eat sperm like peanut
 butter"

turquoise + tattoo

4 higher missions

① All Gangs to SF to stop the spread of AIDS
② Stop government encroachment
③ Stop Com
④ Bring Viet out of mountains

Cathy Sue Caldwell

Lady Justice

malic wounding John Collins 5 yr.
Susan Sm 5 yr
Mistake " Linda S Cooper 5yr.
1650. Joel Ivan Tuell 5yr.

suspended
v₇ in lu

murder Danny Lee life
Life I Page for Life
Aggrap. Mal. Wounding. consecutive.
Life John Wesley Collins
Life — Linda Cooper.
Life Cathy Sue Caldwell.
Susan

175-

Chronology

Sarah G. Cassidy

Donald Moffett
Born in San Antonio, Texas, 1955
Lives and works in New York

EDUCATION
Trinity University, BA Art,
 BA Biology

SOLO EXHIBITIONS

2011
Anthony Meier Fine Arts,
 San Francisco

2008
Easy Clean, Marianne Boesky
 Gallery, New York

2007
Gutted, Anthony Meier Fine Arts,
 San Francisco
Mangle Me, Marianne Boesky
 Gallery, project for Foire
 Internationale d'Art
 Contemporain 2007, Paris
Fleisch, Stephen Friedman Gallery,
 London

2006
Impeach, Marianne Boesky Gallery,
 New York

2005
Hippie Shit, Marianne Boesky
 Gallery, New York

2004
Paintings from a Hole, Anthony
 Meier Fine Arts, San Francisco
D.C., Stephen Friedman Gallery,
 London

2003
The Extravagant Vein, Marianne
 Boesky Gallery, New York

2002
*Donald Moffett: What Barbara
 Jordan Wore*, Museum of
 Contemporary Art, Chicago

2001
Mr. Gay in the USA, Anthony Meier
 Fine Arts, San Francisco
What Barbara Jordan Wore (Part I),
 Texas Gallery, Houston

2000
The Incremental Commandments,
 Stephen Friedman Gallery,
 London
The Ten Commandments, Marc
 Foxx, Los Angeles

1997
Blue (NY), Beaver College Art
 Gallery, Glenside, Pennsylvania

1996
A Report on Painting, Jay Gorney
 Modern Art, New York

1991
I Know What Boys Like, Texas
 Gallery, Houston
Wet Dreams, Simon Watson,
 New York
Wet Holes, Wessel + O'Connor
 Gallery, New York

1990
Oh-Oh-Harder-Oh-Oh, Wessel +
 O'Connor Gallery, New York

1989
I Love It When You Call Me Names,
 Wessel + O'Connor Gallery,
 New York

GROUP EXHIBITIONS

2011
Unpainted Paintings, Luxembourg
 Dayan, New York
dwelling, Marianne Boesky Gallery,
 New York

2010
*Mixed Use: Photography and Other
 Practices in Manhattan,1970s to
 the Present*, Museo Nacional
 Centro de Arte Reina Sofía,
 Madrid
*Range: A Collaborative Work from
 1997*, Marianne Boesky Gallery,
 New York
Reflection, Nathan A. Bernstein &
 Co., New York
*Stripped, Tied, and Raw: Jorge
 Eielson, Donald Moffett, David
 Noonan, Steven Parrino,
 Salvatore Scarpitta*, Marianne
 Boesky Gallery, New York

2009
*ACT UP New York: Activism, Art,
 and the AIDS Crisis, 1987–1993*,
 Carpenter Center for the Visual
 Arts, Harvard University,
 Cambridge; White Columns,
 New York
Amerikana, Neue Gesellschaft für
 bildende Kunst, Berlin
*En todas partes: Políticas de la
 diversidad sexual en el arte*,
 Centro Gallego de Arte
 Contemporánea, Santiago de
 Compostela, Spain
Benches and Binoculars, Walker
 Art Center, Minneapolis

2008
The Collection and Then Some,
 Modern Art Museum of Fort
 Worth, Fort Worth, Texas
*Person of the Crowd: The
 Contemporary Art of Flânerie*,
 Neuberger Museum of Art,
 Purchase, New York

2007
Crimes of Omission, Institute of
 Contemporary Art, University of
 Pennsylvania, Philadelphia
Sparkle Then Fade, Tacoma Art
 Museum, Tacoma, Washington

2006

The Last Time They Met, Stephen Friedman Gallery, London

Trifecta, Bellwether Gallery, New York

Das achte Feld: Geschlechter, Leben und Begehren in der Kunst seit 1960 / The Eighth Square: Gender, Life, and Desire in the Arts since 1960, Museum Ludwig, Cologne

2005

Around about Abstraction, Weatherspoon Art Museum, Greensboro, North Carolina

Ten-Year Anniversary Exhibition, Stephen Friedman Gallery, London

ex.05.03.06103, Cartin Collection, Hartford, Connecticut

Beyond Redemption: Gay Erotic Art, Morris and Helen Belkin Art Gallery, University of British Columbia, Vancouver

2004

Seeing Other People, Marianne Boesky Gallery, New York

North Fork/ South Fork: East End Art Now, Part II, Parrish Art Museum, Southampton, New York

Hidden Histories, New Art Gallery Walsall, West Midlands, England

2003

Image Stream, Wexner Center for the Arts, Columbus, Ohio

puddle-wonderful, Artemis Greenberg Van Doren Gallery, New York

Site Specific, Museum of Contemporary Art, Chicago

International Exhibition of Painting and Sculpture, American Academy of Arts and Letters, New York

2002

Life, Death, Love, Hate, Pleasure, Pain: Selected Works from the MCA Collection, Museum of Contemporary Art, Chicago

Interstate, Texas Fine Arts Association, Jones Center for Contemporary Arts, Austin

Penetration, Marianne Boesky Gallery, New York

VAPOR, Marianne Boesky Gallery, New York

Paintings, Marc Foxx, Los Angeles

2001

The Inward Eye: Transcendence in Contemporary Art, Contemporary Arts Museum Houston

Snap! Photography from the Collection, Wadsworth Atheneum, Hartford, Connecticut

Camera Works, Marianne Boesky Gallery, New York

Standfast Dick and Jane, The Project, Dublin

American, Postmasters, New York

2000

"00," Barbara Gladstone Gallery, New York

Dope, American Fine Arts, New York

Drawing, Stephen Friedman Gallery, London

More, Nicole Klagsbrun Gallery, New York

Photography about Photography, Andrew Kreps Gallery, New York

Power Up: Sister Corita and Donald Moffett, Interlocking, Hammer Museum, Los Angeles

The Sea and the Sky, Beaver College Art Gallery, Glenside, Pennsylvania; Royal Hibernian Academy, Dublin

New Work: Abstract Painting, Hosfelt Gallery, San Francisco

1999

Monochrome, Patrick Gallery, New York

Drawings, Nicole Klagsbrun Gallery, New York

Jesse Amado and Donald Moffett, Finesilver Gallery, San Antonio

The Cathedral Project with Liz Deschenes and Kevin Larmon, Cathedral of Saint John the Divine, New York

1998

Sculpture from the Garden, Museum of Fine Arts, Boston

Les mondes du Sida, entre resignation et espoir / AIDS Worlds, between Resignation and Hope, Centre d'Art Contemporain, Geneva

WACK-O: Extreme Politics and the Poster, curated by Donald Moffett, St. Lawrence University, Canton, New York

PULSE: Painting Now, Rare, New York

Insite 98, Mysterious Voyages: Exploring the Subject of Photography, Contemporary Museum, Baltimore

1997

Matrix 134—Power Up: Reassembled Speech, Interlocking Sister Corita and Donald Moffett, Wadsworth Atheneum, Hartford, Connecticut

Anne Chu, Rachel Harrison, Donald Moffett, and Jasmin Sian, Marc Foxx Gallery, Los Angeles

Public Notice, Exit Art, New York

1996

Fifteen Paintings, Richard Telles Fine Art, Los Angeles

Bare Bones, TZ Art, New York

1995

The Masculine Masquerade: Masculinity and Representation, MIT List Visual Arts Center, Cambridge, Massachusetts

In a Different Light: Visual Culture, Sexual Identity, Queer Practice, University Art Museum, University of California, Berkeley

Temporarily Possessed: The Semi-Permanent Collection, New Museum, New York

1994

Works on Paper: Selections from the Permanent Collection, Whitney Museum of American Art at Philip Morris, New York

Don't Leave Me This Way: Art in the Age of AIDS, National Gallery of Australia, Canberra

The Social Fabric, Beaver College Art Gallery, Glenside, Pennsylvania

1993

Whitney Biennial 1993, Whitney Museum of American Art, New York

Recent Acquisitions, Museum of Fine Arts, Boston

Prospect 1993, Frankfurter Kunstverein, Frankfurt

Robert Gober, Zoe Leonard, Donald Moffett, Adam Rolston, and John Lindell, Fawbush Gallery, New York

1992

Sculpture, Paula Cooper Gallery, New York

Dissent, Difference, and the Body Politic, Portland Art Museum, Portland, Oregon

Object Choice, Hallwalls Contemporary Arts Center, Buffalo, New York

Gegendarstellung: Ethik und Ästhetik im Zeitalter von AIDS, Kunstverein, Hamburg, Germany

Promises: Election Dreams and Desires, Fears and Nightmares, Jersey City Museum, Jersey City, New Jersey

Structural Damage, Blum Helman Warehouse, New York

1991

The Interrupted Life, New Museum of Contemporary Art, New York

(Dis)member, Simon Watson, New York

When Objects Dream and Talk in Their Sleep, Jack Tilton Gallery, New York

Situation, New Langton Arts, San Francisco

Nayland Blake, Ross Bleckner, Donald Moffett, Simon Watson, New York

Someone or Somebody, Meyers/Bloom, Los Angeles

Group Material's AIDS Timeline, Whitney Museum of American Art, New York

Erotic Desire, Perspektief Centre for Photography, Rotterdam, the Netherlands

1990

Strange Ways, Here We Come: Donald Moffett, Felix Gonzalez-Torres, Fine Arts Gallery, the University of British Columbia

Critical Realism, Perspektief Centre of Photography, Rotterdam, the Netherlands

Looking at a Revolution, Simon Watson, New York

Eros / Thanatos—Death and Desire, Tom Cugliani Gallery, New York

Indomitable Spirit: Photographers and Artists Respond to the Time of Aids, International Center of Photography Midtown, New York

Over the Sofa, into the Street, Neue Gesellschaft für bildende Kunst, Berlin

1989

To Probe and to Push: Artists of Provocation, Wessel + O'Connor Gallery, New York

Erotophobia: A Forum on Sexuality, Simon Watson, New York

1988

Group Material: AIDS and Democracy, Dia Art Foundation, New York

Vollbild AIDS: Kunst-Ausstellung über Leben und Sterben, Neue Gesellschaft für bildende Kunst, Berlin, and Bern, Switzerland

HONORS, APPOINTMENTS, AND PROJECTS

2010

Board of Governors, Skowhegan School, Skowhegan, Maine

2004

Resident faculty, Skowhegan School, Skowhegan, Maine

2003

Image Stream symposium speaker, Wexner Center for the Arts, Columbus, Ohio

1997

Panelist, Brooklyn Museum

1996

Lecturer, Museum of Modern Art, New York

Lecturer, Cooper-Hewitt, National Design Museum, New York

Lecturer, Yale University, Graduate School of Art

1992–94

Adjunct professor, Yale University, Graduate School of Art

1991–94

Artist Advisory Board, New Museum of Contemporary Art, New York

1989

Founded Bureau, a transdisciplinary studio

1988

Recipient of Art Matters, Inc. Grant

Founding member of Gran Fury, an AIDS activist collective

BIBLIOGRAPHY

2010

Cotter, Holland. "Act Up New York: Activism, Art, and the AIDS Crisis, 1987–1993." *New York Times*, October 15, 2010.

Moffett, Donald. "Questions of Style." *Artforum* 49 (September 2010): 266.

Myles, Eileen. "Lest We Forget." *Artforum* 48 (March 2010): 89–90.

Smith, Roberta. "Lucio Fontana, Robert Beck, and Donald Moffett." *New York Times*, May 7, 2010.

Valdez, Sarah. "Act Up New York." *Art in America*, November 16, 2010, http://www.artinamericamagazine.com/reviews/act-up-new-york/.

Velasco, David. "Manhattan Transfer." Artforum.com, June 14, 2010, http://artforum.com/diary/id=25832.

2009

Adam, Georgina. "FIAC: È la rivincita dei galleristi." *Giornale dell'arte* 27, no. 292 (2009): 92.

Aliaga, Juan Vicente. *En todas partes: Políticas de la diversidad sexual en el arte*. Exhibition catalogue. Santiago de Compostela: Xunta de Galicia, Centro Gallego de Arte Contemporánea, 2009.

Fakray, Sarah. "Proenza Schouler Designers on Donald Moffett." *Another Magazine*, Spring–Summer 2009: 88.

Rattemeyer, Christian. *The Judith Rothschild Foundation Contemporary Drawings Collection: Catalogue Raisonné*. New York: Museum of Modern Art, 2009.

Velasco, David. "Donald Moffett." *Artforum* 47 (January 2009): 207.

2008

Cartin, Mickey, and Steven Holmes. *Festschrift: Selections from a Collection*. Hartford, Conn.: Leo, 2008.

Rosenberg, Karen. "Art in Review: Donald Moffett / Yuichi Higashionna." *New York Times*, October 31, 2008.

2007

Ault, Julie, and Martin Beck. "Das Ausstellen ausstellen: Ausstellungen sind Struktur, Display und Inhalt, Dialog, Netzwerk und Widerspruch." *Kunstforum International* 186 (2007): 148–59.

Blume, Anna. *Donald Moffett: Mangle Me*. Exhibition catalogue. New York: Marianne Boesky Gallery, 2007.

Devuono, Frances. "'Sparkle Then Fade' at the Tacoma Art Museum." *Artweek* 38 (October 2007): inside back cover.

Fox, Dan. "Donald Moffett." *Frieze*, no. 110 (October 2007): 288.

2006

Douglas, Sarah. "Staying Power." *Art and Auction* 30 (November 2006): 160–67.

Wagner, Frank, Kasper König, and Julia Friedrich. *Das achte Feld: Geschlechter, Leben und Begehren in der Kunst seit 1960/ The Eighth Square: Gender, Life, and Desire in the Arts since 1960*. Exhibition catalogue, Museum Ludwig, Cologne. Ostfildern, Germany: Hatje Cantz, 2006.

2005

Review of "Hippie Shit." *New Yorker*, November 14, 2005, 22.

Richer, Francesca, and Matthew Rosenzweig. *No. 1: First Works by 362 Artists*. New York: D.A.P./Distributed Art Publishers, 2005.

Smith, Roberta. "Art in Review: Donald Moffett,' Hippie Shit.'" *New York Times*, November 4, 2005.

2004

Allen, Greg. "The Best D.C. Art Isn't in D.C." *Greg.org*, July 13, 2004, http://greg.org/archive/2004/07/13/the_best_dc_art_isnt_in_dc.html.

Babias, Maríus. "Subject Production and Political Art Practice." *Afterall*, no. 9 (2004): 101–9.

Coomer, Martin. Review. *Time Out London*, July 7–14, 2004, 49.

Johnson, Ken. "The Hamptons, A Playground for Creativity." *New York Times*, August 6, 2004.

Krygowski, Jill Martinez. "Artworker of the Week #36: Donald Moffett at Stephen Friedman Gallery, London." *Kultureflash*, July 14, 2004.

Longwell, Alicia Grant. *North Fork / South Fork: East End Art Now*. Exhibition catalogue. Southampton, N.Y.: Parrish Art Museum, 2004.

Powhida, William. "'Seeing Other People' at Marianne Boesky Gallery." *Brooklyn Rail*, September 2004, http://www.brooklynrail.org/2004/09/artseen/seeing-other-people-marianne-boesky-gall.

Yablonsky, Linda. "How Far Can You Go?" *Art News* 103 (January 2004): 104–9.

2003

Church, Amanda. "Donald Moffett at Marianne Boesky." *Flash Art* 36 (May–June 2003): 92.

Cotter, Holland. "Donald Moffett—'The Extravagant Vein.'" *New York Times*, February 21, 2003.

Crimp, Douglas. "Gran Fury Talks to Douglas Crimp." *Artforum* 41 (April 2003): 70–71, 232–34.

"Donald Moffett, Marianne Boesky Gallery." *New Yorker*, March 17, 2003, 42.

Gehlawat, Monika. "Focus: 212121 Painting from Postconceptualism to Recontextualism; Profile Donald Moffett." *Contemporary*, no. 58 (2003): 90–93.

Golden, Thelma. "Best of 2003." *Artforum* 42 (December 2003): 126.

Johnson, Ken. "Puddle-Wonderful." *New York Times*, August 8, 2003.

Levin, Kim. "Donald Moffett." *Village Voice*, March 5–11, 2003, 85.

Mar, Alex. Review. *New York Sun*, August 14, 2003.

Molesworth, Helen Anne. *Image Stream*. Exhibition catalogue. Columbus: Wexner Center for the Arts, Ohio State University, 2003.

Muller, Brian. "212121 Painting: From Postconceptualism to Recontextualism." *Contemporary*, no. 58 (2003): 32–41.

Painter, Chad. "Watching a Video Is a Legit Option for Once." *Other Paper*, September 25–October 1, 2003.

Reeves, Jennifer. "The Evergreen Will." *NY Arts* 8 (July–August 2003), http://www.nyartsmagazine.com/index.php?option=comcontent&view=article&id=1351:the-evergreen-will-jennifer-reeves&catid=44:julyaugust-2003&Itemid=688.

Rubinstein, Raphael. "Eight Painters: New Work." *Art in America* 91 (November 2003): 130–41.

Starker, Melissa. "A List." *Columbus Alive*, October 2, 2003.

"Stolen Art Alert." *IFAR Journal* 6 (2003): 63.

Williams, Gregory. "Donald Moffett." *Artforum* 41 (May 2003): 167.

2002

Artner, Alan G. "Barbara Jordan Steps Front, Center in Moffett Installation." *Chicago Tribune*, June 6, 2002.

Camper, Fred. "Rooms with a View: Beth Reitmeyer: You Mean So Much To Me // Steve McQueen: Nov. 7th // Donald Moffett: What Barbara Jordan Wore // Critical Mass." *Chicago Reader*, June 7, 2002, 30.

Cotter, Holland. Review of *Vapor* at Marianne Boesky Gallery. *New York Times*, April 5, 2002.

Hawkins, Margaret. "Fashion of Forthrightness." *Chicago Sun-Times*, June 9, 2002, 14.

"Museum Showcases Famed Congresswoman." *River Bend [Ill.] Telegraph*, August 21, 2002.

"New Art Exhibit Showcases Famed Congresswoman." *Daily Herald*, August 21, 2002.

Richard, Frances. "Penetration." *Artforum* 41 (October 2002): 154.

Smith, Elizabeth A. T. *Donald Moffett: What Barbara Jordan Wore*. Exhibition catalogue. Chicago: Museum of Contemporary Art, 2002.

Smith, Elizabeth A. T., Alison Pearlman, and Julie Rodrigues Widholm. *Life Death Love Hate Pleasure Pain: Selected Works from the Museum of Contemporary Art, Chicago, Collection*. Exhibition catalogue. Chicago: Museum of Contemporary Art, 2002.

West, Cassandra. "Political Icon Hailed; Domestic Icon Assailed." *Chicago Tribune*, July 3, 2002.

2001

Herbert, Lynn M., Klaus Ottmann, and Peter Schjeldahl. *The Inward Eye: Transcendence in Contemporary Art*. Houston: Contemporary Arts Museum Houston, 2001.

Leeb, Susanne. "Selbstreflexive Autorsysteme." *Texte zur Kunst* 11, no. 41 (2001): 49–56.

Wehr, Anne. "American." *Time Out New York*, January 18–25, 2001, 56.

Withers, Rachel. "Donald Moffett." *Artforum* 39 (January 2001): 150.

2000

Aletti, Vince. Review of *Photography about Photography*. *Village Voice*, March 7, 2000, 98.

Colpitt, Frances. "Jesse Amado and Donald Moffet [sic] at Finesilver." *Art in America* 88 (March 2000): 137.

Eggerer, Thomas. "Weich gelandet." *Texte zur Kunst* 10, no. 38 (2000): 181–84.

Geene, Stephan. "Ausgesprochen viel versprechend." *Texte zur Kunst* 10, no. 38 (2000): 185–91.

Gonzales-Day, Ken. "Donald Moffett and Sister Corita Kent at Marc Foxx, at UCLA Hammer Museum, at Luckman Fine Arts Gallery, California State University, Los Angeles." *Art Issues*, no. 63 (Summer 2000): 53.

Hainley, Bruce. "Sister Acts." *Artforum* 38 (January 2000): 34.

Heller, Steven. "Marlene McCarty, Designer, Activist, Virtualist." *Print* 54, no. 5 (2000): 58.

Herbert, Martin. Review. *Time Out London*, November 8, 2000.

Kertess, Klaus. *00: Drawings 2000 at Barbara Gladstone Gallery*. Exhibition catalogue. New York: Barbara Gladstone Gallery, 2000.

LaBelle, Charles. "Sister Corita and Donald Moffett; Corita Kent's 1960s Pop." *Frieze*, no. 52 (May 2000): 94.

Mac Adam, Alfred. "Drawings 2000." *Art News* 99 (October 2000): 177.

Murphy, Patrick T., and Richard Torchia. *The Sea and the Sky*. Exhibition catalogue. Glenside, Penn.: Beaver College Art Gallery, 2000.

Newhouse, Kristina. "Sister Corita, Donald Moffett." *Artext*, no. 70 (2000): 87.

1999

Arning, Bill. Review. *Time Out New York*, August 5–12, 1999.

Cotter, Holland. Review of "The Cathedral Project: Liz Deschenes, Kevin Larmon, Donald Moffett." *New York Times*, July 23, 1999.

Goldsworthy, Rupert. "Plastic Casters." *Artnet*, Summer 1999, http://www.artnet.com/magazine_pre2000/reviews/goldsworthy/goldsworthy5-24-99.asp.

Hegarty, Laurence. Review of *Monochrome*. *New Art Examiner* 26 (July–August 1999): 53.

Johnson, Ken. Review of *Drawings* at Nicole Klagsbrun. *New York Times*, August 13, 1999.

1998

Centre d'art contemporain. *Les mondes du Sida, entre resignation et espoir / AIDS Worlds, between Resignation and Hope*. Exhibition catalogue. Bern, Switz.: Sida Info Doc Suisse, 1998.

1997

Ammann, Jean Christophe, and Ulrich Gooss. *Der Frankfurter Engel: Mahnmal Homosexuellenverfolgung; Ein Lesebuch*. Frankfurt am Main: Eichborn, 1997.

Brown, Gerald. Review. *Philadelphia Weekly*, September 24, 1997.

Donahue, Victoria. "Woodworkers' Traveling Show Has Turned Quite Impressive." *Philadelphia Inquirer*, October 5, 1997.

Rice, Robin. "Big and Blue." *Philadelphia City Paper*, October 17, 1997.

Sozanski, Edward J. "His Flicks and Daubs Add Charm to City Scenes" (includes review of Blue (NY) at Beaver College Art Gallery). *Philadelphia Inquirer*, October 10, 1997.

Torchia, Richard. *Blue [NY]: Donald Moffett*. Exhibition catalogue. Glenside, Penn.: Beaver College Art Gallery, 1997.

1996

Atkins, Robert. "Goodbye Lesbian/ Gay History, Hello Queer Sensibility: Meditating on Curatorial Practice." *Art Journal* 55, no. 4 (1996): 80–86.

Paparoni, Demetrio. "L'astrazione ridefinita." *Tema celeste* 13 (Autumn 1996): 32–39.

1995

Atkins, Robert. "Very Queer Indeed." *Village Voice*, January 31, 1995, 69.

Blake, Nayland, Lawrence Rinder, and Amy Scholder. *In a Different Light: Visual Culture, Sexual Identity, Queer Practice*. San Francisco: City Lights, 1995.

Marincola, Paula. "Fabric as Fine Art: Thinking across the Divide." *Fiberarts* 22, no. 2 (1995): 34–39.

Marincola, Paula, and Elisabeth Sussman. *The Social Fabric: Polly Apfelbaum, Renée Green, David Hammons, Michael Jenkins, Mike Kelley, Donald Moffett, Lois Nesbitt, Stuart Netsky, Elaine Reichek, David Robbins, Jana Sterbak, Rosemarie Trockel, Meyer Vaisman*. Exhibition catalogue. Glenside, Penn.: Beaver College Art Gallery, 1995.

Perchuk, Andrew, and Helaine Posner. *The Masculine Masquerade: Masculinity and Representation*. Exhibition catalogue. Cambridge, Mass.: MIT List Visual Arts Center, 1995.

1994

Cotter, Holland. "Art after Stonewall: Twelve Artists Interviewed." *Art in America* 82 (June 1994): 56–65.

Gott, Ted. *Don't Leave Me This Way: Art in the Age of AIDS*. Exhibition catalogue. Canberra: National Gallery of Australia, 1994.

Hess, Elizabeth. "No Way Out." *Village Voice*, February 22, 1994, 84.

Smith, Roberta. "Response to AIDS Gains in Subtlety." *New York Times*, February 18, 1994.

Watney, Simon. "Aphrodite of the Future." *Artforum* 32 (April 1994): 75–76.

1993

Bhabha, Homi K., and Elisabeth Sussmann. *Whitney Biennial: 1993 Biennial Exhibition*. Exhibition catalogue. New York: Whitney Museum of American Art in association with Abrams, 1993.

Cottingham, Laura, and Hilton Als. "The Pleasure Principled." *Frieze Magazine*, no. 10 (May 1993): 10–15.

Harris, William. "Art and AIDS: Urgent Images." *Art News* 92 (May 1993): 120–23.

Watney, Simon. "Memorializing AIDS: The Work of Ross Bleckner." *Parkett*, no. 38 (1993): 53.

Watson, Simon, and John S. Weber. *Dissent, Difference, and the Body Politic*. Exhibition catalogue. Portland, Ore.: Portland Art Museum, Art/On the Edge Program, 1993.

Weiermair, Peter, Beate Ermacona, and Beate Beering. *Prospect 93: Eine internationale Ausstellung aktueller Kunst / An International Exhibition of Contemporary Art*. Exhibition catalogue. Frankfurt: Frankfurter Kunstverein, 1993.

1992

Ellenzweig, Allen. *The Homoerotic Photograph: Durieu / Delacroix to Mapplethorpe*. New York: Columbia University Press, 1992.

Gegendarstellung: Ethik und Ästhetik im Zeitalter von AIDS. Exhibition catalogue. Hamburg: Kunstverein, 1992.

Glueck, Grace. Review. *New York Observer*, September 21, 1992.

Gonzales-Day, Ken, and Andrew Perchuk. *Object Choice*. Exhibition catalogue. Buffalo, N.Y.: Hallwalls Contemporary Arts Center, 1992.

Sangster, Gary. *Promises: Election Dreams and Desires, Fears and Nightmares*. Exhibition catalogue. Jersey City, N.J.: Jersey City Museum, 1992.

1991

Donahue, John. "Wet Your Whistle: Donald Moffett's Double Header." *Outweek* 84 (February 1991): 49–50.

Review. *New Yorker*, February 18, 1991, 10.

Mahoney, Robert. Review. *Arts Magazine* 65 (April 1991): 104–5.

Morin, France, and Massimo Vignelli. *The Interrupted Life*. Exhibition catalogue. New York: New Museum of Contemporary Art, 1991.

Nesbitt, Lois. "New York: Donald Moffett." *Artforum* 29 (May 1991): 139.

Raynor, Vivien. "Art; Aldrich Offers Visions of Inhumanity." *New York Times*, August 4, 1991.

Schjeldahl, Peter. "Death Warmed Over." *Village Voice*, October 15, 1991, 113.

1990

Crimp, Douglas, with Adam Rolston. *Aids Demo Graphics*. Seattle: Bay Press, 1990.

Donahue, John. "Fund Me." *Outweek* 51 (June 20, 1991): 64–65.

Group Material: AIDS Timeline. Exhibition catalogue. Hartford, Conn.: Wadsworth Atheneum, 1990.

The Indomitable Spirit: Photographers and Artists Respond to the Time of AIDS. Exhibition catalogue, International Center of Photography and Los Angeles Municipal Art Gallery. New York: Photographers + Friends United against AIDS, 1990.

Smith, Roberta. Review. *New York Times*, February 16, 1990.

Sokolowski, Thomas W. "Iconophobics Anonymous." *Artforum* 28 (Summer 1990): 114–19.

Wallis, Brian, ed. *Democracy: A Project*. Seattle: Bay Press, 1990.

Watson, Scott. *Strange Ways, Here We Come: Donald Moffett, Felix Gonzalez-Torres*. Exhibition catalogue. Vancouver: Fine Arts Gallery, University of British Columbia, 1990.

Wulffen, Thomas. "Kunst und schwule Kultur in den USA." *Kunstforum*, no. 107 (1990): 309.

1989

Cooper, Dennis. "New York: Donald Moffett." *Artforum* 28 (September 1989): 145.

Decter, Joshua. Review. *Arts Magazine* 64 (September 1989): 103.

1988

Wagner, Frank. *Vollbild AIDS: Eine Kunst-Ausstellung über Leben und Sterben*. Exhibition catalogue. Berlin: Neue Gesellschaft für bildende Kunst, 1988.

Works in the Exhibition

He Kills Me

He Kills Me, 1987
Offset lithograph
23½ x 37½ inches
Courtesy the artist

Gays in the Military, I–V

Gays in the Military I, 1990
Ink and transfer type on paper,
artist's wood frame
13½ x 11 inches framed
Collection Scott Watson, Vancouver

Gays in the Military II, 1990
Ink and transfer type on paper,
artist's wood frame
13½ x 11 inches framed
Collection Scott Watson, Vancouver

Gays in the Military III, 1990
Ink and transfer type on paper,
artist's wood frame
13½ x 11 inches framed
Collection Scott Watson, Vancouver

Gays in the Military IV, 1990
Ink and transfer type on paper,
artist's wood frame
13½ x 11 inches framed
Collection Scott Watson, Vancouver

Gays in the Military V, 1990
Ink and transfer type on paper,
artist's wood frame
13½ x 11 inches framed
Collection Scott Watson, Vancouver

Nom de Guerre

Nom de Guerre: Poo Poo Platter,
1991
Ink and transfer type on paper,
artist's wood frame
20¾ x 18¼ inches framed
Collection Jennifer McSweeney,
New York

Nom de Guerre: Trigger, 1991
Ink and transfer type on paper,
artist's wood frame
20¾ x 18¼ inches framed
Private collection, Houston

Nom de Guerre: La Treen, 1991
Ink and transfer type on paper,
artist's wood frame
20¾ x 18¼ inches framed
Collection Museum of Fine Arts,
Houston, Gift of Michael A. Caddell
and Cynthia Chapman

Nom de Guerre: Truffles, 1991
Ink and transfer type on paper,
artist's wood frame
20¾ x 18¼ inches framed
Whitney Museum of American Art,
New York, Gift of Emily Leland Todd,
93.50

Blue (NY)

Lost Weekend, 1997
Unique reversal prints, artist's wood
frame
3 prints, 60 x 26⅞ inches overall,
framed
Courtesy the artist and Marianne
Boesky Gallery, New York

Untitled, 1997
Unique reversal print, artist's
wood frame
17⅛ x 14 inches, framed
Collection Siobhan Liddell,
New York

Untitled (in four parts), 1997
Unique reversal prints
4 prints, 23 x 19 inches each, framed
(overall dimensions variable)
Courtesy the artist and Marianne
Boesky Gallery, New York

a.m., noon, p.m. (4th of July), 1999
Unique reversal prints
3 prints, 19⅛ x 73½ inches overall,
framed
Collection Dr. Alan Fard and
Ed Simpson, New York

Mr. Gay in the U.S.A.

Mr. Gay in the U.S.A., 2001
Graphite on paper, linen tape
16 drawings, 11 x 17 inches each
2 drawings, 11 x 8½ inches each
Collection Mickey Cartin/The Cartin
Collection, Hartford

What Barbara Jordan Wore

Texas, 1967, 2001
Digital chromogenic development
print in artist's wood frame
44¼ x 35½ inches
Museum of Contemporary Art,
Chicago, gift of the artist

Texas, 1969, 2001
Digital chromogenic development
print in artist's wood frame
44¼ x 35½ inches
Museum of Contemporary Art,
Chicago, gift of the artist

Texas, 1971, 2001
Digital chromogenic development
print in artist's wood frame
44¼ x 35½ inches
Museum of Contemporary Art,
Chicago, gift of the artist

Untitled (We the People #2), 2001
Oil on linen
74 x 54 inches
Collection Dr. Marc and Livia Straus,
Chappaqua, New York

Untitled (We the People #3), 2001
Oil on linen
74 x 54 inches
Collection Howard and Donna Stone,
Chicago

Untitled (The Committee), 2002
Video projection, oil and enamel
on linen
45 x 60 inches
Museum of Contemporary Art,
Chicago, restricted gift of Nancy A.
Lauter and Alfred L. McDougal,
Judith Neisser, Barbara and Thomas
Ruben, Faye and Victor Morgenstern
Family Foundation, and Ruth Horwich

Untitled (Ms. Jordan), 2002
Video projection, oil and enamel
on linen
45 x 60 inches
Museum of Contemporary Art,
Chicago, restricted gift of Nancy A.
Lauter and Alfred L. McDougal,
Judith Neisser, Barbara and Thomas
Ruben, Faye and Victor Morgenstern
Family Foundation, and Ruth Horwich

Untitled (The Public), 2002
Video projection, oil and enamel
on linen
45 x 60 inches
Museum of Contemporary Art,
Chicago, restricted gift of Nancy A.
Lauter and Alfred L. McDougal,
Judith Neisser, Barbara and Thomas
Ruben, Faye and Victor Morgenstern
Family Foundation, and Ruth Horwich

The Extravagant Vein

Gold/Blue Sky, 2003
Video projection, oil and enamel
on linen
54 x 96 inches
Collection Jeff Stokols and Daryl
Gerber Stokols, Chicago

Gold/Landscape #2, 2003
Video projection, oil and enamel
on linen
54 x 96 inches
Courtesy the artist and Marianne
Boesky Gallery, New York

Gold/Landscape #3, 2003
Video projection, oil and enamel
on linen
36 x 64 inches
Collection Sharon and Michael Young,
Dallas

Gold/Passage, 2003
Video projection, oil and enamel
on linen
80 x 60 inches
Collection Tony and Deb Clancy,
Atlanta

Gold/Tunnel, 2003
Video projection, oil and enamel
on linen
54 x 96 inches
Private collection, New York

Gold/Tupelo Plains, 2003
Video projection, oil and enamel
on linen
2 panels, 60 x 160 inches overall
Collection Alan Hergott and Curt
Shepard, Beverly Hills

D.C.

Aluminum/Dupont Circle, 2004
Video projection, oil and alkyd
on linen
60 x 80 inches
The David Roberts Art Foundation,
Ltd., London

Aluminum/FDR and Friends, 2004
Video projection, oil and alkyd
on linen
80 x 60 inches
Collection Teri and Barry Volpert,
New York

*Aluminum/J. Edgar Hoover FBI
Building*, 2004
Video projection, oil and alkyd
on linen
48 x 36 inches
Collection Mickey Cartin/The Cartin
Collection, Hartford

Aluminum/Watergate, 2004
Video projection, oil and alkyd
on linen
45 x 60 inches
The Linda Pace Foundation,
San Antonio

Aluminum/White House Unmoored,
2004
Video projection, oil and alkyd
on linen
45 x 60 inches
Courtesy the artist and Stephen
Friedman Gallery, London

Paintings from a Hole

Untitled/Black (Lot 070504), 2004
Video projection, oil and alkyd
on linen
30 x 40½ inches
Collection J. Ben Bourgeois,
Los Angeles

Untitled/Cobalt (Lot 072204), 2004
Video projection, oil and alkyd
on linen
30 x 40¼ inches
The Rachofsky Collection, Dallas

Untitled/Green Brush (Lot 093003),
2004
Video projection, oil and alkyd
on linen
25 x 30¼ inches
Collection Adam Clammer,
San Francisco

Untitled/Green Roller (Lot 080104),
2004
Video projection, oil and alkyd
on linen
16 x 20 inches
Collection Mickey and Jeanne Klein,
Austin

Hippie Shit

Lot 022005, 2005
Oil and alkyd on linen
64 x 36¼ inches
Collection Charles and Nathalie
de Gunzburg, New York

Lot 062005, 2005
Oil and alkyd on linen
80 x 44 inches
Courtesy the artist and Marianne
Boesky Gallery, New York

Lot 070705, 2005
Oil and alkyd on linen
35¼ x 28 inches
Collection Peter Marino/Peter Marino
Architect + Associates,
New York

Lot 080105, 2005
Oil and alkyd on linen
35¼ x 28 inches
Collection Shelley Fox Aarons and
Philip Aarons, New York

Lot 082105, 2005
Oil and alkyd on linen
64¼ x 36 inches
Courtesy the artist and Marianne
Boesky Gallery, New York

Lot 091405, 2005
Oil and alkyd on linen
36 x 64 inches
Collection Milton Dresner, Michigan

Impeach

Impeach, 2006
DVD-A with DVD-A player and five
speakers
Duration: 2:20 minutes
Courtesy the artist and Marianne
Boesky Gallery, New York

Fleisch

Lot 022407 (O-O), 2007
Oil, charcoal, rayon, aluminum, rabbit
skin glue, and polyvinyl acetate
on linen
24 x 20 inches
Courtesy the artist and Marianne
Boesky Gallery, New York

Lot 030807 (Oo), 2007
Oil, charcoal, rayon, rabbit skin glue,
and polyvinyl acetate on linen
24 x 20 inches
Courtesy the artist and Marianne
Boesky Gallery, New York

Lot 032407 (11–11o), 2007
Oil, rayon, aluminum, rabbit skin
glue, and polyvinyl acetate on linen
72 x 60 inches
The David Roberts Art Foundation,
Ltd., London

Lot 081907 (IOo), 2007
Oil, cotton, aluminum, rabbit skin
glue, and polyvinyl acetate on linen
24 x 20 inches
Courtesy the artist and Marianne
Boesky Gallery, New York

Lot 081907 (Xoooo), 2007
Oil, cotton, aluminum, rabbit skin
glue, and polyvinyl acetate on linen
24 x 20 inches
Collection Clo and Charles Cohen,
Los Angeles

Lot 091507 (O5o_), 2007
Oil, rabbit skin glue, and polyvinyl
acetate on linen
24 x 20 inches
Courtesy the artist and Marianne
Boesky Gallery, New York

Lot 091607 (I12O13o), 2007
Oil, cotton, aluminum, rabbit skin
glue, and polyvinyl acetate on linen
24 x 20 inches
Courtesy the artist and Marianne
Boesky Gallery, New York

Lot 092107 (X15o), 2007
Oil, cotton, aluminum, rabbit skin
glue, and polyvinyl acetate on linen
24 x 20 inches
Courtesy the artist and Marianne
Boesky Gallery, New York

Lot 092207 (O), 2007
Acrylic, rabbit skin glue, and polyvinyl
acetate on linen
24 x 20 inches
Collection Agnes Gund, New York

Gutted

Lot 020207 (O), 2007
Acrylic, rayon, aluminum, and
galvanized tin zipper on cotton duck,
wood stretcher
35 x 28 inches
Private collection, London

Lot 060707 (O-Black), 2007
Acrylic, polyvinyl acetate with rayon,
and steel zipper on linen, wood
stretcher
35½ x 28½ inches
Courtesy the artist and Marianne
Boesky Gallery, New York

Lot 102807 (X), 2007
Acrylic, polyvinyl acetate with rayon,
and steel zipper on linen, aluminum
stretcher
72 x 72 inches
Courtesy the artist; Marianne Boesky
Gallery, New York; and Anthony
Meier Fine Arts, San Francisco

Lot 102907 (X), 2007
Acrylic, polyvinyl acetate with rayon,
and steel zipper on linen, wood
stretcher
54 x 44 inches
Collection Adam Clammer,
San Francisco

Lot 110107 (X), 2007
Acrylic, polyvinyl acetate with rayon,
and steel zipper on linen, aluminum
stretcher
76 x 100 inches
Collection Meryl Lyn Moss, Chicago

Lot 051408 (X), 2008
Acrylic, polyvinyl acetate with rayon,
and steel zipper on linen, wood
stretcher
54 x 44 inches
Private collection, New York

Comfort Hole

Lot 121909 (18/o), 2009
Oil on linen with wood panel support
17 x 17 inches
Collection Mickey and Jeanne Klein,
Austin

Lot 122109 (o8c), 2009
Oil on linen with wood panel support
17 x 17 inches
Collection Jennifer and John Eagle,
Dallas

Lot 010510 (3o), 2010
Oil on linen with wood panel support
17 x 17 inches
Collection Chris Hill, San Antonio

Lot 011710 (O), 2010
Oil on linen with wood panel support
17 x 17 inches
Lora Reynolds and Quincy Lee,
Austin

Lot 012010 (Lucky Pierre), 2010
Oil on linen with wood panel support
16 x 16 inches
Collection Jennifer and John Eagle,
Dallas

Lot 120309 (4/0), 2010
Oil on linen with wood panel support
31 x 25 inches
Collection John and Lisa Runyon,
Dallas

Photography of artworks courtesy
Donald Moffett, Marianne Boesky
Gallery, Anthony Meier Fine Arts, and
Stephen Friedman Gallery.

Thanks to the following
photographers:
Ron Amstutz (New York)
Christopher Burke Studio (New York)
Erma Estwick (New York)
Jason Mandella (New York)
Adam Reich (New York)
Jason Wyche (New York)
Ira Schrank Sixth Street Studio
(San Francisco)
Stephen White (London)

Artist's Acknowledgments

Donald Moffett would like to offer his sincere thanks to the following:

Valerie Cassel Oliver

Bill Arning and the staff at CAMH

Eric Shiner

John Weber and Ian Berry

John Smith

Douglas Crimp

Russell Ferguson

Marianne Boesky, Serra Pradhan, Adrian Turner, and the staff of Marianne Boesky Gallery, New York

Anthony Meier, Rebecca Camacho, and Sarah Granatir Bryan of Anthony Meier Fine Arts, San Francisco

Stephen Friedman, David Hubbard, and the staff of Stephen Friedman Gallery, London

Fredericka Hunter and Ian Glennie of Texas Gallery, Houston

The collectors who have lent works to the exhibition

Miko McGinty and the staff of Miko McGinty, Inc.

Charles Miers, Margaret Rennolds Chace, and Julie Di Filippo at Skira Rizzoli

Karen Jacobson

Gwendolyn Skaggs

Shaun Krupa

Gayle Brown

Julia Rommel

Larry Levine

And a very special thanks to:

Bob Gober

Bettie Goodwin Moffett and the late T. H. Moffett